DRAWING
CARTOON
FACES

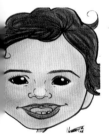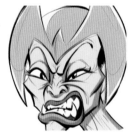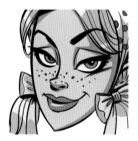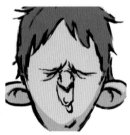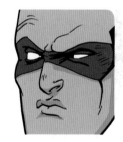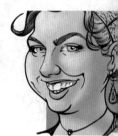

Harry
Hamernik
and 8fish

IMPACT
CINCINNATI, OHIO
www.impact-books.com

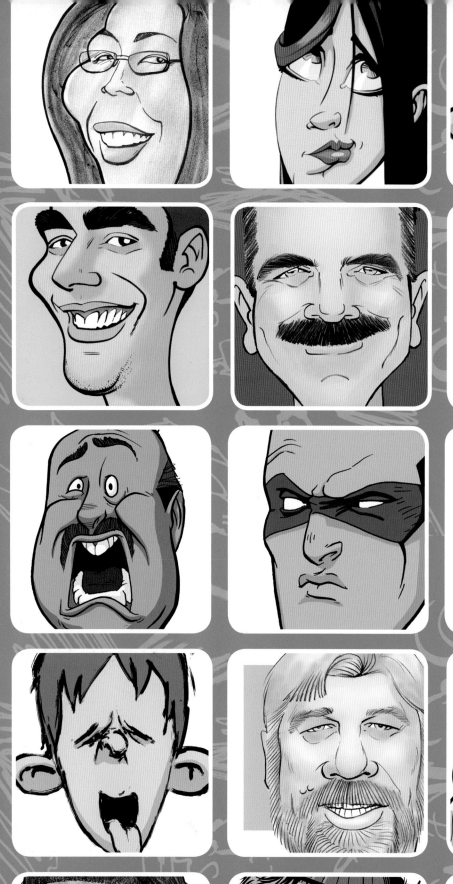
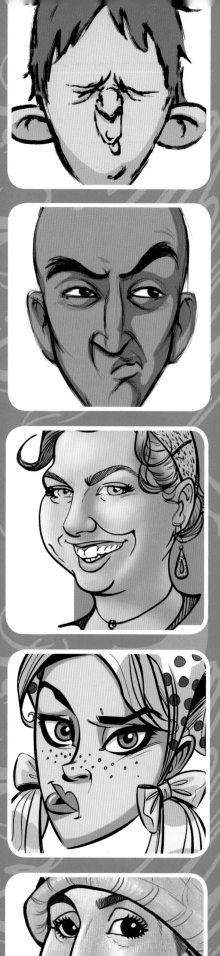
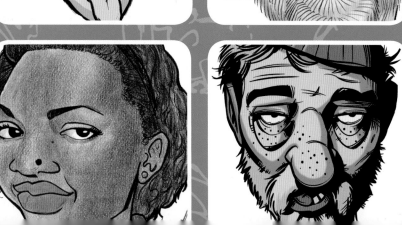

Table of Contents

Chapter 1:
Fundamentals

Chapter 2:
Caricatures

Chapter 3:
Scenarios & Characters

Chapter 4:
Storytelling

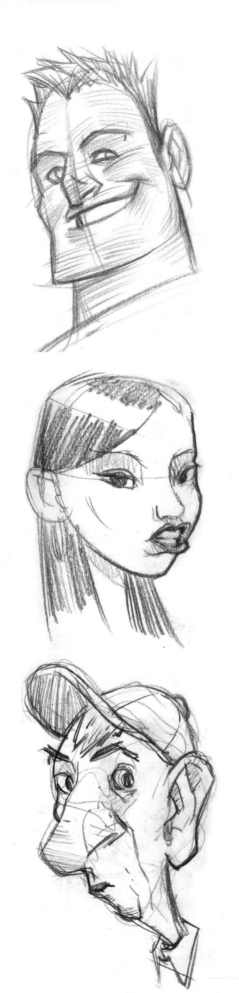

Introduction

Art and expression are commonly considered synonymous. This is especially easy to see in the world of comics and cartoons. The main purpose of a comic was to grab the reader's attention with larger-than-life drama. The stories and characters were big and bold. Comics and cartoons have progressed into areas of sophistication and subtlety today, but they are still all about expression and telling a story. All comics have characters, and all characters have expressions.

A compelling story is told with a range of emotions. The characters are more than just happy, sad or angry. They can be ecstatic, depressed or full of rage. If you truly want to create characters that are realistic, three-dimensional and engaging, you have to start delving into the infinite number of complex expressions we possess. Why? Because the human experience is deep.

We'll look at many different emotions to explore that human experience. Faces are made up of many shapes that change with each expression. Cartoons frequently take these main aspects of the face and exaggerate them to show more expression. Caricatures are a perfect example of exaggerated features. That's what makes drawing them so much fun! You'll learn how to focus in on the standout pieces of the face, such as the eyes, nose or lips. Then these lessons can be applied to explore various expressions. Practicing caricatures of real people will help stretch your imagination and ability to create new characters. By the end of the book, you'll know how to draw cartoon faces, expressions and how to put it all together to create a story.

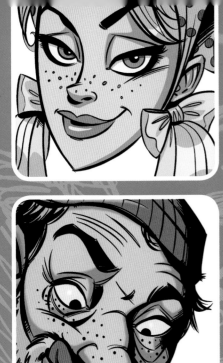

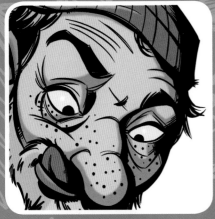
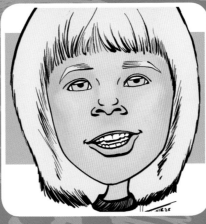
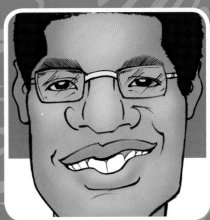
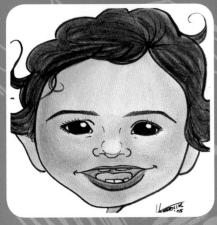

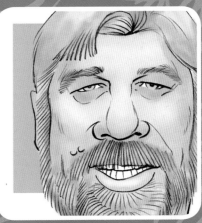
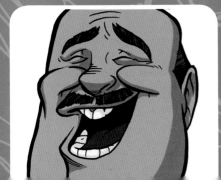
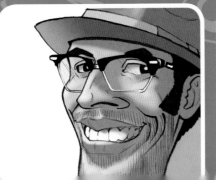
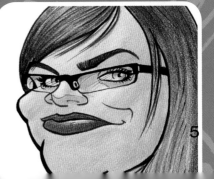

1

The Fundamentals

There are a lot of different reasons for expressions, but whatever the reason, it all ends up on the face. That is why we have to start with the fundamentals. In this chapter, we'll cover basic sketching techniques as well as how to draw heads, mouths, noses and eyes. You'll learn about all their standard movements and how they change shape when they move. Once you learn these foundation lessons, complex expressions will be much easier to draw!

Materials and Equipment

These pages show the materials and tools that we use for expressing our ideas visually.
All artists are unique. So when it comes to tools, each of us prefers something different.
But every artist's arsenal includes such basics as paper and pencil.

Paper

Any paper will do—even yellow sticky notes work great for nailing down your ideas. However, a ream of cheap 8.5" × 11" (22cm × 28cm) copy paper purchased from your local grocery or office supply store will give you a little more room to work. Most of us prefer spiral-bound sketchbooks with nice, heavy paper and a medium tooth, like 30 to 60 lbs. (65gsm to 125gsm). Sketchbooks in a variety of sizes and weights can be bought at art supply stores for the same price or slightly more than a ream of good, thick paper.

Pencils

This is where it gets personal. A good pencil is an artist's best friend, and when you find a brand that you like, the relationship may last for a lifetime. (Even so, many a drawing has been well rendered with a standard, chewed-up no. 2 pencil long after the eraser has been worn away.) Our list includes the following: Mechanical pencil—any weight is fine, but make sure you get soft lead (HB or B). Col-Erase pencil in Blue or Carmine Red—for blocking in your rough; these colors are easily removed on the computer or copy machine after your dark line has been drawn over the top. Faber-Castell Polychromos pencil—for your tight clean-up drawing. Remember, in the end it's really up to you and what you like.

Pens and Markers

For some of us, using a standard black ballpoint pen for drawing and sketching is a lot of fun, considering that it forces us to be accurate because mistakes can't be erased. Others prefer to use them for the finishing touches because they make a nice black line. You may also consider using felt-tip pens like the Sakura Pigma Micron, which comes in a variety of sizes. The Pilot Precise Rolling Ball pen (extra fine) works great for inking in details and making sure they are black. A variety of pens and markers can be found at your local art supply store on racks with places to test each one before you buy. Once you've found a pen you like, pick up a few of them in case the ink runs out right in the middle of a big, life-or-death project.

Mirror, Mirror

What does a mirror have to do with drawing? Well, nothing, really—except that a good facial expression is usually based on a good reference, and your handsome mug in a small mirror taped to your drawing table might provide all the reference you need. No longer will it only be used for cleaning the spinach out of your teeth.

Overcoming Drawing Bias

We all have an unconscious bias toward our own drawings, so much so that we sometimes miss errors that are glaringly obvious to someone else. As you're drawing, hold your picture up to the mirror, and you'll see what we mean. The reverse image of your masterpiece will suddenly seem like a childish scribble. All the errors will become apparent, and you'll be able to fix them in a snap.

If you don't happen to have a mirror handy, turn your drawing over and hold it up to a light. Just make sure you don't have anything drawn on the other side.

Pencil Sharpener

Any pencil sharpener will do, but a good electric one will give you a nice, sharp tip. You can also get a battery-powered one for those drawing sessions on the road. If your budget calls for a handheld version, try to get one that is all metal. Plastic body versions quickly lose the strength to hold the metal blades for sharpening.

Software

If you can afford it, good software can really speed up the artistic process, especially in a professional working environment. Our software of choice includes Adobe Photoshop® and Corel Painter®. Each has the ability to mimic the look of all types of mediums, including pencil, pen, watercolor, acrylic, oil and so much more. But these programs are almost useless for an artist without a trusty pressure-sensitive graphics tablet made by Wacom. These tablets give you a feeling similar to drawing on paper. Once you get used to using one, you will quickly see the benefits. They come in a variety of sizes and price ranges.

Drawing and Sketching

A good drawing will set you apart from the crowd of other would-be artists who claim they can wield a graphite pencil. It's all in how you lay down your marks. Following these tips will not only make your work look better, but will help you to work faster with less erasing.

Draw All the Time

Drawing constantly will increase your confidence, and that confidence will show through in your drawings.

Thick to Thin Strokes

Strokes with varying width add interest and weight to your drawings. Use the side of your pencil as well to get softer lines for blocking in shapes. Create shading from light to dark by gradually applying more pressure to the pencil.

Be Confident

Confident strokes look much better (even if they're in the wrong place) than a series of tentative hatch marks.

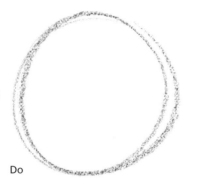

Do

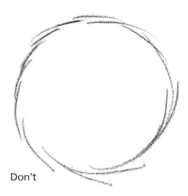

Don't

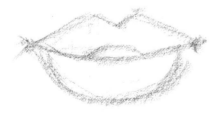
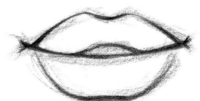
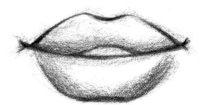

Keep It Light at First

When blocking in your initial shapes, keep it light by using the pencil's edge instead of the point. When you feel like you have it down, turn your pencil back up and use the tip to create edges, using thick and thin lines. Once the outline is complete, rotate the pencil back down to create the shading.

Inking and Shading

When inking your drawings, keep in mind the line quality. Line quality refers to the attributes of your line work that emphasize form, weight, volume and focus. This can be the crucial element to really making your finished drawing pop.

Tapering Adds Volume
Taper your strokes at the ends. Strokes that end abruptly kill the sense of volume in a drawing.

Lines should be even and smooth. Draw from your wrist and elbow to make continuous, smooth lines.

Types of Marks for Shading

Thick to Thin
This is a standard mark for shading with ink. Start thick in the shadow areas and thin out toward the light areas.

Crosshatching
Stroke in two directions to create transitions from dark to light.

Airbrush Spatter
Use an airbrush filled with ink to get this shaded effect.

Ink Spatter
Next time you want to add some texture or shading to your work, dip the tip of a toothbrush into your ink and use your thumb or a pencil to run across the bristles. Be sure to aim it at your paper instead of at your friend.

Bold and Subtle Strokes
Use bolder strokes for larger shapes and shapes in the foreground. Bolder strokes should also be used on the underside of shapes to give them a sense of weight.

Use subtler strokes for smaller shapes and shapes in the background. Smaller strokes should also be used to describe details on the surface of objects.

Strokes can change in thickness to emphasize the fullness of an object. For example, a stroke should be wider at the fullness of the curve of a cheek.

Once you've finished the inking, let it dry completely. Then you can come back with an eraser to remove your pencil lines.

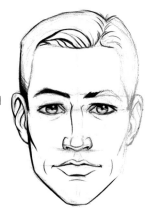

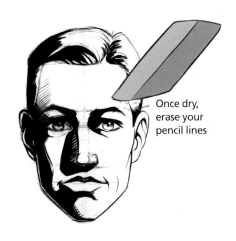

Once dry, erase your pencil lines

Marker Techniques

The best way to practice with a marker is to use the same one all the time. Get a marker and do all your writing with it. To practice using a marker for drawing cartoons, memorize the basic line patterns used for each feature. Once you memorize the patterns, draw hundreds of versions of each feature. Try to draw each facial feature with as few strokes as possible.

Avoid End Dots and Fuzzy Lines

If your marker is touching the page, ink will keep coming out, which explains those ink dots at the ends of your lines. You must draw without hesitation and pick up your pen quickly at the end of each stroke. If you are getting fuzzy lines, you are moving your pen too slowly.

Practice Making Lines With Markers

At first, your marker lines may look like this—unsure and uncontrolled, with bleed dots, fuzzy lines and so forth. That's OK. The more of these kinds of sketches you do, the sooner you will get them out of your system.

Try Geometric Shapes

Practice drawing each facial feature as a geometric shape. This is a great way to practice variations for each feature. Make some wide and others tall, or even an entirely different shape.

Turn Geometric Shapes into Features

When you get tired of drawing geometric shapes, try turning them into features. The shape will tell you what to draw so you can focus on your line quality.

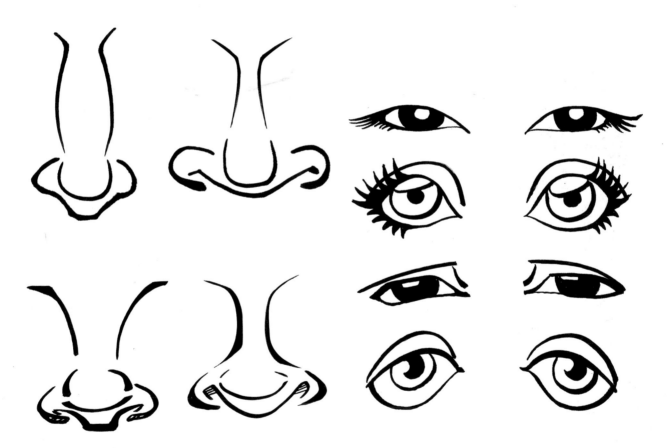

Exaggerate

When you first start practicing, try to exaggerate as much as you can. When you draw live, you will be looking for subtle differences in features. By knowing what types of exaggerations work for you, it will be a lot easier to see those differences.

Practice Variations

Fill an entire page with variations of each feature. By studying one feature at a time, you will learn how to avoid drawing the same eyes on everyone, and so on.

Pencil Techniques

Markers are a great way to start drawing cartoons, but most of us are accustomed to using pencils. It's in our nature to sketch with them. The trouble with pencils is that we often put too many lines on the paper, and the drawings get messy. By working with markers, you will learn to put down fewer strokes. For those of you who prefer pencil, follow the same marker guidelines as well as those included here.

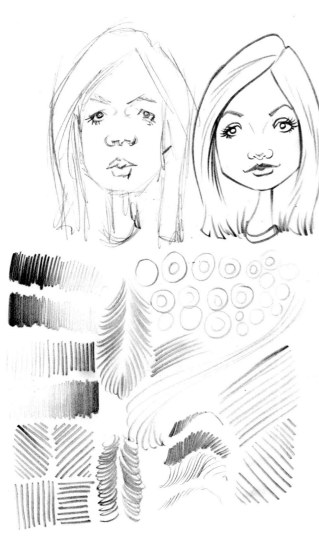

Shape Your Lead
Shape the tip of your pencil lead by rubbing it back and forth on a scrap sheet of paper until you have an angled flat spot on the tip. The flat spot lets you draw the thick lines. Spin the pencil around and draw with the tip to get thin lines.

Practice Line Variation
Draw thick, medium and thin lines. You will have to resharpen the tip often on a separate sheet of paper.

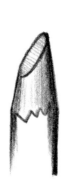

Shaping Pencil Tips and Blending Stumps
On the left is what your pencil tip should look like when shaped to make both thick and thin lines. In the center is a blending stump; on the right is how the stump should look after you sand the tip to prepare it for use.

Avoid Messy and Unorganized Drawings
See how the face above on the right looks more professional? Every line is intentional and clearly made. Practice drawing strokes in every direction with straight and curved lines. Vary the pressure on your pencil and the spacing between your marks. Be bold with your lines.

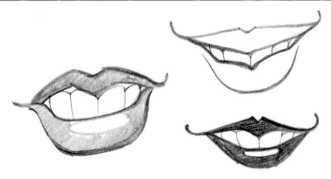

Working With Value

Using pencil gives you the opportunity to add different values or shading to each feature. By applying more pressure on your pencil, you can darken features to suggest enhancements such as lipstick, for example.

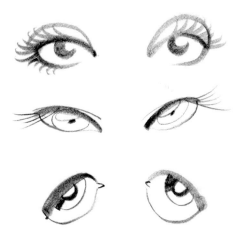

Use Varied Lines

Practice drawing line variations within each feature. A thick line will look thick only if there is a thin line nearby to balance it.

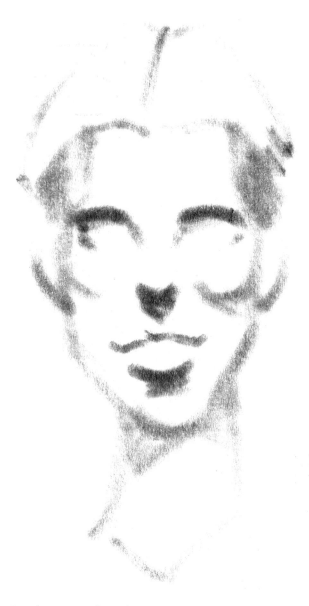

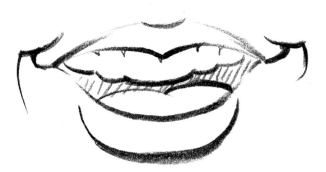

Shade Your Sketch

Use your sanded blending stump to shade each sketch. Shade the exact same areas on every face. Shading should take you less than a minute. Notice how easily you can recognize a face with shading done this way.

Draw Features Decisively

Draw features as cleanly and precisely as possible, and avoid sketching as much as you can. Think like a calligraphy artist—you only get one chance to do it right. Notice how these features are not quite as clean as the marker versions.

Colored Pencil Techniques

Coloring a good drawing makes it great, but coloring a bad drawing makes it a bad drawing. Coloring does not cover up mistakes, so practice your drawings until you are confident about your lines. Then begin coloring.

Coloring a basic cartoon face should not take longer than one or two minutes. Definitely don't take more time to color than you did to draw the sketch.

As in the drawing part of the process, you will make small mistakes in the coloring process. It's part of the quick-sketch look. Don't worry about it, but try to color inside the lines as much as possible. Always color lightest to darkest, because you can always make an image darker, but you can't make an image lighter.

A Colored Pencil Palette

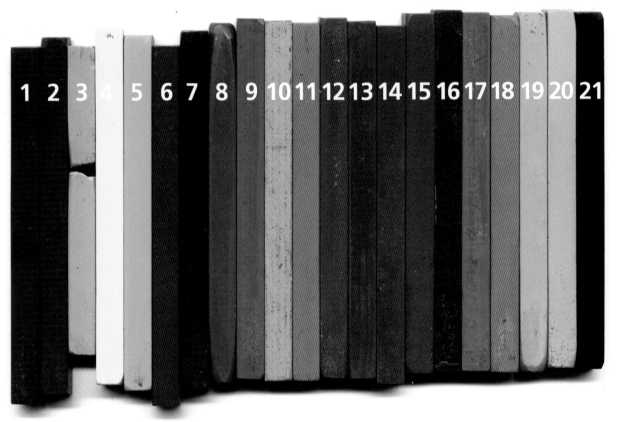

1	Forest Green	8	Raw Umber	15	Scarlet Lake
2	Burnt Umber	9	True Blue	16	Violet
3	Yellow Ochre	10	Sky Blue	17	Gray
4	Canary Yellow	11	Orange	18	Pink
5	Green Bice	12	Terra Cotta	19	Flesh
6	Copenhagen Blue	13	Raw Sienna	20	Blush
7	Ultramarine Blue	14	Burnt Ochre	21	Black

Visit www.impact-books.com/cartoonfaces for free bonus demonstrations.

Eye Colors

Use these samples as a guide for selecting the correct eye color for your character.

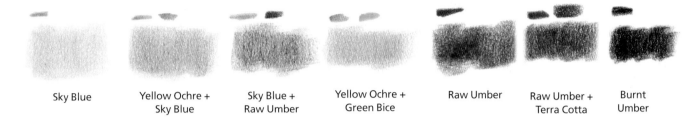

| Sky Blue | Yellow Ochre + Sky Blue | Sky Blue + Raw Umber | Yellow Ochre + Green Bice | Raw Umber | Raw Umber + Terra Cotta | Burnt Umber |

Hair Colors

Experiment with blending colors together to create the shades you want. Just remember to always work lightest to darkest. This chart will help you get started.

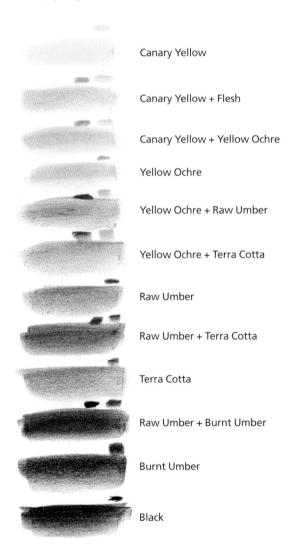

Canary Yellow

Canary Yellow + Flesh

Canary Yellow + Yellow Ochre

Yellow Ochre

Yellow Ochre + Raw Umber

Yellow Ochre + Terra Cotta

Raw Umber

Raw Umber + Terra Cotta

Terra Cotta

Raw Umber + Burnt Umber

Burnt Umber

Black

Skin Tones

Use this chart to help you create the correct skin tone. Get the color as close as you can with your limited palette. A caricature is not a realistic portrait, so it does not have to be exact. The coloring should be bright and fun.

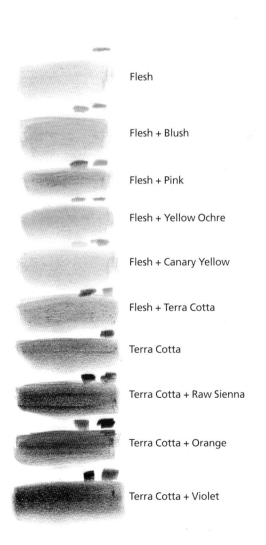

Flesh

Flesh + Blush

Flesh + Pink

Flesh + Yellow Ochre

Flesh + Canary Yellow

Flesh + Terra Cotta

Terra Cotta

Terra Cotta + Raw Sienna

Terra Cotta + Orange

Terra Cotta + Violet

Using the Pattern Technique

These two pages show the pattern to use when coloring. To avoid spending too much time coloring, color every face using the same pattern.

Creating Highlights

For highlights in the skin tone, let the white of the paper show through some instead of heavily covering the area with color.

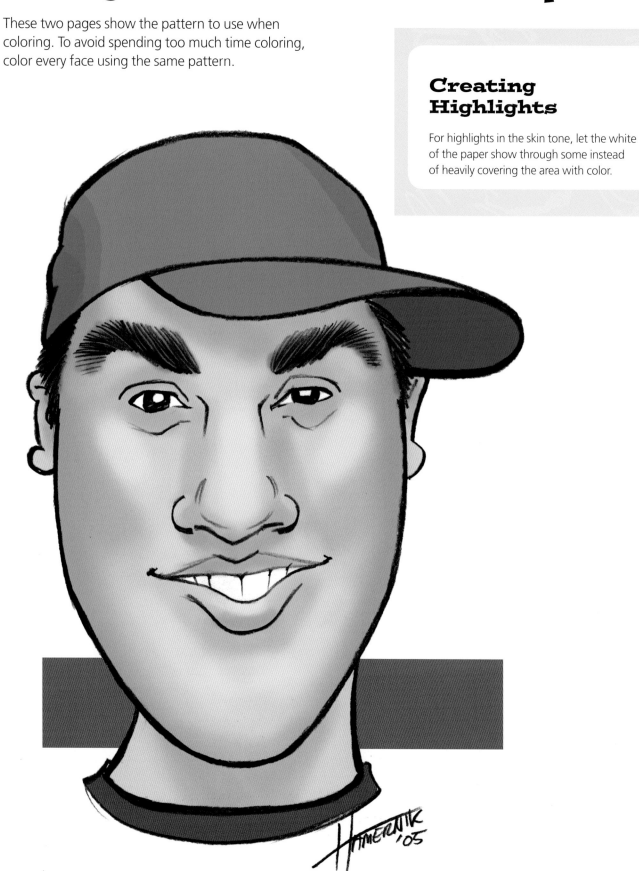

Visit www.impact-books.com/cartoonfaces for free bonus demonstrations.

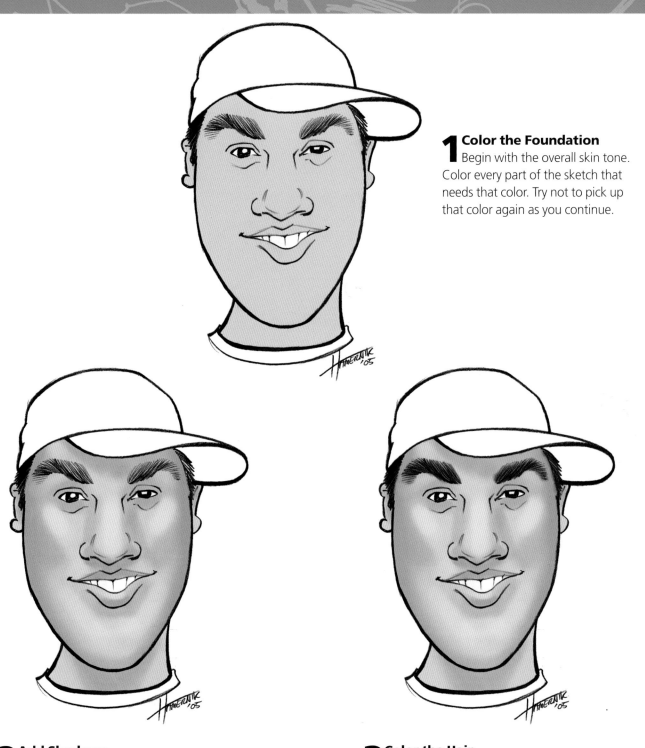

1 Color the Foundation
Begin with the overall skin tone. Color every part of the sketch that needs that color. Try not to pick up that color again as you continue.

2 Add Shadows
Overlay another color to adjust the skin tone. Use pressure to darken the shadow areas of the face. Your shadows need to be in the same places on every person; darken the sides of the face, under the chin and anywhere a shadow would appear if there was an overhead light. Note that you are creating the shadows with the flesh-color values, not with black or gray.

3 Color the Hair
Add the hair color. You should already have most of the details in place at this point, so all you need to do is color the hair with some simple shading.

Coloring a Face With Colored Pencils

Colored pencils are the least expensive and the fastest way to add color. When using them, be very aware of how much time you are spending coloring. Use as few pencils as possible.

Visit www.impact-books.com/cartoonfaces for free bonus demonstrations.

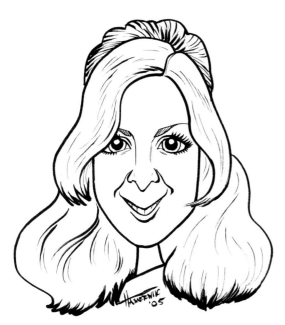

1 Finish Your Line Drawing

Complete your sketch. Avoid going back to drawing at this point.

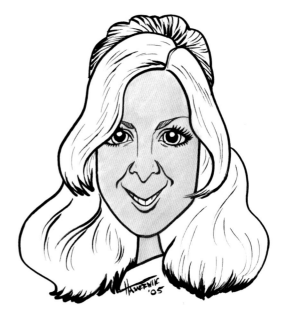

2 Color the Foundation

Fill in the general skin tone. The easiest way is to color from the top down. Avoid leaving streaks across the sketch by coloring in circles, using the broadest part of the pencil. Leave highlight areas as you color by using a lighter hand in these spots. Darken the shadow areas.

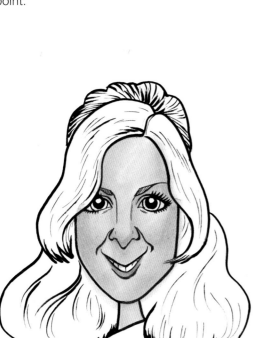

3 Add Shadows

Add any color over the skin tone to adjust it so it's closer to the actual skin tone you want. This should be so subtle that you can't actually distinguish the new color from the general skin tone. The overall appearance should be a blend of the two colors. Using the skin tone color, darken the shadow areas.

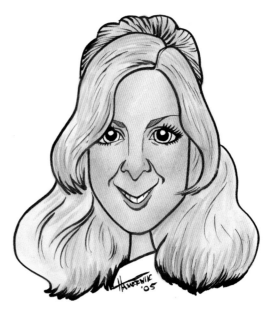

4 Color the Hair

To color the hair, work lightest to darkest. Leave highlights in the hair toward the top of the head. You can also add a few more decorative strokes using the colors.

Computer Coloring

The information given here is for those of you who have Adobe® Photoshop CS® for Windows and have used it before. It is not intended for individuals who have never used this software. Here, we describe the basic process for coloring line art in Adobe® Photoshop®. Please experiment and add to this process based on what you know about Photoshop®.

Preparing the Image

1 Save the sketch file onto your hard drive.
2 Rotate your canvas so the image is correct side up (Menu Bar> Image> Rotate Canvas).
3 Convert to Grayscale mode (Menu Bar> Image> Mode> Grayscale).
4 Adjust your line art. Use levels (Menu Bar> Image> Adjustments> Auto Levels).
5 Convert to RGB mode (Image> Mode> RGB).
6 Copy the Background layer on the Layers palette by dragging the background layer over the Create New Layer icon located on the bottom of the Layers palette, second from the right.
7 Rename the new layer "Line Art," and rename the background layer "Color."

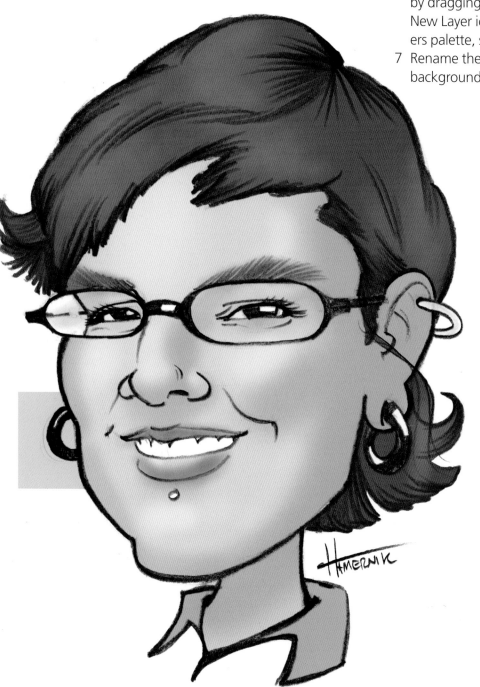

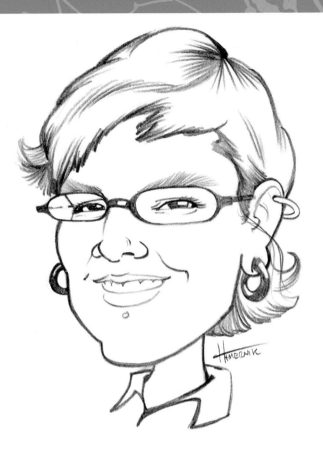

1 Scan Your Art

Scan in your artwork at 300 DPI using the RGB mode or color image function of your scanner. If your sketch is too large to fit on the scanner, try taking a digital picture of it using the highest quality settings of your digital camera. Save the file as a JPEG file. Then open the sketch in Photoshop®.

2 Multiply the Layer

On the Layers palette, change the Line Art layer's mode from Normal to Multiply.

A Word of Advice About the Wand

When you get to step 3, if the wand selects too much of the sketch—rather than the isolated area you want to color—there is probably a break in the line somewhere. The wand works only if your lines make complete shapes. Are there any breaks in the outline of the shape you're trying to color? Then correct the original sketch and rescan it.

3 Select An Area to Color

Use the wand tool (press "W" on your keyboard to select it) to select an area to color. Have "Anti-Aliased" and "Contiguous" selected in the wand's preferences toolbar. Don't select "Use All Layers." Choose a color to use from your color swatches. Then click to select an area to color. Slightly expand that selection (Menu Bar> Select> Modify> Expand> 2 Pixels). Press Alt + Delete to fill your area with color.

4 Start Adding Color

Select the brush tool (press "B" on the keyboard). Under the menu bar in the Brush preferences toolbar, on the left side next to the word "Brush," there is a dot with a number under it. Click on the number. This opens up the Options window. The Master Diameter is the size of the brush, and the Hardness is the fuzziness of the brush. A hardness of 100 percent means crisp edges, while 0 percent hardness means soft edges. Correct any parts of the sketch that were colored by mistake using the brush.

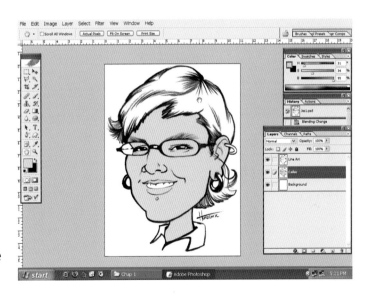

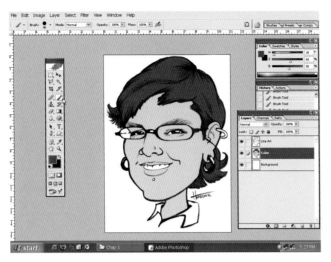

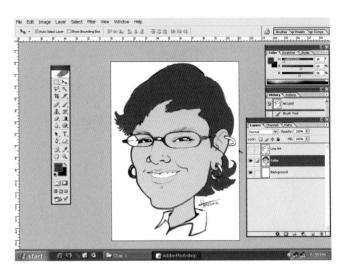

5 Color the Hair

Use the technique described in step 3 to fill in the hair section. Make any corrections using the brush as described in step 4.

6 Double-Check the Layers

Turn off the Line Art layer (click on the eye icon in the Layers palette) to see what you are actually coloring. By using this technique, your original drawing is protected on its own layer. This way, you color behind it, and you don't mess up your original sketch.

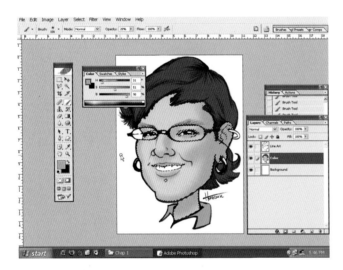

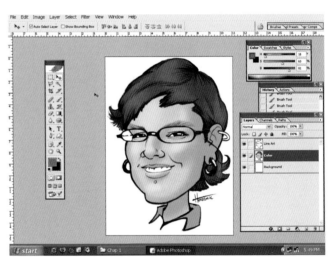

7 Add Depth to the Skin Tone

Turn on the Line Art layer. Select the Color layer. Use the wand to select the skin tone. All of the skin tone should be selected. Using the Color palette instead of the Swatches palette, select a darker version of the skin tone. Under the red "X" close box in the Color palette, there is a black Options arrow; click on it and select "HSB Sliders." The "H" is for hue or color, the "S" is saturation and the "B" is brightness. Slide the "B" to get a darker version of the skin tone. Use the brush with 20 percent hardness and paint all the shadows. Now select a lighter version of the skin tone and do the same for the highlight areas.

8 Add Shadows and Highlights to the Hair

Add shadows and highlights to the hair the same way you added shadows and highlights to the face in step 7. With the brush, you will not be able to paint individual hairs very easily. Just shade the overall shape.

Visit www.impact-books.com/cartoonfaces for free bonus demonstrations.

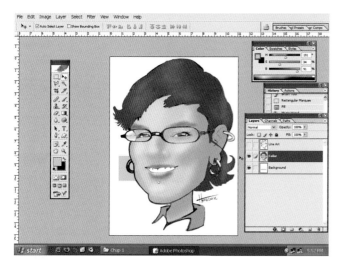

9 Add a Background
Paint a simple background. You may have to select and delete the white around the drawing in the Color layer. If you do not have a Background layer, click on the New Layer icon on the bottom of the Layers palette window (second from the right, next to the trash can). Rearrange the layers so the Line Art layer is on top, the Color is in the middle and the Background is on the bottom.

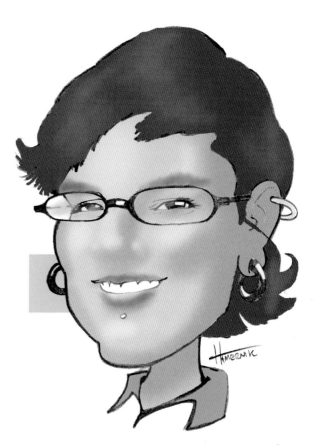

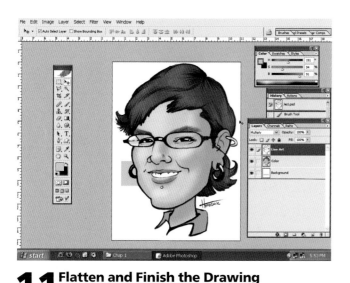

10 Check the Layers One More Time
If you turn off the Line Art layer, your drawing should look like this. Notice how some of the hair and lines of the face have been painted over? You can do this to eliminate any unattractive white pixels next to the lines you drew.

11 Flatten and Finish the Drawing
Turn on the Line Art layer. Be sure you colored everything you wanted to. After this next step, you will not be able to make any changes. On the Layers palette window, under the red "X" close box, there is a black Options arrow; click on the arrow and select Flatten Image. This step gets rid of all the layers and leaves your image ready to print. Once you flatten, you cannot make changes to the sketch.

Computer Coloring Comments

There are many books on Photoshop®. Pick one up to learn more. Computer coloring shouldn't take you longer than twice as long as you spent drawing it. If your drawing took five minutes, then spend ten minutes coloring it, on the computer or off. We recommend waiting until you are producing high-quality sketches before you start playing on the computer.

The 4 Points of Expressions

Expressions Show:

1. State of Mind: What we would commonly call feelings. But state of mind also means thoughts, and thoughts about what you're feeling and feelings about what you're feeling. (Complicated, we know.)
2. Personality: This is an extension of state of mind, but more fundamental. Who your character is should show on their face.
3. Relationships: Expressions are essential to showing how two people feel and think about each other. For example, when a man and a woman exchange flirting glances, we know exactly what their relationship is.

4. Involuntary Physical States: Bad gas, sickness, pain, relief. Sometimes the body feels something so intensely and so rapidly that it shows up on the face before we can even do anything about it.

Expressions Are Stories

Now, try to think of some sort of story that isn't going to make use of expression in one of the four ways we've outlined. You can't—and you know why? Stories are all about how people react to their own state of mind, to each other and to the world around them. And the expressions of your characters are the best tools you have to communicate those reactions.

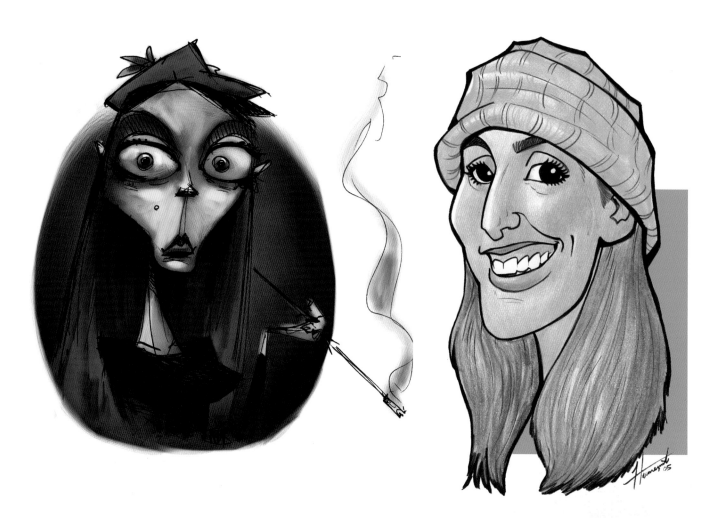

Visit www.impact-books.com/cartoonfaces for free bonus demonstrations.

Creating Expressions

Here are a few guidelines to keep in mind as you create expressions:

- Find the reason behind the expression.
- Expressions are always reactions, so be specific and clear about what your characters are responding to.
- Be specific about the expression.
- Happy, sad and angry are usually too general. What is unique about your character's particular emotion in this moment? How is it different from another type of emotion in another moment?
- Observe expressions from real life.
- Watch the expressions of your friends and family. Try to identify expressions that you don't have a name for, and learn how to draw them.
- Draw with feeling.
- Remember those class pictures you took as a kid, when you were told to smile and you stretched open your mouth in a big, fake grin? The picture ended up looking more like you were being electrocuted didn't it? That's what the expressions you draw will look like if you don't draw with feeling. Draw with the same passion you want your characters to have, and their expressions will explode off the page.

By studying and applying the principles presented here, you will learn to create expressions that are impossible to describe with words, but that communicate exactly how your character is feeling. In other words, you should be able to create characters that act like real people.

To do this, you will follow the process that all artists follow: Start with the general and move to the specific. Start by learning the big shapes and the general expressions, then move on to the little details and the idiosyncrasies that make an expression fun.

Don't be afraid to make mistakes, don't give up and have fun!

The Head

Remember, always start with the big shapes first. When it comes to expression, that means learning how to draw the head. This lesson is the foundation of everything else you'll be doing, so take the time to master it.

The Cranium

The head is made up of two main parts: the cranium and the face. The cranium is a big sphere with the sides lopped off; it makes up the bulk of the head.

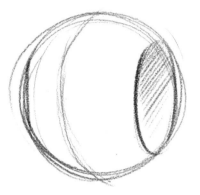

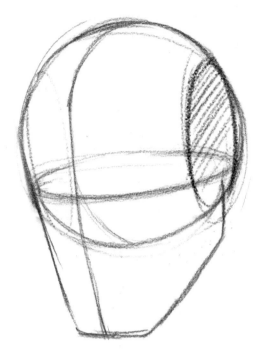

The Face and Cranium Together

You can think of the way they fit together as a bowling ball with a beard.

The Face

The face is a tapered box with a sloped bottom. It hangs off the cranium from the eyes down to the chin and jaw.

Wrapping Around the Form

When we look at a face straight on, the construction lines form a simple cross. When we start moving the head around, the construction lines stay in the same place in relation to the features and thus help to establish direction and dimensionality as they move in relation to the picture plane.

As you draw a head turned to one side, imagine that you are wrapping extended construction lines like string around three-dimensional shapes. This technique is called "wrapping around the form."

Um… Yeah

Remember that this just gives you the general shape of the head. Do not try to put the eyes and nose of your face where the bowling ball holes are!

Demonstration

Let's draw a simple head from the front.

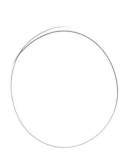

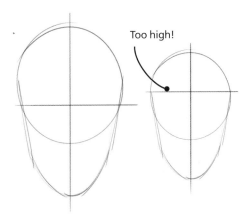

Too high!

1 Draw a Circle
Start by drawing a circle. This is your cranium. Think of it as a round ball, not a flat circle.

2 Add the Face as a "U" Shape
Next, add the face. You can do this by drawing a "U" shape to define the jaw.

3 Add Construction Lines
Add one line splitting the head in half vertically, and another splitting it in half horizontally. The horizontal line is called the eye line. The vertical line is called the centerline.

Make sure your eye line is in the middle of the head, not in the middle of the cranium. The middle of the cranium is too high for the eyes.

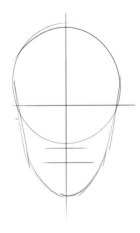

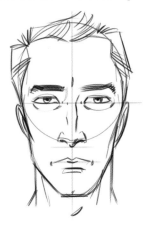

4 Add Nose and Mouth Lines
Add another horizontal line halfway between the eye line and the bottom of the chin. This is where the bottom of the nose will sit. Make another line one-third of the way down from the nose to the chin. This is where the mouth will sit.

5 Add Features and Details
Finally, add the facial features. Place the eyes about one eye-width apart. Place the ears underneath the eye line.

Different Views of the Head

Let's practice some simple head shapes from different points of view. Don't worry about the features for now; just focus on the cranium, face and construction lines.

Profile View

The profile view has an eye line, but no centerline. That's because the centerline here represents the edge of the face. The back of the jaw sits about halfway between the front and back of the head, and the ear sits right behind the jaw.

The head doesn't sit right on top of the neck when in profile. The neck actually extends out of the body at a 30° to 45° angle.

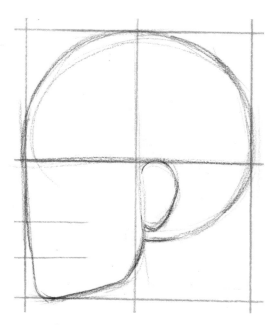

The Box Profile
Construct the profile view within a box divided into four quadrants. The head is about as long as it is tall, and the jaw and ear fall right along the halfway line from front to back.

Three-Quarters View

This is where things get interesting. The three-quarters view is simply the face rotated halfway between the front view and the profile view. This view is called a three-quarters view because now you can see three-quarters of the face. It can be constructed by combining the front and profile views.

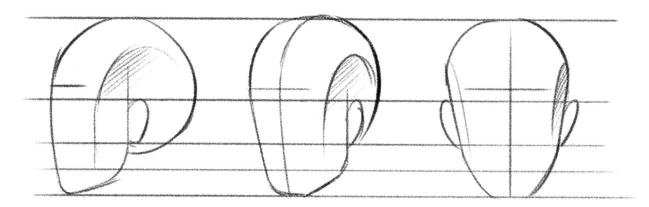

Construction Lines
Notice that the height of the head and the eye line stay in the same place as you rotate the head. The only thing that moves is the centerline.

Keep Practicing!

Keep practicing drawing basic head shapes from different points of view (POV). There are a million different angles to discover. Try to draw a head from a completely different POV. If you get stuck, referring to a simpler POV can help.

Worm's-Eye and Bird's-Eye Views

A worm's-eye view is a picture in oblique perspective from an extremely low eye level, with the horizon at the bottom of the picture or below it. Imagine you're the worm looking up at an object.

A bird's-eye view is a view as seen from above, like a bird would see. It's just like when you fly in a plane and look down.

The Secret Weapon: The Neck

The neck is not a part of the head or the face, but it can make a big difference with expression. A body standing upright and perfectly still can give you all the points of view of the head on this page, and the neck does it all.

This might be a good time to check your sketches in a mirror. If they don't look symmetrical in the mirror, adjust them until they do.

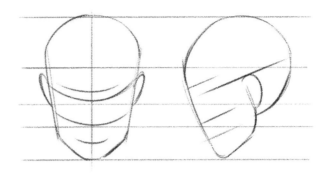

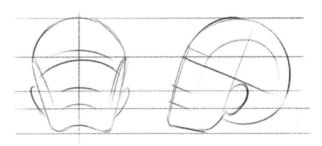

Maintain the Centerline

As you tilt the head up and down, notice that the centerline stays in the same place, while the placement of the eye line, nose line and mouth line changes.

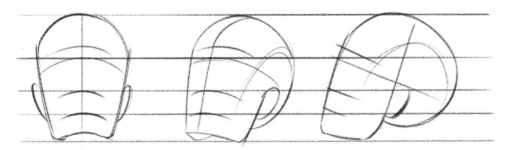

Worm's-Eye View

Remember to think of the head and features as three-dimensional, and always wrap your construction lines around the form. The head shape is very important. Once you master this, everything else will fall into place.

Bird's-Eye View

Use the same construction lines as a reference to create the bird's-eye view. Notice how the eye line, nose line and mouth line curve as the head tilts up and down. They're wrapping around the form!

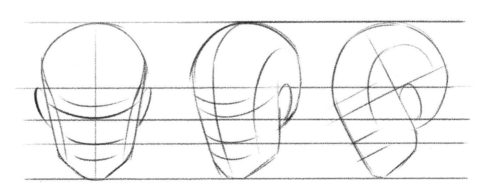

Drawing a Front View

Basic Process

This is the basic pattern used to draw faces. Memorize this process. Practice it by inventing faces. Draw ten faces every day for twenty days in a row. You need to have a good foundation before you can draw complex cartoons and expressions.

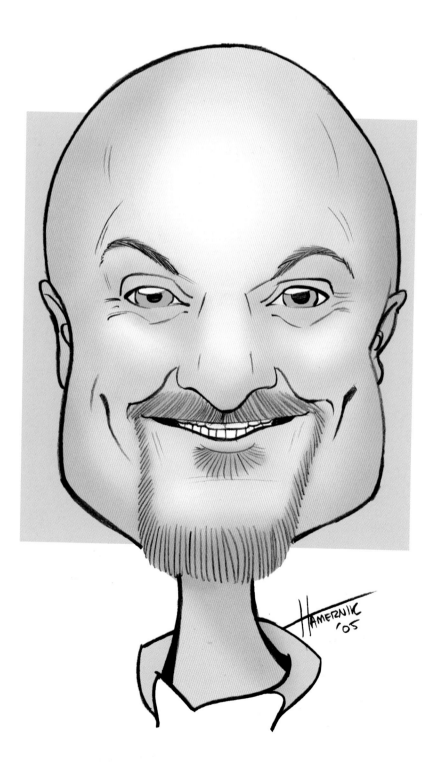

1 Draw the Structure
Begin with one cheek and work your way down to the chin. Continue up the jaw to the other cheek. Try to do this all in one stroke. Add the goatee. Also add the ears at this point, if they are visible.

2 Add the Hairline
Add the hair (or lack of). This one is easy—just draw the outline of the head.

3 Start Adding Features

Work your way down the face. Begin with the eyebrows, then add the eyes. Draw one eyebrow, then the other. Avoid drawing the eyebrow and eye on one side and then starting the other. It is much easier to mirror your strokes as you go.

4 Add More Features

Add the nose. Make sure you add all the details while you are on that feature. Complete each section before moving on.

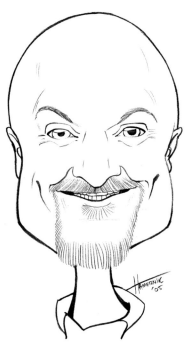

Know the Process

Practice by inventing ten heads a day. Focus on getting the process down: jaw, hair, eyes, nose, mouth, neck and signature. Try to do this in three minutes. Now is a good time to work on your speed.

5 Finish and Refine Features

Add the mouth opening, lips, smile lines, dimples and facial hair. Keep it plain and simple. Finish one section and move onto the next. This improves your speed tremendously.

6 Add the Neck

There should be no floating heads, so add a neck and a collar. Be sure to sign and date your work.

Distance, Anchor and Pivot Points

What should you look for when drawing each feature? Here are two principles that will organize your thought process. Everyone has two eyes, but what makes one person's different from the next person's? It is the shape, angle and distance between them. The anchor and pivot point principle will help you identify the angle of that feature. The distance principle will help you place the feature on the caricature.

Familiarize yourself with these two principles that you need to know to start drawing.

Principle 1: Anchor and Pivot Points

Anchor points do not move, which is easy enough to remember. Pivot points move. Every feature of the face has an anchor point and a pivot point. Anchor points are the center of the feature, and pivots are the edges of the feature.

Principle 2: Distance

How far is one side from another? How far is one shape from another? The anchor and pivot points tell you how to draw the feature, and the distance tells you how far to place the features from one another.

Options for Pivot Points
Pivot points can be above, even with or below the anchor. These are the only options you have.

Anchor Location
Anchors will always be toward the center of any feature unless otherwise indicated.

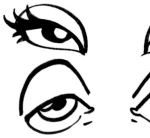
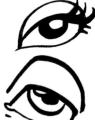

Pivot Points and Expression
Pivot points above the anchor tend to look sexy. Pivot points below the anchor tend to look tired or sad.

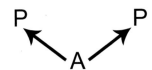
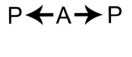
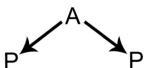

Placing Pivot Points
Find the anchor, then compare it to the pivot points. It may look subtle, but decide whether the pivots are above, even with or below the anchor.

Deciding the Distance Between Features

After you draw an eye using the anchor and pivot point principle, use the distance principle to help you place the other eye. Do the eyes look like they are close together or far apart? The distance principle is your impression of the subject's features. Avoid measuring; just go with your first impression. Remember to exaggerate. If they are close, then draw them extra close; if they are far apart, then place them extra far apart.

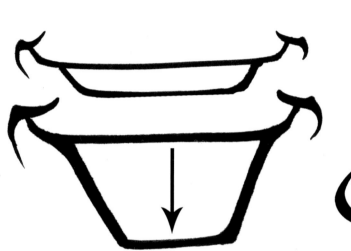

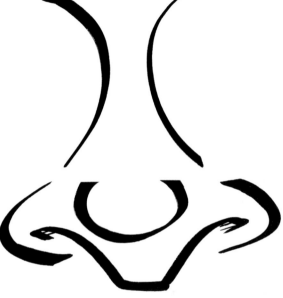

Choosing the Distance Between Sides

How far should I put one side of a shape from the other? Thinking about this helps you determine what shape to draw.

Determining Length and Angles

The distance principle tells you how long to draw the shaft of the nose. The anchor and pivot points tell you at what angle to draw the tip of the nose and nostrils.

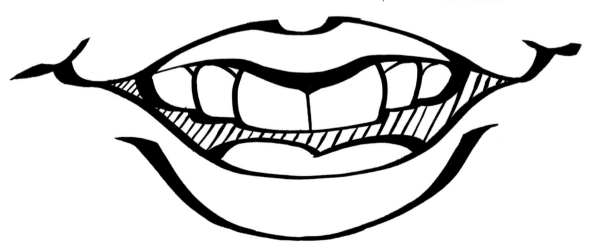

Placing Features Before Drawing Them

This is a well-drawn mouth. Before you draw the mouth, use the distance principle to figure out where to draw it.

35

Forming Face Shapes

The anchor point for the whole face is the widest point of the cheek. This anchor point can vary slightly from face to face. The pivot is the corner of the jaw. The pivot will swing out, down or in.

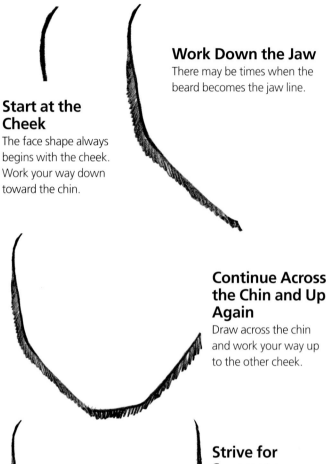

Start at the Cheek
The face shape always begins with the cheek. Work your way down toward the chin.

Work Down the Jaw
There may be times when the beard becomes the jaw line.

Continue Across the Chin and Up Again
Draw across the chin and work your way up to the other cheek.

Strive for Symmetry
If you are struggling with symmetry, you can draw from the cheek down on both sides, meeting at the center of the chin.

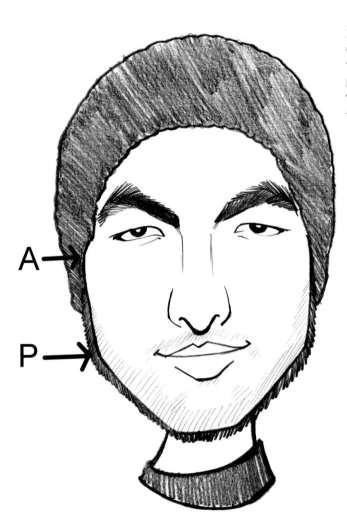

A →

P →

The pivot is directly below the anchor in this drawing.

Beards and Other Facial Hair
There is not a secret formula, just a pattern to follow (See page 62), when drawing facial hair.

Goatee · Full Beard

Finding Pivot Points More Easily

If you struggled with finding the pivot points in the examples, try ignoring the facial features and focus on the head shapes only.

Chin Variations

Cleft chins and double chins are very important to the face shape. Capture them accurately.

The Head

Try these variations:

- Change the shape of the head and face. Try any random shape and then fit a cranium and face inside.
- Vary the placement of your construction lines. Keep wrapping them around the form, but place the eye line, nose line and mouth line at different levels.

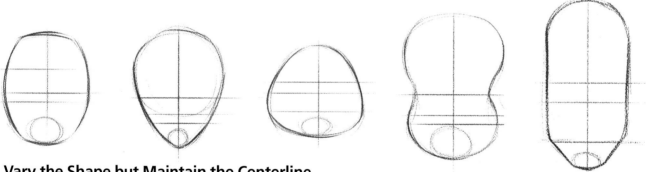

Vary the Shape but Maintain the Centerline

You can move most of the construction lines around, but don't mess too much with the centerline. It's an important anchor for the rest of the structure.

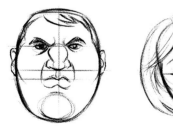
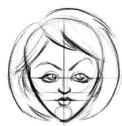
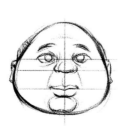
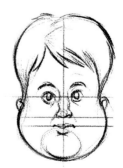
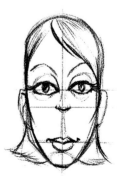

Explore the Variations

When you add features to the face, things start to get interesting. As you vary the shape of the head, you will be naturally inspired to vary the other features on the face.

Drawing Noses

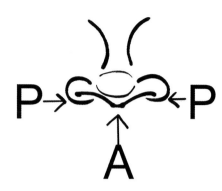

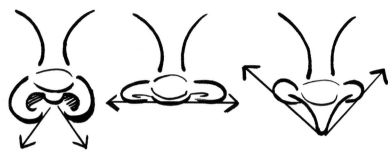

Locate Your Anchor and Pivot Points

The anchor point is the center of the base of the nose at the philtrum. The philtrum is the indentation of the skin directly under the nose and just above the upper lip. The pivot points are the bottoms of the nostrils. Anchors will always be at the center of the feature.

Different Pivot Point Placement

Here are examples of different pivot points. These examples show some of the exaggeration you can do to create different looks for your cartoons. Remember, pivots are higher than, even with or lower than the anchor point.

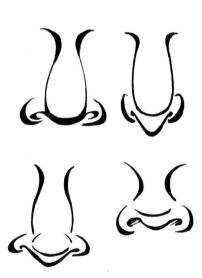

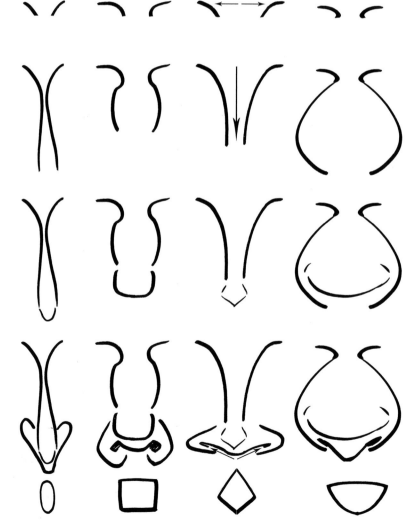

Nose Shapes

Always simplify the shaft of the nose to a straight line or a curved line. Start at the root of the nose at the eyebrows and work your way down. Observe the ball of the nose and figure out what shape it resembles.

Visit www.impact-books.com/cartoonfaces for free bonus demonstrations.

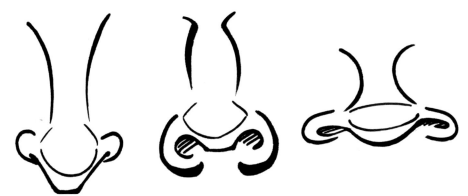

Different Noses, Same Number of Lines

Here are more samples of noses for you to see how you can vary the feature while still using the same amount of lines.

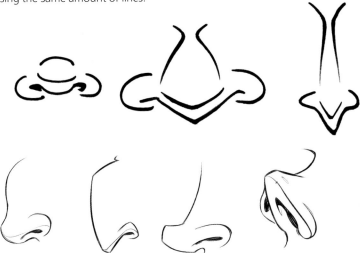

Basics of a Nose

Let's take a quick look at the nose and how to draw it using basic shapes. The basic nose shape is very similar to a wedge-shaped rubber doorstop with sloped sides.

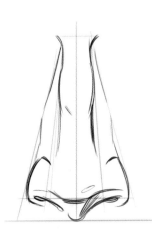

1 **Draw Construction Lines**
Indicate where the middle and bottom of the nose are located.

2 **Draw the Basic Wedge Shape**
The nose should get wider as it spreads out. The two lines in the middle tell you where the bridge of the nose is.

3 **Sketch the Tip, Wings and Nostrils**
Typically, nostrils do not face directly out. You should see slits that show only where the bottom of the nose opens.

4 **Add Detail**
Make sure to wrap your details around the form of the nose.

Forming Eyes and Eyebrows

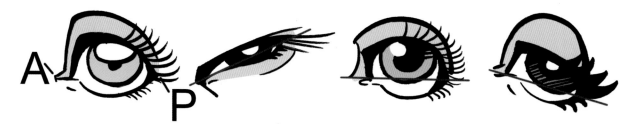

Eye Anchor and Pivot Points
The anchors for the eyes are the tear ducts. The pivots are where the top and lower eyelids meet on the outer edges of the eyes.

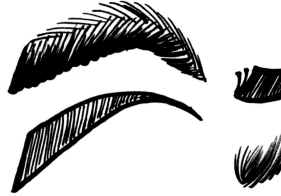

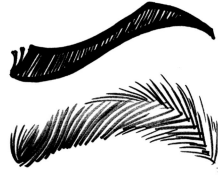

Using an Outline
Eyebrows can be neat whether you use an outline shape or not.

Groomed vs. Natural
Draw well-groomed eyebrows with smooth, connecting lines. Natural-looking eyebrows will have disconnected strokes to show the different pieces of hair.

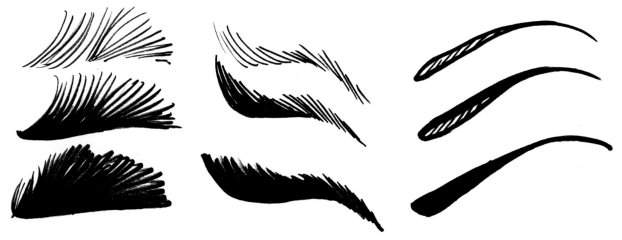

Eyebrow Variations
You can show the color and thickness of the eyebrows by the amount and spacing of your strokes. On the left are thick eyebrows, from lightest on top to darkest on the bottom. On the right are thin eyebrows, and the ones in the center are average in thickness. Consider the shape of the eyebrows, and put down fewer strokes for a thin look or lots of strokes for a thick look.

Drawing Eyes

 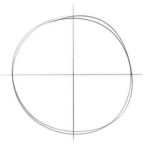 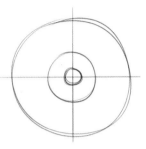 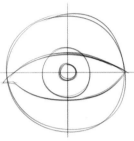

1 Start With a Circle
Like all good drawings, start with a basic shape: in this case, a circle.

2 Add Construction Lines
Sketch construction lines that intersect in the middle.

3 Indicate the Iris and Pupil
Use your construction lines to draw two circles in the center. These will be the pupil and the iris.

4 Sketch the Eyelids
Sketch where the eyelids are going to be. The top lid should cover the top of the iris a bit and overlap the bottom lid on the outside. Make sure to indicate a divot on the inside corner of the eye for the caruncle (that pink thing in the corner of your eye).

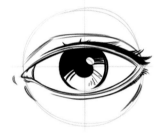

5 Add Details
Darken the pupil and iris and give the eye a highlight that suggests the direction of the light. Be sure to indicate the edges of your eyelids and don't go overboard with the eyelashes. A solid group of eyelashes is much more appealing than individual hairs.

Try to follow this process to increase your speed when drawing eyes.

 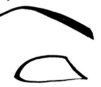

1 Begin with the eyebrows, minding the distance between them.

2 Draw the eye shape. Look at the shape first, and find the anchor and pivot points. Draw one eye and then the other.

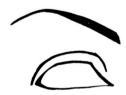 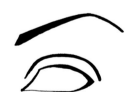

3 Continue with the eyelids for both. Notice how you aren't bouncing back and forth? Draw one thing at a time.

4 Add the highlights, pupils and irises.

5 Finish off with eyelashes and lower eyelids, if necessary.

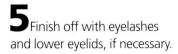 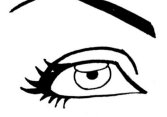 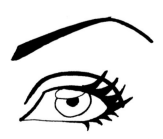

Varying the Eyes

Vary Your Shapes
This example shows manly, square eyes.

Adding Lashes
Even the most manly, square eyes will look feminine if you add eyelashes.

The Iris and Expression
How much of the iris you show has a lot to do with the expression of the eyes. Here we have "sexy."

 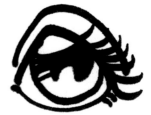

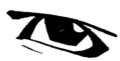

Curved lines look feminine. Angular lines look masculine.

A larger iris will make your subject look younger. Think Bambi.

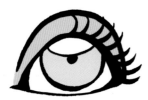 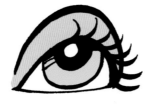

Eye Color Characteristics
Each eye color should be drawn with different highlights, pupils and irises. Study the chart on the opposite page. Look closely at the differences among the highlights and pupil sizes. Blue eyes are drawn differently than brown eyes, etc. Practice by drawing them ten times each. This is very important when your sketches will not be in color.

Visit www.impact-books.com/cartoonfaces for free bonus demonstrations.

Sample Eyes

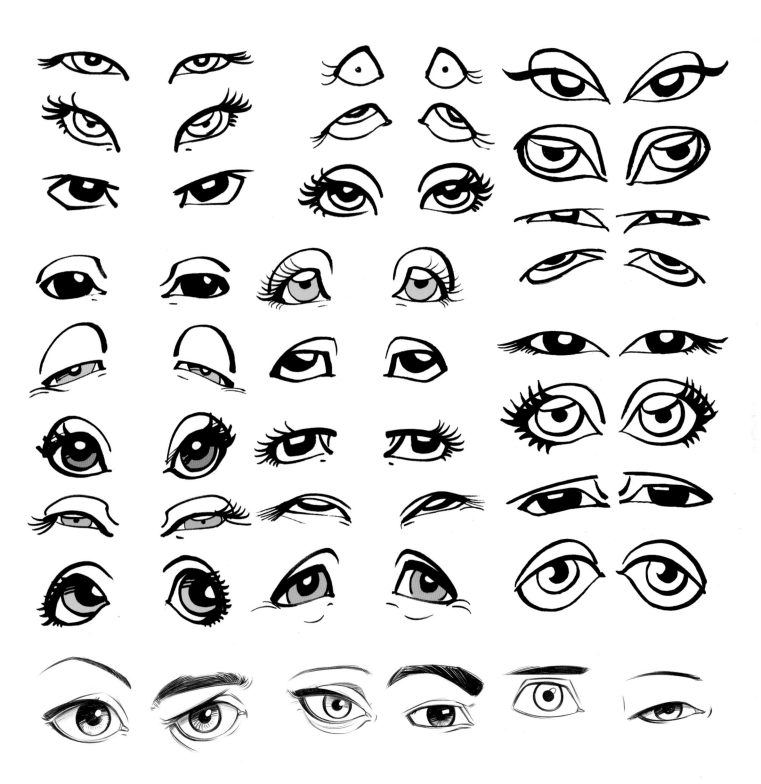

Creating Mouths

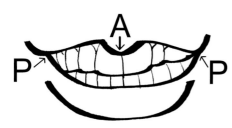

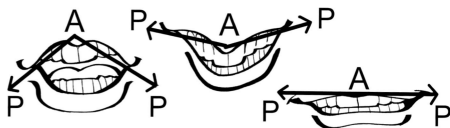

Mouth Anchor and Pivot Points

For the mouth, the anchor is the dip of the upper lip. The pivots are the corners of the mouth.

Vary Mouth Shapes by Placing Pivot Points

Pivot up, across or down? Is this starting to sound repetitive? You see, there is no mystery to cartoon portraits. Just lots of repetition with a variety of shapes.

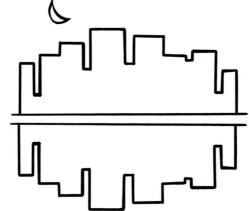

Drawing Teeth

Think of teeth as a city skyline. Turn the skyline upside down and you have teeth! Draw them as a group, not as individuals. Drawing individual teeth makes them look awkward as a whole.

Mapping the Mouth

Start the mouth at the anchor point and draw toward the pivots. Be sure to draw the correct angle (up, across or down). From the corners, draw down and meet at the middle. Be sure you capture the correct shape of the mouth opening.

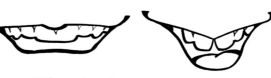

Draw What You See

Can you see the tongue, gaps, gums or lower teeth? Be sure your pivot points and your lower-mouth letter shape are correct.

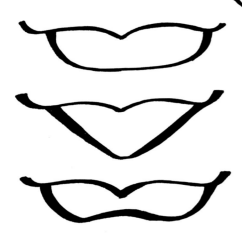

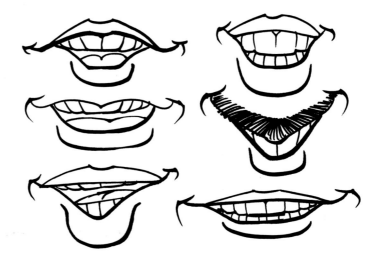

Forming the Lower Mouth Shape

In general, the shape created by the lower line of the mouth forms a "U," "V" or "W."

The Jaw

The jaw is the largest moving part of the face. It operates any time you open your mouth: talking, eating, yelling or whatever.

The jaw almost always works in conjunction with your mouth muscles, but also notice how it moves by itself and what it does to the face.

The Mouth

The mouth is made up of the lips and a mass of seven interconnected muscles that sit under and around the lips. The illustrations show three basic mouth shapes and describe which muscle groups make them.

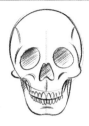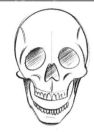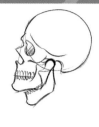

The Jaw Swings...

The jaw is hinged to the skull right in front of the ears, and it swings back and down.

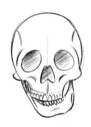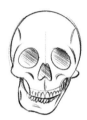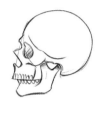

... and Slides

The jaw also has limited side-to-side as well as forward and backward movement.

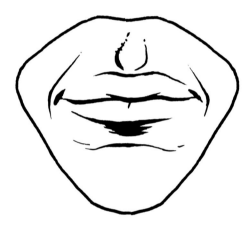

The Mouth

Once you know the basic mechanics of the mouth's muscle groups and how they transform the face, you can create an infinite number of unique mouth shapes.

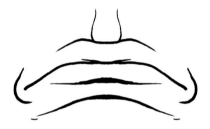

The Frown Muscles

These muscles pull the sides of the lips down toward the side of the face, causing general frowning motions.

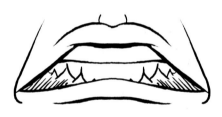

A Big, Weird Frown

The muscles extend all the way down the neck onto the chest. When you do a big frown, you'll feel your neck tighten up all the way down to your clavicle. That's a big frown!

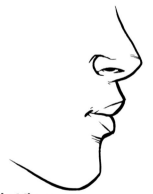

Profile View

When relaxed, the corners of the lips don't extend back very far; they stay in front of the eyes. Notice the slope from the nose to the chin. The bottom lip sits behind the top lip, and the chin sits behind the bottom lip.

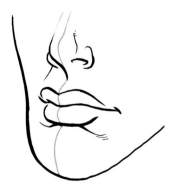

Three-Quarters View

The mouth in three-quarters view doesn't just wrap around a cylinder. The lips sit on top of a mass of muscles, so they stick out a little bit.

Indicate a centerline when you draw the mouth in a three-quarters view. It'll keep you aware of the contour of the mouth and lips.

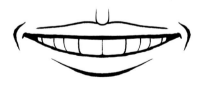

The Smile Muscle

This major muscle draws the corner of the lips up and away from the middle of the face.

A natural smile, with no other muscles engaged, will part the lips to show the top row of teeth.

Drawing Hair

Drawing hair is simple. You have to concentrate on only two lines.

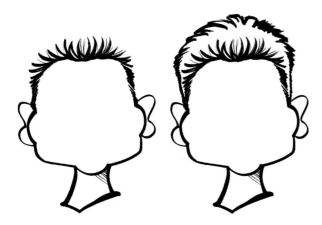

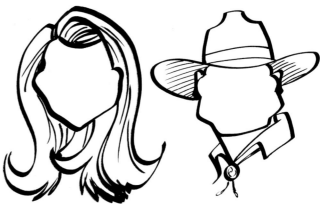

Lines 1 and 2
Line 1 is the hairline around the face. Line 2 is the silhouette of the hair.

Extra Lines
Any other lines you draw in or around the hair are purely ornamental and should be left out if your speed is too slow. These extra lines do not make the sketch look more like your subject.

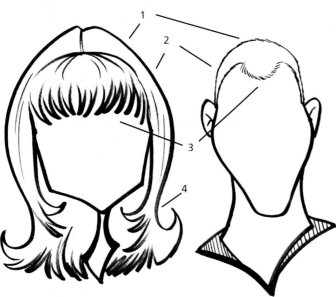

Hair Sections
Hair can be broken down into sections. Identify the top, sides, bangs or layers of the hair.

1 Top
2 Side
3 Bangs
4 Layers (mainly on females)

Hair Styles
Remember this: Thick lines make dark hair, and thin lines make light hair. The length of the stroke relates to the length of the hair. Strokes should be drawn in the direction that the hair grows.

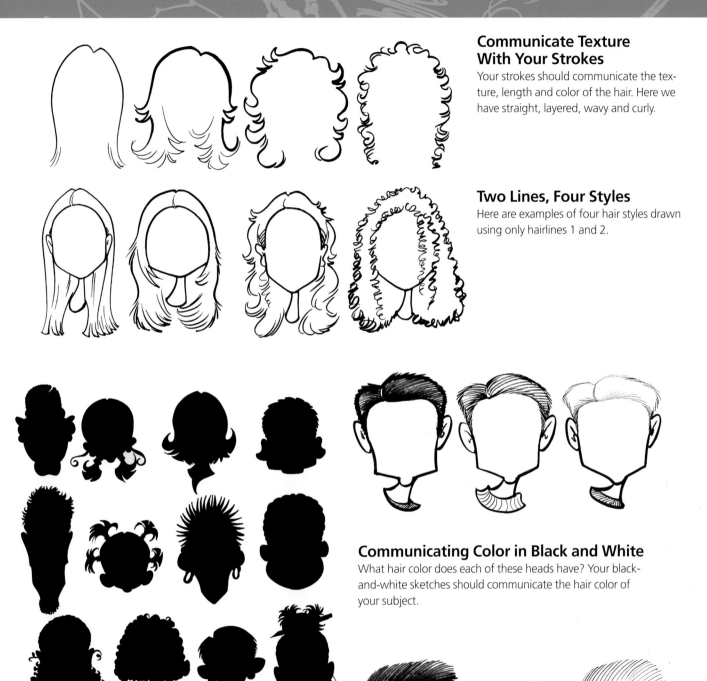

Communicate Texture With Your Strokes
Your strokes should communicate the texture, length and color of the hair. Here we have straight, layered, wavy and curly.

Two Lines, Four Styles
Here are examples of four hair styles drawn using only hairlines 1 and 2.

Communicating Color in Black and White
What hair color does each of these heads have? Your black-and-white sketches should communicate the hair color of your subject.

Creating Color, Length and Texture
Color is determined by the thickness of your stroke. Length is determined by the length of your stroke. Texture is determined by how many strokes you use.

Using Line 2
Look at the difference hairline 2 makes. The silhouette of a person is made up of the face shape and hairline 2. Draw these accurately.

Embellishing Ears

 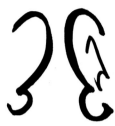

Start With Silhouettes
Draw the silhouette of the ear.

Add Details
Draw the details of the inside of the ear.

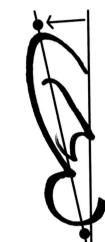

Placing Anchor and Pivot Points
As in drawing the face shape, the anchor is at the top of the feature, and the pivot is toward the bottom.

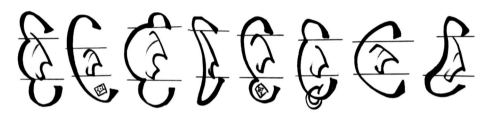

Divide the Ear Into Three Sections
The ear has three sections: the top, the middle and the lobe. Ears with a simple silhouette can be divided up by the inside details of the ear.

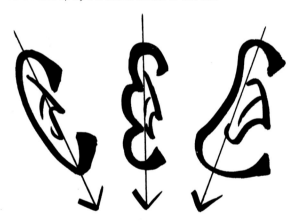

Pivot Point Positions
Here are samples of the three pivot-point positions.

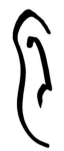
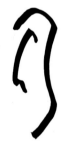

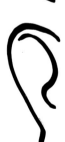

Ear Variations
Pay close attention to the silhouette. Some ears push inward at the middle, while others push outward.

Sample Ears

Visit www.impact-books.com/cartoonfaces for free bonus demonstrations.

Knowing Your Necks

The anchor and pivot points for the neck are similar to those for face shapes and ears.

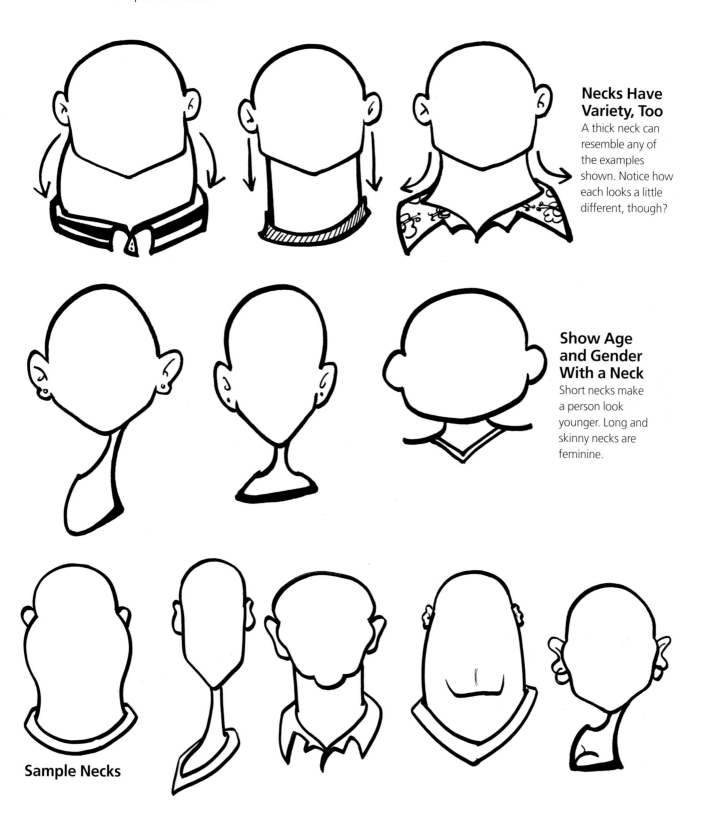

Necks Have Variety, Too
A thick neck can resemble any of the examples shown. Notice how each looks a little different, though?

Show Age and Gender With a Neck
Short necks make a person look younger. Long and skinny necks are feminine.

Sample Necks

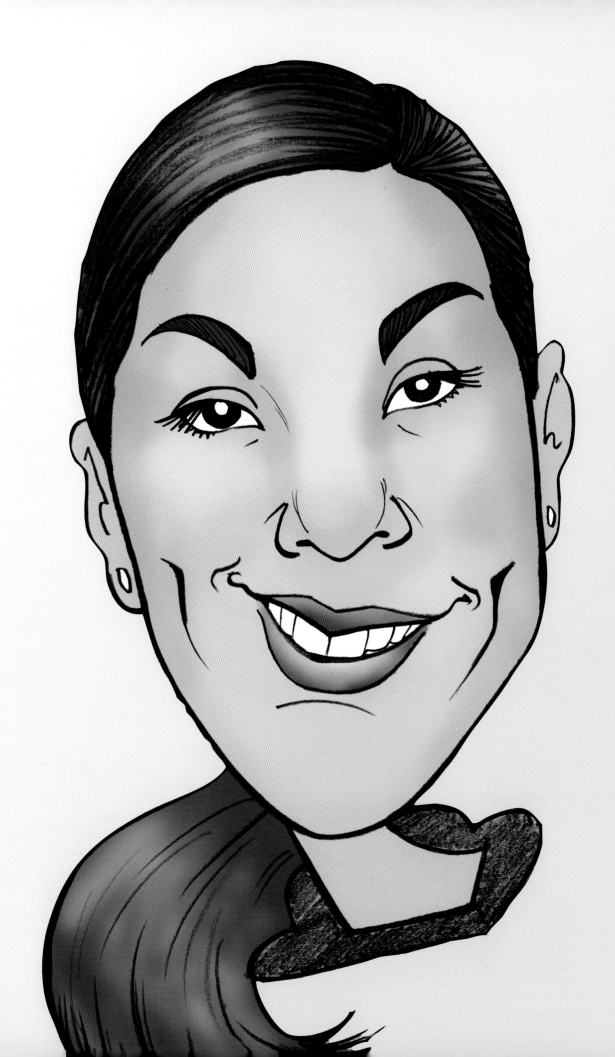

Caricatures

In this chapter, we'll take a closer look at drawing cartoon portraits. These portraits are best known as caricatures. The features and expressions of the face still need to be recognized and accurately represented, but we can exaggerate and have some fun! You'll learn the basic technique to create quick and easy caricatures. After you learn the basics, you can stretch your skills and draw more complex portraits and characters for your cartoons.

Using the Same Angle

When drawing a live model, try to sit at the same angle each time. If you want a different view, ask the model to tilt their head. Don't move your sitting position. Start with the basic front view.

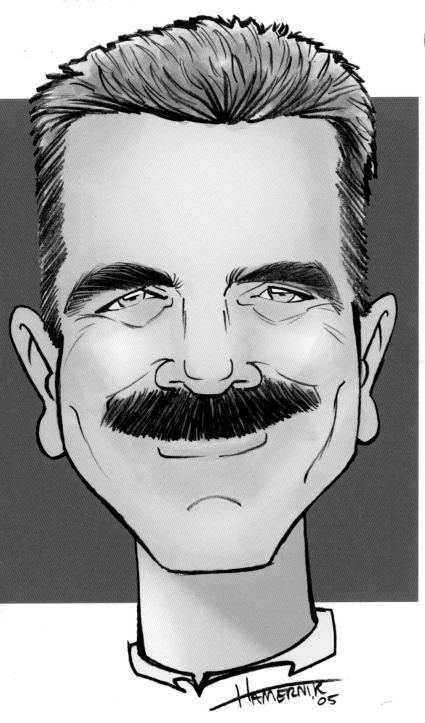

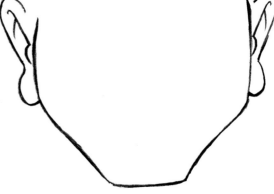

1 Draw the Structure
Draw the cheek down to the chin and back up the other side. If you are right-handed, begin on the left, and vice versa. Add the outside edge of the ear on both sides of the face, then draw the inside of the ear.

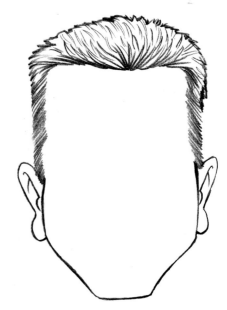

2 Draw the Hair
There are a lot of lines in the hair, but first draw the hairline around the face and then the silhouette of the hair. All the other strokes are decorative.

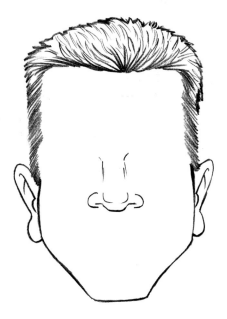

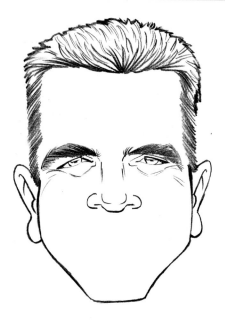

3 Start Adding Features

One size does not fit all. Draw the nose before the eyes if that makes more sense to you. Just try to use your same pattern as regularly as possible. Frequently switching between patterns will create problems for you. When you draw the nose, pay attention to where you drew the cheeks. The nose starts a little higher than the cheeks and ends halfway into them.

4 Add Eyes and Details

Now work your way down the face. Start with the eyebrows, then add the eyes. Indicate the color of the iris. Smile lines form the bags under the eyes. The difference between eye bags that make you look tired and smile lines is that you can still see eye bag lines when a person is not smiling.

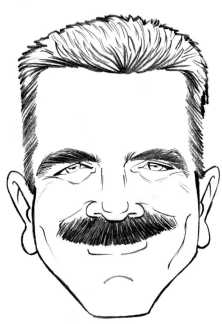

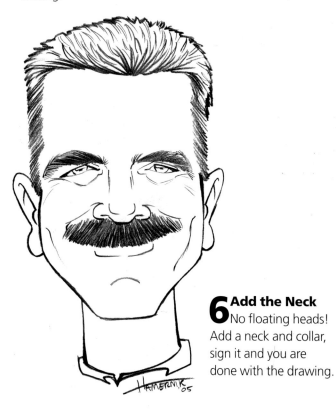

5 Finish and Refine the Features

Draw the upper mouth, based on the pivot point and anchor point. Then draw the moustache and lower lip. Add dimples and the chin crease.

6 Add the Neck

No floating heads! Add a neck and collar, sign it and you are done with the drawing.

Drawing a Baby

When you're drawing babies, notice how the length of the cheeks are much shorter than that of the adult in the previous demonstration. Here are some other differences:

- Children have shorter jawlines. This creates a smaller area for the features to fit into.
- The features sit lower on the head.
- Their craniums appear larger because the features are so low on the head.
- As they age, the facial features move up the head.
- Noses on infants are small, as are mouths.
- The eyes and hair are great features on which to focus.
- Keep the ears low on the head, and the neck short and thin. Refer to head-drawing books for more details on capturing age.

Adding Color

Remember, color should make a good drawing look great. Coloring a bad drawing won't make it good. Practice drawing before you take up coloring.

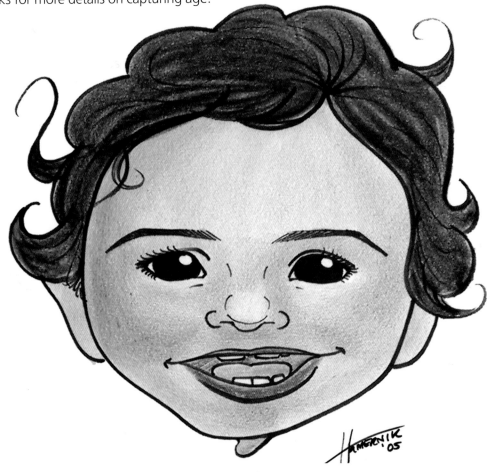

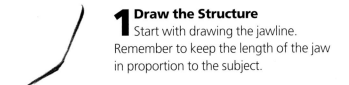

1 Draw the Structure
Start with drawing the jawline. Remember to keep the length of the jaw in proportion to the subject.

Visit www.impact-books.com/cartoonfaces for free bonus demonstrations.

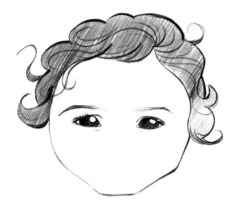

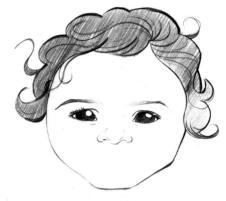

2 Draw the Hair
Describe the hair texture, color and length with each stroke. Draw line 1 of the hair, followed by line 2. Add decorative strokes after these two lines are done. You can shade in the hair if you like. Keep it neat and organized, though.

3 Start Adding Features
A child's eyes are large and expressive, so draw them that way. Indicate the color of the iris by the placement and size of the highlight.

4 Add More Facial Features
Draw the nose, which is usually small on children. However, the ears and nose continue to grow throughout a person's life.

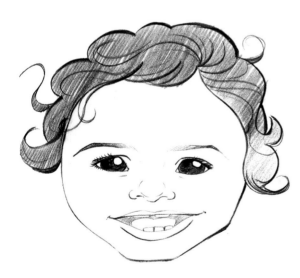

5 Finish and Refine the Features
Put in the final details of the face. Add the mouth, paying attention to the little details. Here, the gap and the tongue are very important aspects of her smile to capture.

6 Add the Neck
Necks on children are small. You will add a lot of age to a child by adding a thick or long neck. Use this knowledge to your advantage. If your drawing is looking too young, a big or long neck can add a few years to your sketch.

55

Simple Faces

There are times when the face shape does not say anything in particular. This means that there is probably another feature screaming for attention. If the face is simple, then draw it that way.

1 Draw the Structure
Draw a simple jawline.

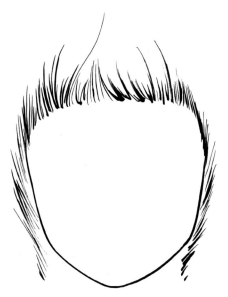

2 Add Hair
Hairline 1 covers the ears, so don't feel as though you have to include them.

3 Finish the Hairline

Simple shapes, such as hairline 2 here, help attract attention to other features by not attracting attention to themselves. If it is plain, then leave it that way.

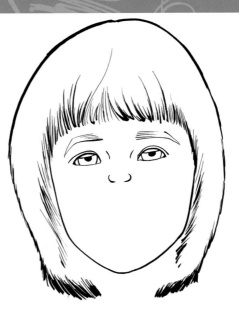

4 Add Facial Features

It is very important to stick to your pattern. Work your way down the face so you don't miss any details. Artists can easily leave out eyebrows, glasses and lips by accident. Skipping around the face will make you miss things.

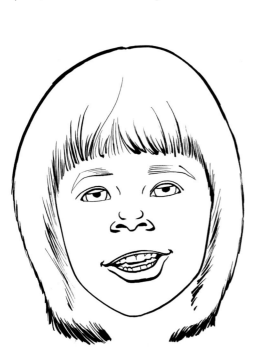

5 Finish and Refine the Features

Finish the face by adding the nose and mouth. Is it starting to feel easier now? You are drawing the same lines over and over from face to face. They are just arranged differently for each person.

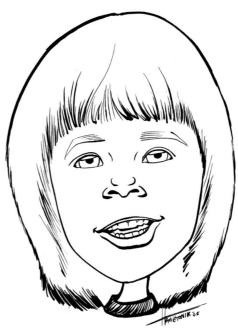

6 Add the Neck

Add the neck, collar and your signature to complete the sketch. Pencils and markers down. Except for adding color and a background, you should be done drawing at this point.

Working With Ponytails

Caricatures are cartoons. Cartoons are exaggerations of life. This means we can change reality so that we can get our point across. Ponytails, in general, cannot be seen from a front view. Ask your subject to turn around or pull her hair over her shoulder. This way you can see how long the hair is and add it over the shoulder. If the ponytail is really short, draw the subject's neck at an angle so you extend the hair just past the jawline and still see the short ponytail.

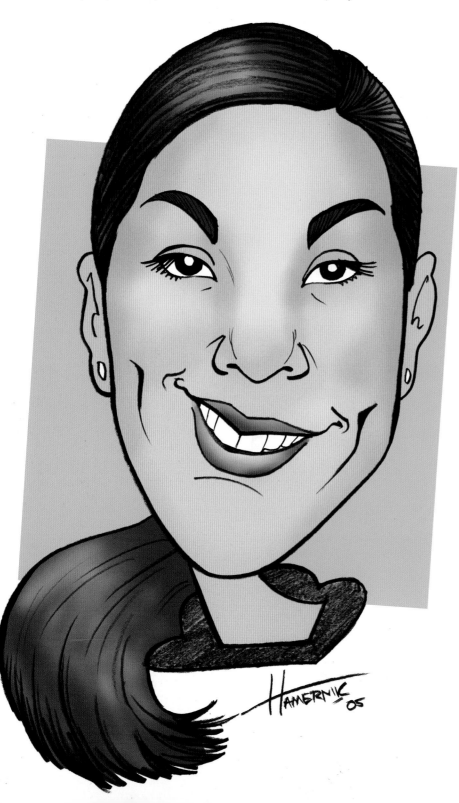

1 Draw the Structure
In general, the best point to start a sketch over is after you've drawn the jawline. If you are not happy with the sketch at this point, you probably will not be happy with it in the end.

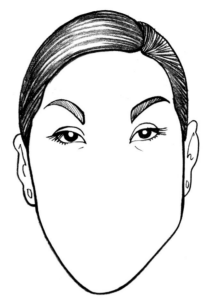

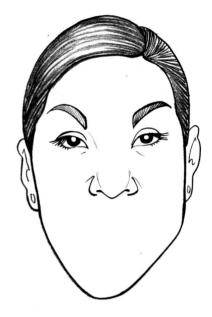

2 Add Hair

Draw the ears and hairlines; then fill in the hair. Ponytail styles will look like men's short hairstyles if you don't show length.

3 Start Adding Features

Well-groomed eyebrows are important for this portrait. Draw them neat, and catch the correct angle for the pivot point. Draw the correct iris color. Even notice the direction that the eyelashes grow. Simplifying the face doesn't mean changing what you see.

4 Add More Features

When drawing women, you can downplay the size of the nose by not drawing the shaft or by using thin lines. Doing this will attract less attention to their noses, and they will thank you for it!

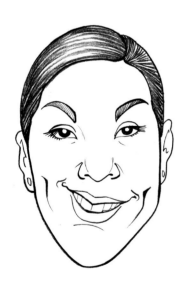

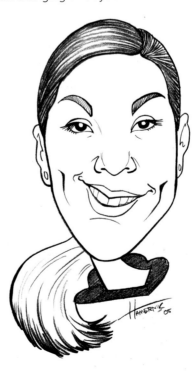

6 Add the Neck

Here I've drawn the long hair over one shoulder and angled her neck slightly.

5 Finish and Refine the Features

Subtle quirks make people unique. Can you see the slight tilt in her smile? Enhance those types of details. Look for dimples. Including these unique features will make the face stand out.

Hair With Texture

Hair can be difficult at times. Here, the hair creates an oval shape around the head. The hard part is drawing curl shapes around the hairlines while maintaining the overall oval shape. To avoid ending up with a lumpy, bed-head shape, use a really dry marker or a hard pencil to draw hairlines 1 and 2, establishing the head shape and the line where the hair meets the face. Keep the lines as thin and light as possible. Now you have a guide as you add the curls over these lines. You shouldn't see the original shape lines when you're done.

1 Draw the Structure
Start with the jawline and hairline 1. After lightly placing the hairline with a dry marker or a hard pencil, switch back to your regular marker or soft pencil and add strokes describing the hair texture and length directly over the guideline.

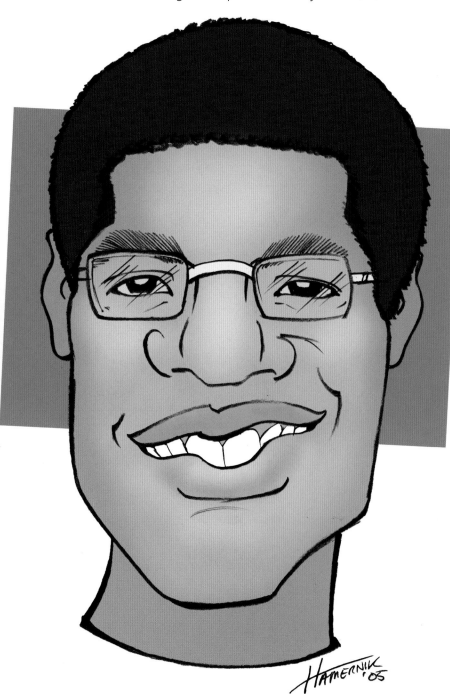

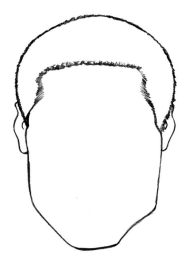

2 Add Hair
Lightly add hairline 2, then add the curls as you did with hairline 1 in step 1. Then add the ears. When drawing a specific head shape (such as a circle), always draw a thin, light line of the shape first. Then draw the hair strokes over it. This will help avoid lopsided head shapes.

Visit www.impact-books.com/cartoonfaces for free bonus demonstrations.

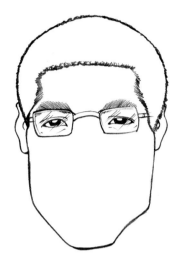

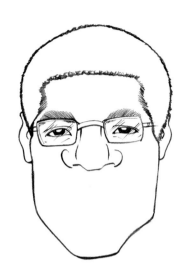

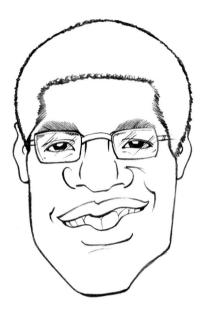

3 Start Adding Features
Draw every aspect of the face as you see it. Add eyeglasses while you are drawing the eyes. Ask yourself what size and shape they are. Asking yourself questions will keep you focused on what you are trying to draw.

4 Add More Facial Features
Add the nose. Make sure its placement and its bridge shape make sense in relation to the eyeglasses you drew. Otherwise, the glasses will look like they're floating on the face instead of being supported by the nose.

5 Finish and Refine the Features
Add the smile. This smile tilts up to the side, which shifts the shape of the cheeks. The cheek lines help to better define this quirky smile.

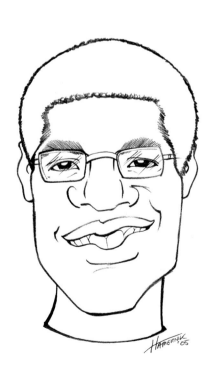

6 Add the Neck
Thick necks are masculine and add age. Think about the neck before you draw it. Long, thinner necks work better for women.

Embellishing Features

The nose and jawline are generally masculine features. Feel free to enhance these on men. The eyes and lips are good features to exaggerate on women.

Working With a Beard

A beard creates the jawline, and making it look symmetrical can be tough. Use a light line to establish the shape you are about to draw, then add the individual strokes for the hair. You can also just draw half of the beard and stop. Draw small dots on the other half, where the rest of the beard will be. Think of it like connect-the-dots drawings. Use these dots to help you finish the beard symmetrically.

Coloring Highlights

As you color, use the white of the paper when needed. If you want to create a highlight area, leave that spot without color, or add a much lighter layer of color there. Avoid using white colored pencils to try to create highlights in areas you've already colored; they do not cover up other colors.

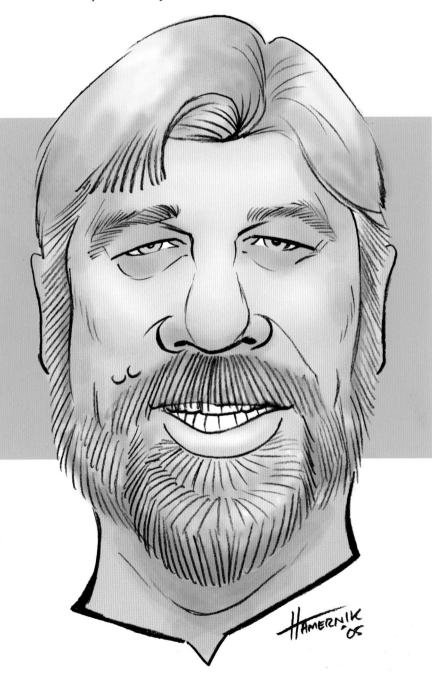

1 Draw the Structure
The jawline may have to be drawn with many strokes to indicate a beard. The group of strokes will create the shape of the jaw. Note that the cheeks will usually still show up.

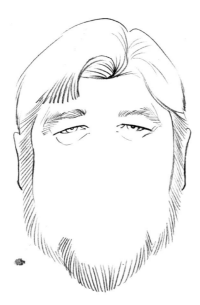

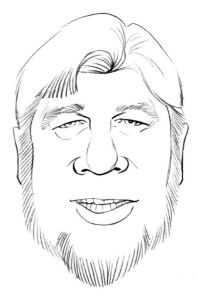

2 Add the Hair
Don't completely finish the beard yet. You need to place the facial features first. Continue with the pattern by adding the ears and hair lines.

3 Start Adding Features
Work your way from top to bottom. In general, the older the person is, the more lines you can use on a sketch.

4 Add More Features
Now that all the facial features are in place, go back to the beard.

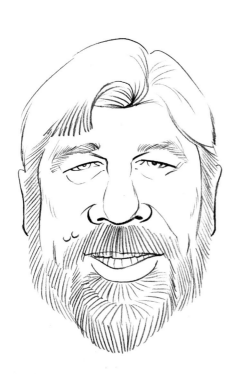

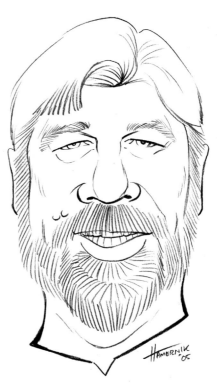

5 Finish and Refine the Features
Fill in the space with the hair strokes of the beard. Organize them into sections, minding the direction of the hair growth in each.

6 Add the Neck
Complete the sketch by adding the neck, collar and your signature.

Drawing the Three-Quarters View

Basic Process

As with the front view, draw in the same pattern or order for every sketch, with few exceptions. If you're drawing a real model, ask them to look right at you first. Then tell them to tilt their head until you only see one nostril. This is the three-quarters view. Avoid skipping around the face when you're drawing the features; you may forget to draw an eyebrow or something else.

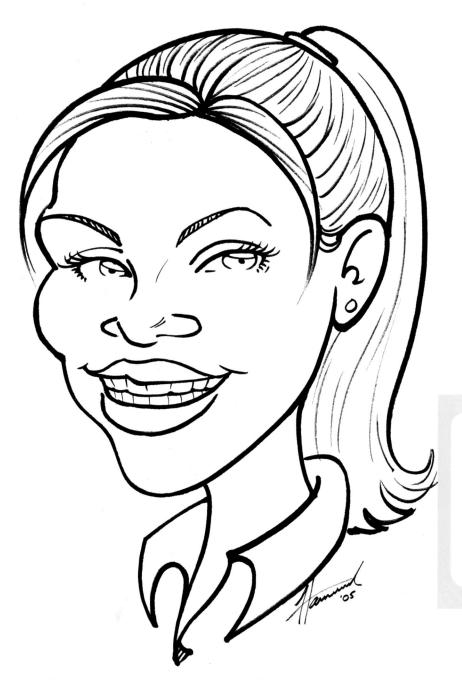

1 Draw the Structure
Start at the eyebrow and work your way down the face. Go around the chin and up the jawline to the ear. Be sure to line up the corners of the jaws.

Choosing Sides

If you are right-handed, start with the cheek on the left side of the face. If you are left-handed, then do the opposite.

2 Add Hair
Next add line 1 of the hair, followed by line 2. Pay close attention to the silhouette shape of the hair. Also add the ear at this point.

3 Start Adding Features
For the features, begin with the eyebrows and work your way down the face.

4 Add More Features
Add the nose. Focus on the far side of the shaft of the nose. This line will be very evident from a three-quarters view. Think about the distance down to the base. Use the anchor and pivot points to draw the base.

5 Finish and Refine the Features
Draw the mouth, making sure the corners of it point toward the cheeks. You'll see more of the side closest to you, so the far side of the mouth should be drawn shorter.

6 Add the Neck
Add the neck and collar.

Drawing Three-Quarters View Eyes

To further illustrate drawing three-quarters view caricatures, this section will cover the different methods for each feature as compared to the front view. We'll start with the eyes.

Using Highlights

You can use the highlight in the iris to direct the gaze of the eyes. This helps if you want the eyes to look in a certain direction.

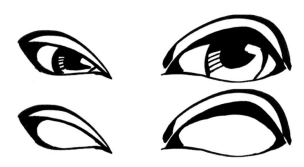

Eye Basics

The eye farthest away from you will look smaller than the one nearest to you. Draw the far eye first. Think about where the nose falls so you don't draw the eye too big. Use the white part of the eye to help establish the overall shape. Always look for the shape of the whole eye first. You will draw the closer eye similar to a front-view eye.

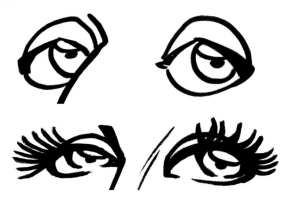

Defining the Eyes

Use anchor and pivot points to establish the tilt of the eyes. Eyelashes make the eyes look feminine, so skip them on men.

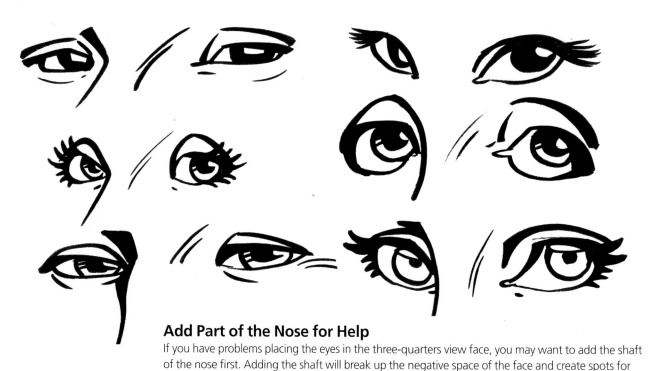

Add Part of the Nose for Help

If you have problems placing the eyes in the three-quarters view face, you may want to add the shaft of the nose first. Adding the shaft will break up the negative space of the face and create spots for the eyes to fit into. The shaft may even cover part of the far eye.

Creating a Three-Quarters View Nose

In the three-quarters view, you typically see only one nostril of the nose. Make sure the nose is angled enough to show this in your drawing.

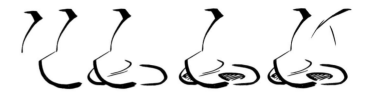

Nose Progression

Draw the shaft of the nose. Decide how long it will be. Fit it properly onto the face shape you created earlier in the drawing. You can draw the base of the nose by considering the anchor and pivot points. Finish by adding some decorative strokes to better define the near side of the nose.

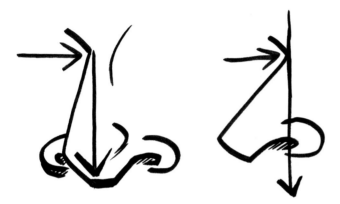

Line Up Your Features

Pay attention to the point where the nose shaft meets the eyebrow. Compare that to the center of the nose at the base. They should roughly line up, as in the example on the left. If the top is too far over, the bottom of the nose will look more like a profile nose than a three-quarters view nose.

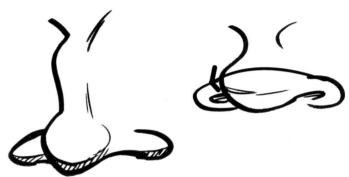

Defining the Nose

The far side of the shaft will define that person's nose. You can use a bold line here. Be sure that the nostrils relate to each other. The example on the right has a line that connects the two together. Do this mentally before you draw the second nostril.

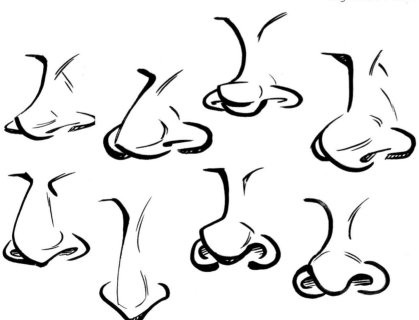

Nose Examples

Practice drawing many, many noses. The ones here are exaggerated. Study these and compare them to people you see. You may not see these shapes at first. Look closely for subtle differences, then exaggerate them.

Forming a Three-Quarters View Mouth

All the principles of the front view mouth also apply to the three-quarters view mouth. The big difference is that the far side is shorter than the near side.

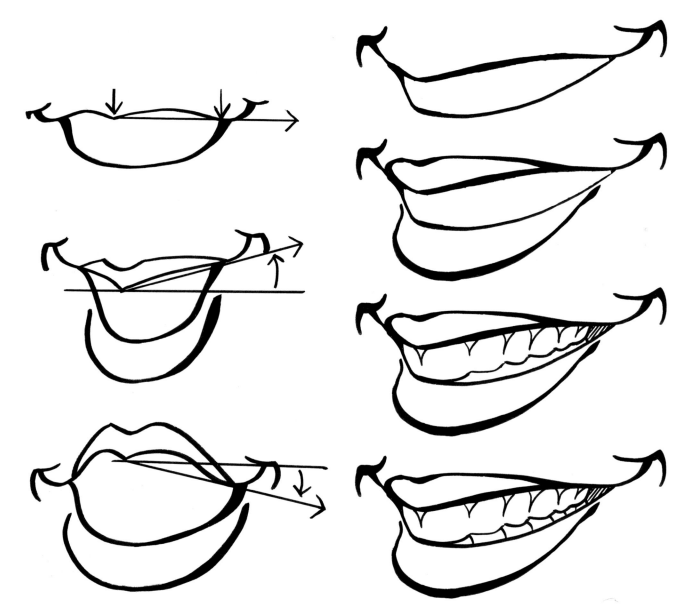

Study Anchor and Pivot Points
Look for the anchor and pivot points first, then determine whether the shape of the lower part of the mouth will form a "U," "V" or "W." The lips come after this.

Keep Using Your Pattern
Draw the mouth using the same pattern as you used for the front view. Start with the mouth opening. Add the lips, followed by the upper teeth and then the gum line. Finish with the lower teeth or tongue, if you can see them.

Designing Three-Quarters View Face Shapes

Face shapes will vary dramatically in the three-quarters view. Study the examples on this page closely to find some of the differences. It can be difficult to make all the features line up on a three-quarters view face. The only way to get good at this is to practice inventing faces. When you are practicing, focus on only one thing at a time. For example, draw a whole page of face shapes, then a whole page of noses. Drawing only one face shape here or a nose there will not benefit you.

An Angular Face
This male face has many angular points.

A Curvy Face
This female face is made up of curves and flowing lines.

A Round Face
Notice the round jawline. The face shape is just as important as the features. Use bold lines to attract attention to important features.

Find the Active Lines
The far side of the face really affects the look of the three-quarters view sketch. It also contains a lot more active lines than the near side.

Drawing Three-Quarters View Hair

Here is the basic process for drawing the hair in a three-quarters view caricature. The only difference from the front view is in the way the silhouette shape is drawn.

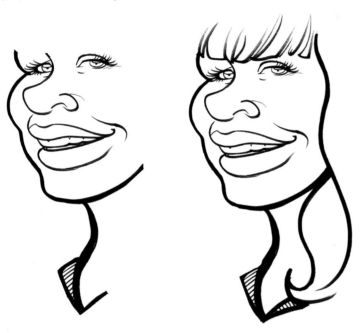

Adding Hair

Draw the face shape first. Add all the facial features to this sketch so that you can see where the hair goes in relation to the face. Start with the hair around the forehead and work your way toward the near ear. Now add the silhouette shape of the hair starting at the top of the head and working toward the near side of the face. Add the silhouette of the far side, if necessary. Finish by accenting the hair with decorative strokes.

Visit www.impact-books.com/cartoonfaces for free bonus demonstrations.

Using Facial Rhythm Lines

Rhythm lines create shapes that give character to the three-quarters view caricature and the profile caricature. The shape created is where you will capture the likeness of your subject. The features are still important, but the negative shape and silhouette that are created really stand out. Pay close attention to this page. It contains a great secret for creating awesome caricatures.

Locate the Three-Quarters Line
Draw the face shape. The three-quarters view rhythm line is made up of the far eyebrow, the shaft of the nose, the far shape of the upper lip, the far side of the mouth opening and the lower lip. It's not really a "line," but an abstract concept for capturing a likeness.

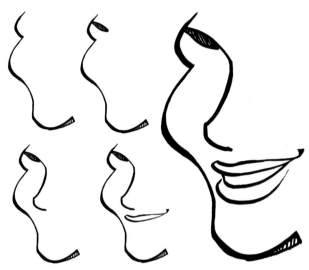

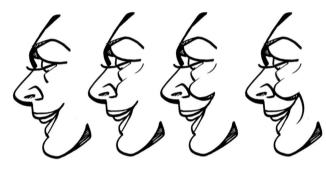

Direct Your Strokes
Here is an example of the direction each of the strokes should follow. Pay close attention to where the rhythm line meets the face silhouette.

Locate the Profile Line
The profile rhythm line is made up of the eyebrow, the top of the cheekbone, the silhouette shape of the cheek and the smile line going to the corner of the mouth, finishing at the chin crease.

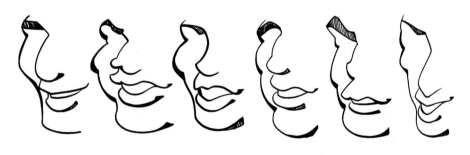

Notice Different Characteristics
Study these examples. Look at the difference in character types that are created by the face silhouette and the rhythm line. Note that sometimes the far smile line will be predominant.

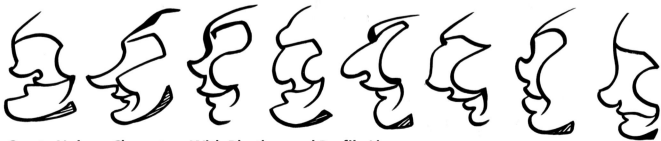

Create Unique Characters With Rhythm and Profile Lines
Study these profile examples. Look at the character type created by the profile line and the rhythm line.

Pulling the Face Together

You should be getting used to this process now. Continue to follow the same formula. You want to draw in the same order every sketch. This will help the process go faster, and it will free your mind from focusing on the drawing too much. You'll be able to let your imagination run wild with ideas for new characters!

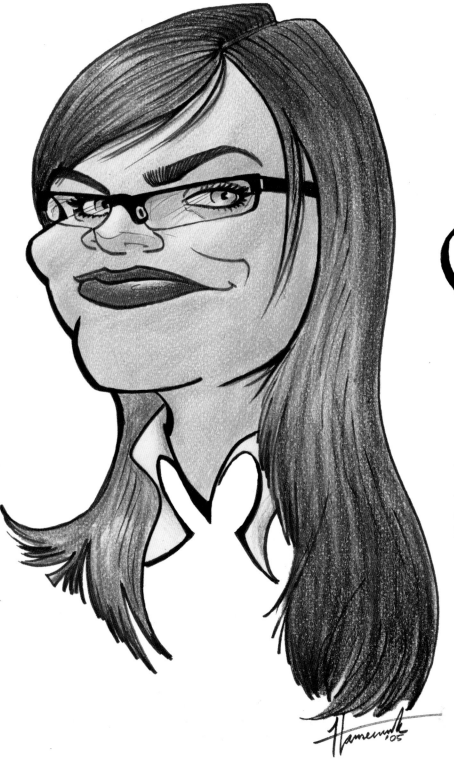

1 Draw the Structure
Draw the profile line of the face. Begin at the eyebrow, then draw the cheek, jaw and chin. Vary the line width for interest. Thicker lines attract attention.

Visit www.impact-books.com/cartoonfaces for free bonus demonstrations.

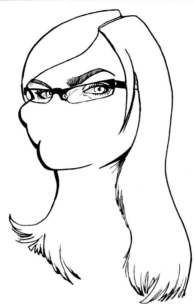
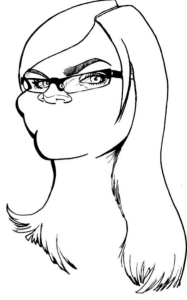

2 Add Hair
Add the hairline around the face. Then add the silhouette shape of the hair. Use a "V" shape to indicate a part in the hair—the deeper the "V," the puffier the hair will appear. You can break the two lines up by using decorative strokes, but they should appear to create a "shape" of hair.

3 Start Adding Features
Draw the eyes. These are the windows to the soul. Draw them carefully; if you miss the mark here, you are heading into troubled water. Draw the far eyebrow first, then the near one. Continue with the far eye, then the near one. Add the glasses now if you wish.

4 Add More Features
Draw the nose. Start at the bridge by the eyebrow and work your way down to the tip of the nose. Add the near nostril, then the far one if you can see it. Add any decorative strokes that will help define the nose.

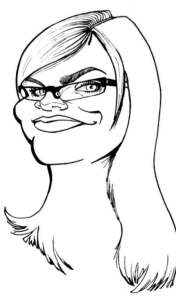
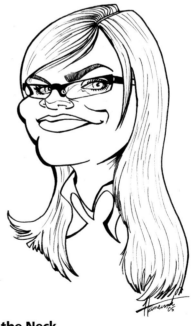

5 Finish and Refine the Features
Draw the mouth area. There is no opening in this model's expressive grin, so you will simply draw the top lip, then the bottom one. Don't forget the smile lines.

6 Add the Neck
Complete the sketch by first drawing the neck and collar. Go to the top of the sketch and work your way down adding decorative strokes. Look for anything you may have skipped: freckles, earrings, strokes in the hair, glasses and so on.

73

Capturing a Likeness

It is very important to accurately exaggerate the profile line and the silhouette line of the hair to capture your subject. Nailing such features as the eyes and nose will not be enough to get a likeness if you don't get the main profile and silhouette lines right.

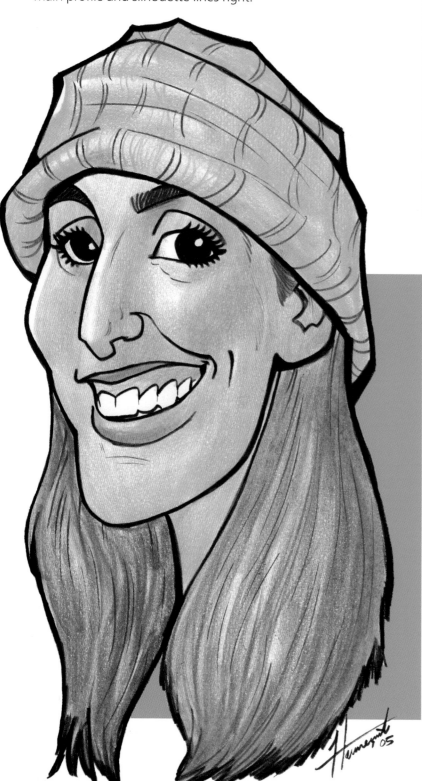

Vary the Profile Line

Practice varying the shapes of the profile line. Start the profile line at the widest point of the eyebrow ridge. Imagine a plumb line dropping straight down from that point. Ask yourself, how far does the ridge go in? How far does the cheek go out? When do you cross the plumb line again? At the cheek? At the jaw? At the chin? Remember to exaggerate.

1 Draw the Structure
Draw the profile line. What point extends the farthest? The brow, cheek, jaw or chin? Draw this all in one stroke. When you are practicing, draw the same profile line ten times in a row or until you get the exact line you want.

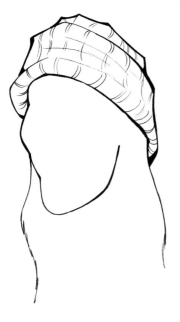
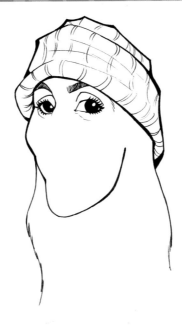
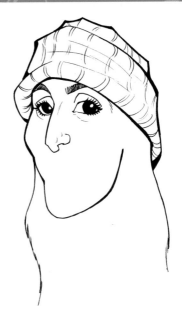

2 Add Hair
Draw the hair. The hair around the face is hidden by the beanie in this case. Add the silhouette shape next. You can add decorative strokes if it keeps your flow going.

3 Start Adding Features
When you reach the eye region, draw the eyebrows first (the far side, then the near side). Then draw the far eye and the near eye. Add lashes on women only.

4 Add More Features
Draw the nose next, using the formula of bridge down to the tip. Watch those angles. Add nostrils, near then far (if you can see it). Don't forget any decorative strokes.

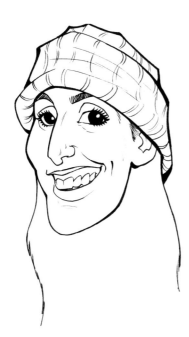
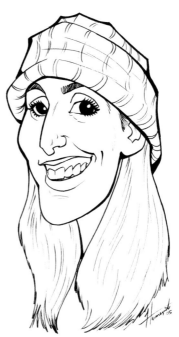

5 Finish and Refine the Features
Draw the mouth opening first. Then draw the top lip, bottom lip, upper teeth and gums, lower teeth and tongue. Only draw what you can see. Add smile lines and dimples, plus the ear.

6 Add the Neck
Finish your sketch by adding the neck and finishing the hair. Notice here that the neck is implied by the space left for it between the two sections of hair, instead of being clearly drawn.

Clothing and Decorative Lines

There will be moments when you encounter elements that challenge the formula. Turtlenecks are not difficult, and neither is any other item of clothing. Think of it like hair: Get the inside shape and the outside shape. The remaining lines are just decorative.

Simplify Minor Elements

Always simplify patterns and details of clothes. You don't want to take attention away from the face with overly detailed clothes.

1 Draw the Structure
Start at the eyebrow and work your way down. By now, it should feel like a familiar process. Stick to it and you will improve at a rapid pace. Complete an entire sketch; then go and practice the parts you didn't like.

Visit www.impact-books.com/cartoonfaces for free bonus demonstrations.

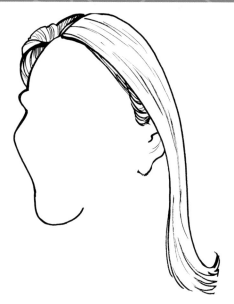

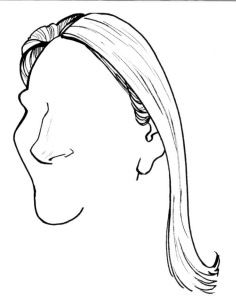

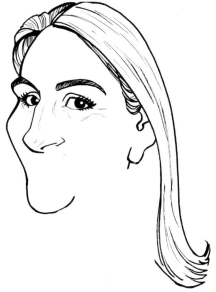

2 Add the Hair
Draw line 1 of the hair and then line 2. Add the decorative strokes. Notice how the direction of the hair changes in the section that is tucked behind the ear.

3 Start Adding Features
Draw the nose. You don't have to exaggerate the bump on a woman's nose, but make sure you draw it.

4 Add More Features
Draw the eyes. Remember the process: eyebrow first, eye opening next, then the iris and finally the eyelids. Add lashes at the very end.

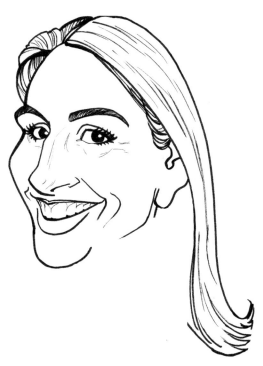

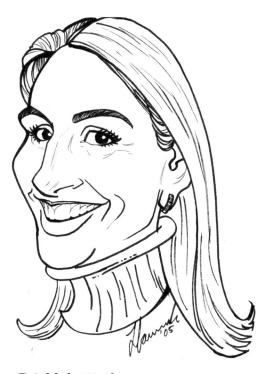

5 Finish and Refine the Features
Draw the smile. Use caution with the smile lines. The longer the lines, the older the person will look. Draw the gums if they show.

6 Add the Neck
Finish the drawing by adding a neck and turtleneck collar. Draw the main lines that describe the collar, then sparingly add a few decorative lines to it. Always double-check to see if you missed anything, such as jewelry.

Analyzing Face Shapes

When you see a friend from far away, you recognize the person by the silhouette shapes of her face and figure. The face shape is very important to the design of a caricature. Look at how different face shapes are from person to person.

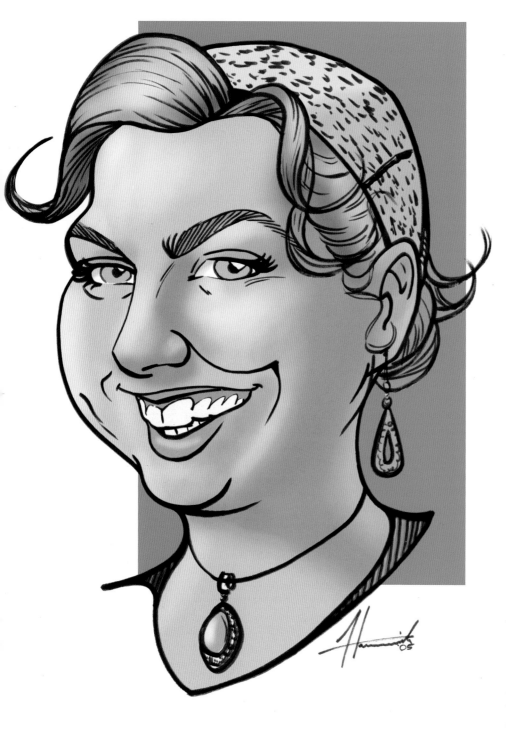

1 Draw the Structure
Start with the face shape. Use only "C" curves, "S" curves or straight lines—no sketchy or messy lines allowed. Compare the placement of the eyebrow to the placement of the cheek and the chin.

Visit www.impact-books.com/cartoonfaces for free bonus demonstrations.

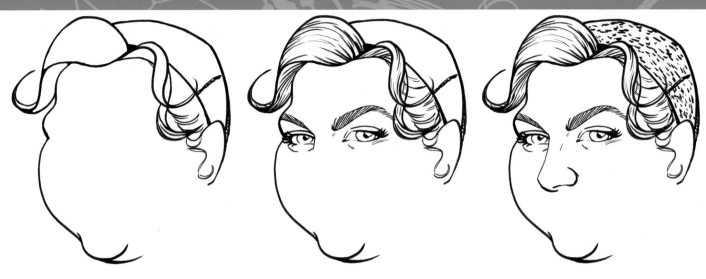

2 Add Hair
Draw the hair lines. Draw complex hair in sections. Draw the bangs first, then the handkerchief; the decorative strokes should always come last.

3 Start Adding Features
Draw the eyes. Once you're comfortable with caricatures, you can change the order of how you draw. But pick a formula you like and stick with it for one hundred sketches at a time instead of changing your formula from drawing to drawing.

4 Add More Features
Draw the nose, keeping it simple. Forget about the shadows. Sketch in a linear and graphic style.

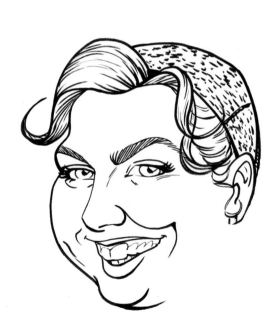

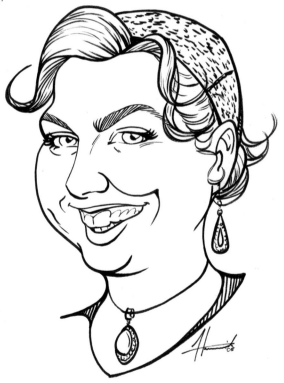

5 Finish and Refine the Features
Draw the mouth. Remember to look for the anchor and pivot points. The smile lines reveal just as much personality as the other lines of the face.

6 Add the Neck
Complete the sketch. Enjoy adding details to jewelry or patterns on the clothes.

Using Pencils Like Markers

When sketching in pencil, use the same approach as you do with markers. A good pencil has a wide lead and can draw light and dark without smearing a lot.

Matching Directional Strokes

Matching directional strokes means you should draw all the lines going in the same direction, with the same distance between them.

1 Draw the Structure
Start as you usually do, but sketch slightly smaller when using pencils. Pencil tips are smaller than markers, so be sure to adjust for that.

Visit www.impact-books.com/cartoonfaces for free bonus demonstrations.

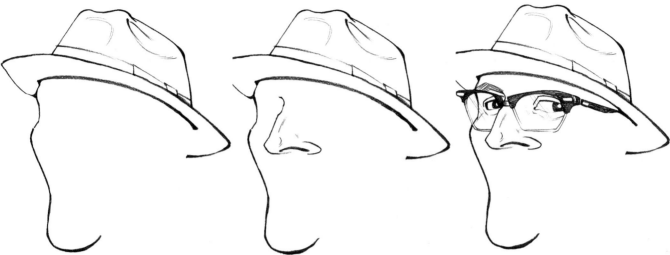

2 Add the Hat
Drawing hats is no different than drawing hair. Draw around the face first, then the outside shape. Finish with the decorative details.

3 Start Adding Features
Noses on men are fun to draw. Exaggerate this feature as much as you want on men.

4 Add More Features
Always work in the biggest sections first. Because the glasses take up more room than the eyes, draw the glasses before the eyes. Make sure they rest on the nose properly. Glasses can change the position of the eyes on the face.

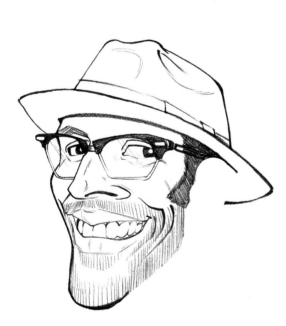

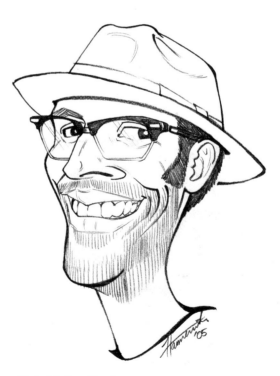

5 Finish and Refine the Features
Draw the mouth and the sideburn. Then add the five o'clock shadow, filling it in with matching directional strokes. If you change the angles as you go around the face, it will look like a beard instead.

6 Add the Neck
Finish the ear and hair, then draw the neck. Necks can be very funny, so experiment a little and see what results you get. An elongated neck fits this caricature perfectly.

Mastering Facial Hair

Facial hair can be shaggy or groomed, light or dark, thick or thin. Be sure to pay attention to the color, texture and type of facial hair, and how it varies on different areas of the face.

Hair Strokes

To draw shaggy hair, use long "C" curves. To draw hair of a light color, use thin lines. To draw dark hair, use dark strokes. To draw thick hair, leave less space between your strokes.

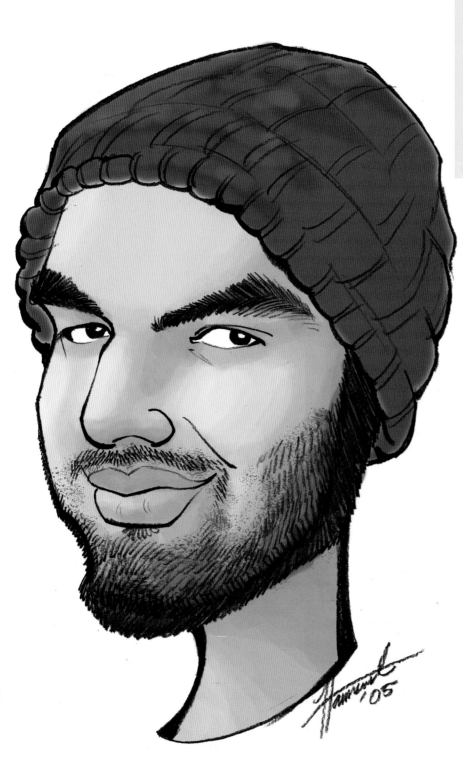

1 Draw the Structure
Draw the profile line of the face. Add the jaw by describing the hair texture, color and volume.

Visit www.impact-books.com/cartoonfaces for free bonus demonstrations.

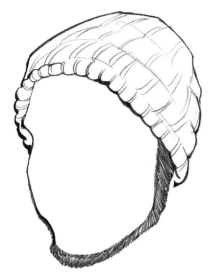 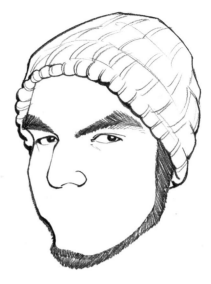

2 Add the Hat
Add the beanie. Go around the face and then add the silhouette shape. Draw the details of the hat one row at a time.

3 Start Adding Features
Draw the nose. Features that are not the focal point in your sketch should be kept simple. Draw them smaller so you have more room to exaggerate the other features.

4 Add More Features
Pay attention to the negative spaces created when you add the eyes. Look at his left eye. See the space between the eyebrow and the beanie? Spots like this are good anchor points to use.

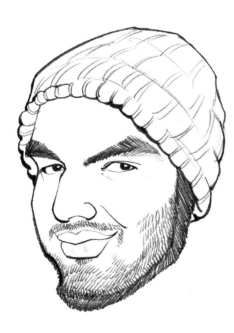 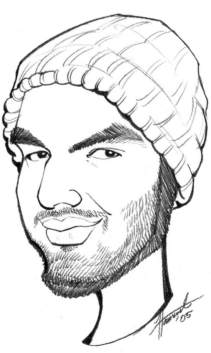

5 Finish and Refine the Features
Draw the mouth. Only one in ten people actually smile without showing their teeth. The facial hair is thin on much of the face and the moustache, so add it with fewer and thinner strokes.

6 Add the Neck
Keep the neck simple and collarless when your sketches are getting too busy or are taking a long time to finish.

Hair Covering the Face

Sometimes a character's hair will cover their face. If the hair is thicker and hides the features, then draw the hair first. If the features are shown through thinner hair, continue as you normally would, then add the hair over the features.

Unify Multiple Lines

When you have a lot of lines in a sketch, you can create a heavier outline to unify the drawing and anchor it to the page.

1 Draw the Structure
Draw the profile line. Notice the angle of the face and the very subtle variations in the line.

Visit www.impact-books.com/cartoonfaces for free bonus demonstrations.

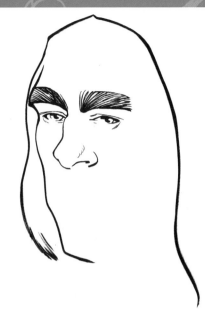

2 Add the Hairline
For this portrait, you can see the features through the hair. Skip line 1 of the hair and draw line 2. We will add line 1 later.

3 Start Adding Features
Add the eyes. The eyebrows can be more interesting than the eyes themselves. Enhance one or the other.

4 Add More Features
Add the nose. Be sure not to make all features big, even when you are tempted. Pick the best one and go with that. The hair is our focus here.

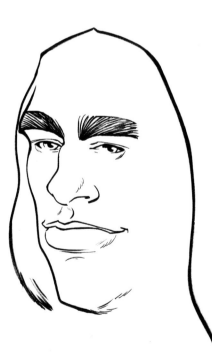

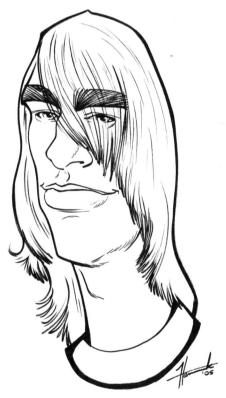

5 Finish and Refine the Features
Draw the lips. You can contrast one against the other by making one very thin and the other very thick.

6 Finish the Hair and Add the Neck
Finish the sketch. Add hairline 1 first, then the neck and collar. Draw the hair right over the features. Mix the decorative strokes in with line 1.

Color Enhances Ethnic Faces

Pay close attention to different ethnicities. Capture the correct look based on what you see, not what you think you know. The color will then enhance your drawing.

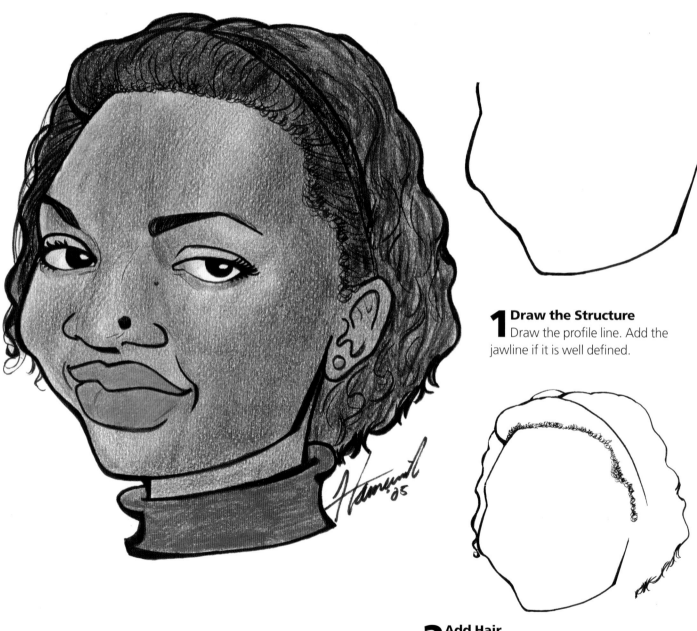

1 Draw the Structure
Draw the profile line. Add the jawline if it is well defined.

2 Add Hair
Draw line 1 of the hair. Notice the texture and volume. Add line 2, breaking it only where there are layers in the hair. Always include hair bands, ponytails or anything else that may be in the hair.

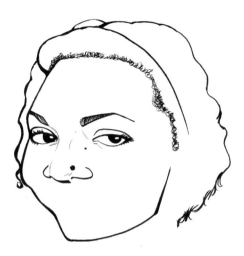

3 Start Adding Features
Add the eyebrows and eyes. The eyes speak volumes about someone's personality, and the eyebrows can really show off the expression you want.

4 Add More Features
Draw the nose. Don't be afraid of adding particular features, such as moles.

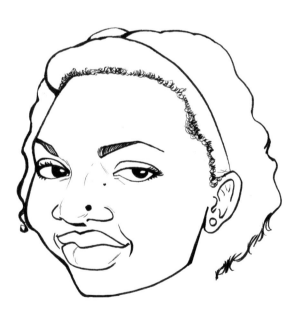

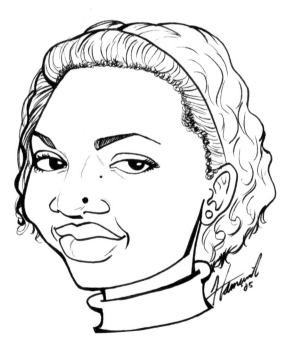

5 Finish and Refine the Features
Draw the ear and the mouth area. Study the amount of space the mouth occupies between the nose and the chin. Lip lines are thicker when the character is wearing lipstick.

6 Add the Neck and Details
Add the decorative strokes and complete the drawing. Notice that the wavy strokes in the hair help define the texture. The strokes tucked into the head band define the bangs.

Working With a Dynamic Model

Sometimes you find a dynamic model that seems made for caricature, and you want to go crazy on the sketch. Take a deep breath, relax and follow the standard process. Figure out what you want to exaggerate first, then start drawing. You might be tempted to exaggerate nearly everything, but don't—just pick a couple features.

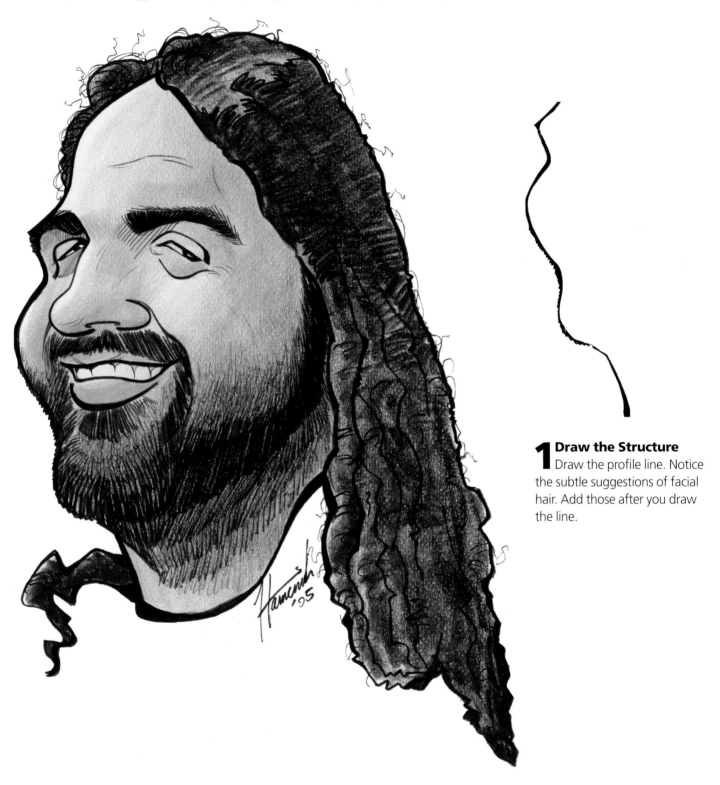

1 Draw the Structure
Draw the profile line. Notice the subtle suggestions of facial hair. Add those after you draw the line.

2 **Add Hair**
Draw line 1 of the hair, then line 2. Pick one or two dreadlocks of hair, or braids, and add lots of detail to them. Be careful not to overdo it.

3 **Start Adding Features**
Draw the eyes. Add some shadows if you feel confident. Keep the directional strokes consistent so as not to confuse the viewers.

4 **Add More Features**
Draw the nose. The nose is a great feature for men, but keep it simple for this sketch.

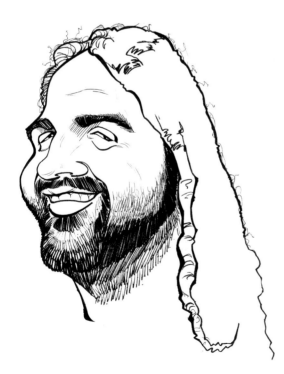

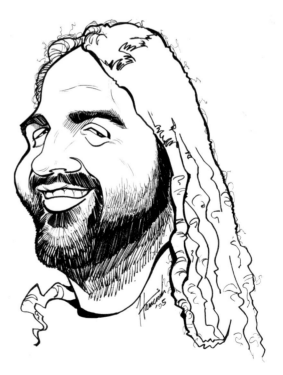

5 **Finish and Refine the Features**
Draw the mouth first, then add the facial hair that defines the lower half of the face. Vary the lines and their thickness to create that scraggly look.

6 **Add the Neck and Details**
Complete the hair with decorative strokes, but not too many. He has darker hair, which you are going to color. Keep the collar simple.

Making Hair a Graphic Element

A good caricature has areas of detail that are cool to look at. For the viewers to enjoy those areas, you need to balance the detailed areas with simple graphic elements. This means the areas that are far away from the details should be as simple as possible. Simple areas do not attract attention. This allows the details to be seen faster because our eyes go to details quickly.

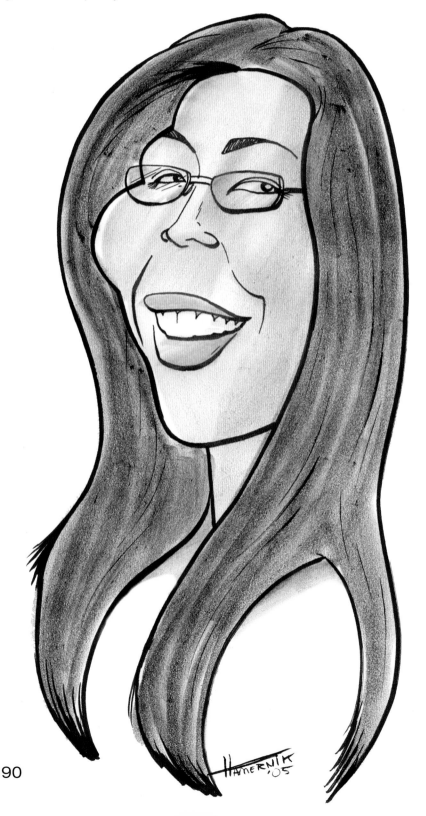

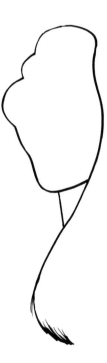

1 Draw the Structure
Use the hair as a graphic element to make the outline of the face more interesting.

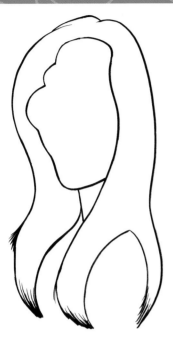

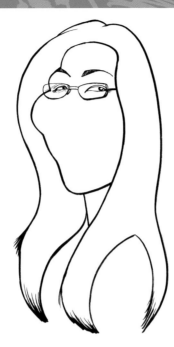

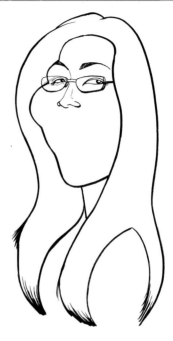

2 Add Hair
Drawing line 2 of the hair is simple. Simple shapes will allow the face to attract more attention.

3 Start Adding Features
Glasses can be added later in the drawing if they confuse you at this point. When you do put in the glasses, draw them before the eyes.

4 Add More Features
The nose fits into its place. Remember, it has to fit with the original cheek shapes you created.

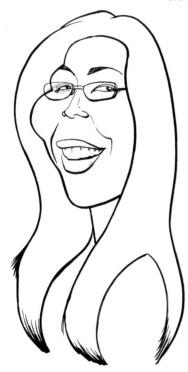

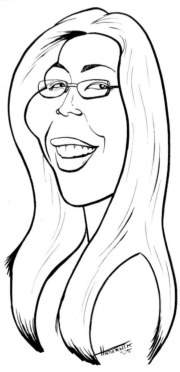

5 Finish and Refine the Features
You can draw normal-looking features, but changing the spacing of them creates an exaggerated look, as shown here in the distance between the mouth and nose.

6 Add Final Details
Add some decorative lines at the end. Make sure you didn't miss anything.

Drawing Profile Caricatures

Basic Process

This lesson covers the basic pattern you will use for profiles. Follow the same basic formula that you used for drawing the front view and the three-quarters view.

Use Your Imagination!

Models and references are wonderful tools, but make sure you practice drawing from your imagination. It'll sharpen your perspective and your skills. Take the basics you know and stretch them even further.

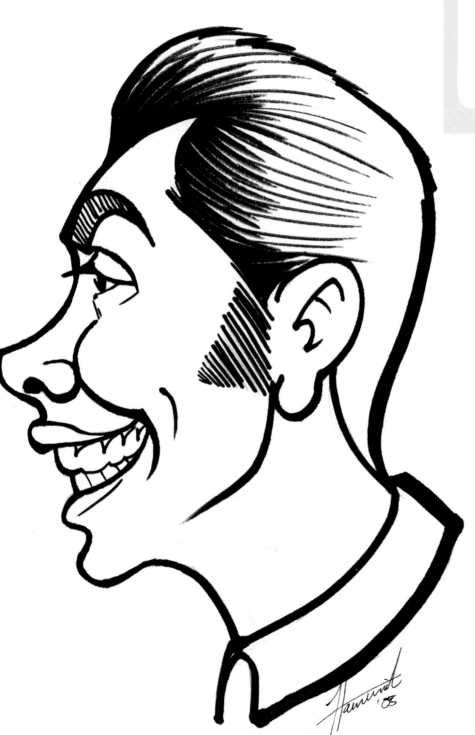

1 Draw the Structure
Start at the brow ridge and work your way down the profile line of the face. Capture the nose and mouth with the teeth, and stop at the chin.

2 **Add Hair**
Continue the profile line up the forehead and add line 1 of the hair. Then add line 2 of the hair. The back of the head is a good place to exaggerate the shape.

3 **Start Adding Features**
Work your way down the face as you draw the features. Start with the eyebrows, then add the eyes.

4 **Add More Features**
Add the nostril and the cheek.

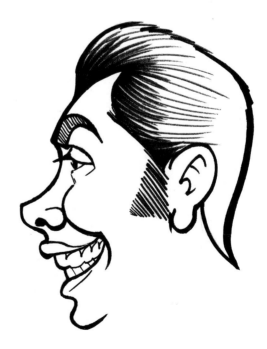

5 **Finish and Refine the Features**
In this example, you drew the teeth in step 1, so now just add the lips and complete the smile line.

6 **Add Final Details**
Draw the ear and its details. You can add some decorative strokes on the sketch now, if you like.

Profile Facial Features

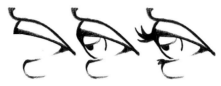

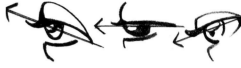

Profile Eye Shape
Think of the profile eye as the letter "A" tipped on its side.

Drawing the Eye
Draw the upper opening, the lower opening, then the eyelids. Next comes the iris, pupil and highlight. Finish with eyelashes, if necessary.

Placing the Anchor and Pivot Points
There are anchor and pivot points to the profile eye. Use the upper opening and the back corner of the eye. Notice the angles of each of the examples.

Placing the Lower Lid
The lower lid slants in many ways. Practice the various angles so you can easily adjust for different expressions.

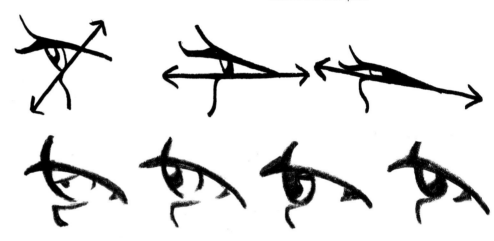

Profile Eye Color Indications
They are (from right to left): blue, hazel, light brown and dark brown.

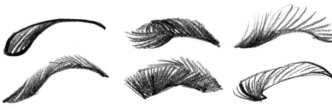

Profile Eyebrows
Eyebrows come in many shapes, colors and textures. They can be groomed or natural, straight or wavy, and light or dark.

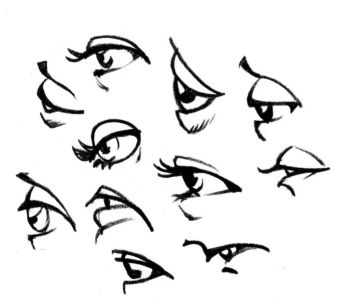

Profile Eye Examples

Anchor and Pivot Your Eyebrows
Look for the angle of the anchor and pivot points. Use the side closest to the profile line as the anchor.

Visit www.impact-books.com/cartoonfaces for free bonus demonstrations.

 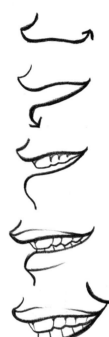

Drawing Profile Noses

Pay close attention to the swoop of the nose. The nose line can get too long fast, so watch that length.

Work Down, Not Up

Work your way down the shaft of the nose. Pushing the marker up the page when drawing the profile nose will seem awkward.

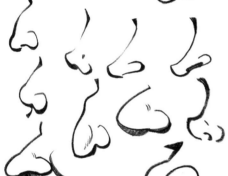

Profile Nose Examples

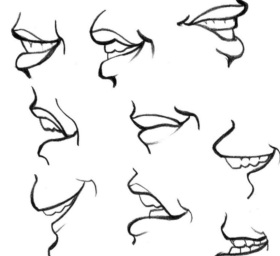

Profile Mouth Examples

Forming the Profile Mouth

The mouth will be part of the profile line. Work your way down and into the mouth. Break the line only when necessary. The teeth, lips and smile lines should be done last.

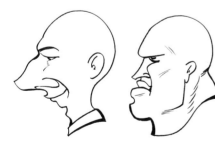 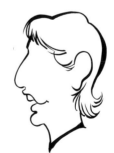

Adding a Neck

The neck will have a huge effect on the drawing. Keep in mind that a large neck on a woman will make her look like a football player.

Drawing the Hair in Profile

Hairline 1 creates the facial area. Hair line 2 creates the silhouette of the caricature. Decorative strokes should always be added last.

Profile Line and Hair Silhouette Are the Key

Notice how just the profile line and the silhouette of the hair make the image here? The features come second to these two lines in a profile sketch.

Varying the Profile Line

You always begin a profile sketch with the profile line, but that line and the angle of it can have countless variations. The profile line of the face reveals the most amount of character. Feel free to design the strokes. Lines should be straight ones or simple "C" curves. Square shapes need to be made more square; round shapes need to be made rounder. This helps to simplify it.

Styling Short Hair

When drawing very short hair, draw the head shape with the thinnest and lightest line you can draw. Then go over it with the hair strokes. The first line will help you get the correct shape; the second will help you focus on getting the hair right.

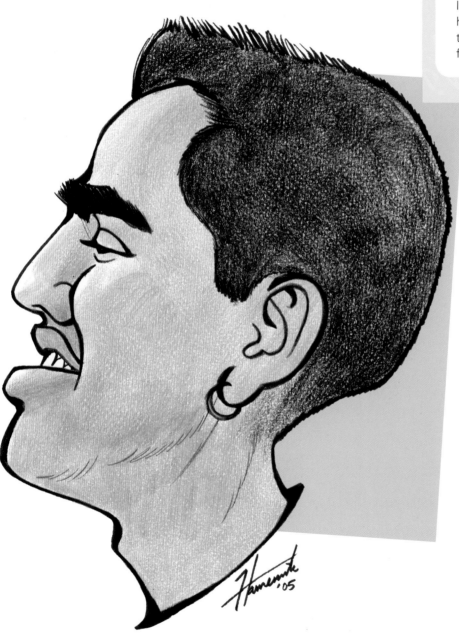

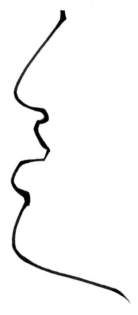

1 Draw the Structure
Draw the outline of the profile. Flip through the book and compare this step with the first step of each demo. See the difference? Design each stroke.

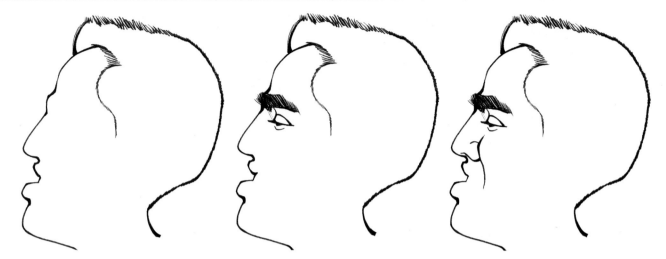

2 **Add Hair**
Draw lines 1 and 2 of the hair to set up the rest of the sketch. Enhance head shapes for a more interesting sketch. You could shorten the back and make it a tall, skinny head, or lengthen the back to create a huge cranium.

3 **Start Adding Features**
Draw the eyebrow and eye shape. If you can't see parts of the eye, don't draw them. You can emphasize other areas of the face to balance the smaller features.

4 **Add More Features**
Add the nostril and cheek using your anchor and pivot points. Notice the distance between the nose and the upper lip? This is an important characteristic to capture.

5 **Finish and Refine the Features**
Try to capture the mouth characteristics. The lips are large, but there will be no mistaking it for lipstick on this face. It fits in perfectly.

6 **Add the Neck**
Complete the sketch, adding the Adam's apple. The eyes, nose and mouth are not the only features that you can emphasize.

Drawing a Complex Profile

Sometimes the profile line is very complicated because of strong features. Don't rush on this sketch. Slow down and tackle each section individually. You want those unique features to stand out, but they also have to go together!

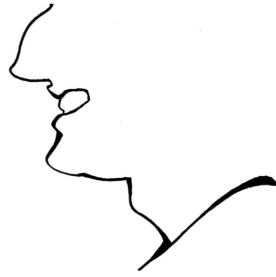

1 Draw the Structure

Plan carefully and establish which features stick out the most or the least. Relate everything else to those points. The eyebrow and the nose can provide the anchor points for the rest of the profile line. Here, we start with the top of the nose because the brow will be hidden by the man's hat.

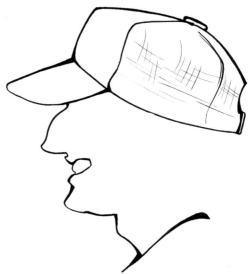

2 Add the Hat

Draw the hat as the hairline. Memorize how to draw hats. You can repeat the same basic hat shape for each sketch. Then later it's easier to add more detail to the hat.

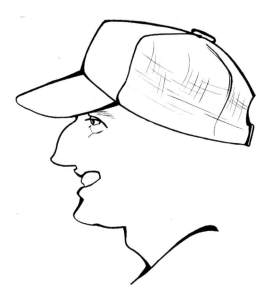

3 Start Adding Features

Add the eye area. If the eyebrow is under the hat, leave it out. Be sure to get the eye color indication correct.

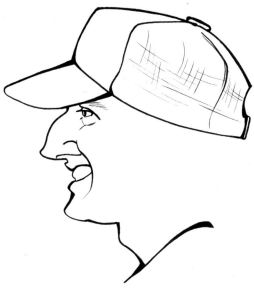

4 Add More Features

Draw the nostril and cheek line. It's plain and simple if you follow the anchor and pivot points you've established.

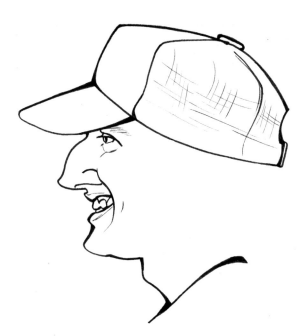

5 Finish and Refine the Features

Add the lips, teeth, gums, dimples and any other minor features of the mouth.

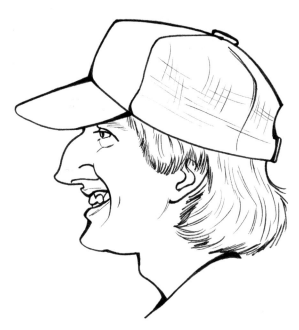

6 Add the Hair and Final Details

Add the hair and the part of the ear that shows. Draw the hair color, volume and texture correctly. Notice that the neck was completed in step 1 when we established the most and least prominent features of the face (his Adam's apple is pretty noticeable).

Using Heavy Pencil Lines

When sketching with markers, you can easily achieve different line thicknesses. In pencil, you have to go back over and thicken the lines where you want emphasis. Be sure to keep it stylized—don't start sketching realistically.

Savor Stray Lines

There may be stray lines in your sketch that you want to erase. Leave them. Comic portraits are quick and spontaneous! These stray lines add character to your drawing. If you make that big of a mistake, start over.

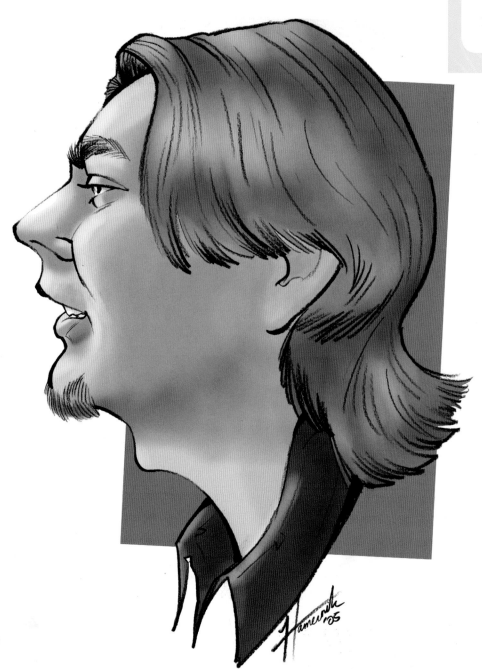

1 Draw the Structure
Draw the profile line. Think about how much room you will need for the rest of the head. Go back over and thicken any areas that you want to emphasize.

Visit www.impact-books.com/cartoonfaces for free bonus demonstrations.

2 Add Hair

Draw line 1 of the hair. "Line" 1 does not mean it is made up of one continuous stroke. Use as many as you need to get the look of the hair. Line 2 is a simple shape. Break up the hairline (in this case, near the forehead) to show the length of the hair.

3 Start Adding Features

Draw the eyebrow, following the direction that the hairs grow. Then add the eye.

4 Add More Features

Add the nostril and the cheek line. Notice that the same line has been used on every profile sketch so far. What changes is the angle and the distance.

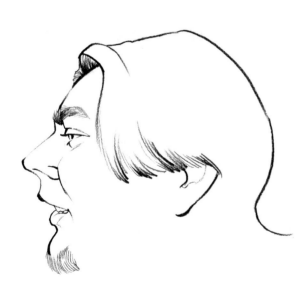

5 Finish and Refine the Features

Draw the mouth. If the lips are very small, you can leave off one or both of them. This is another form of exaggeration.

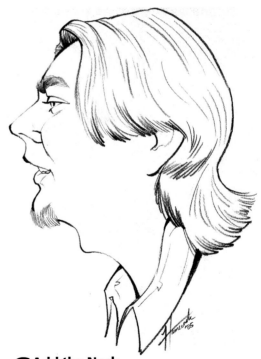

6 Add the Neck

Finish the sketch by completing the hair shape first, then the neck line and the collar. Add any decorative strokes last.

Drawing Long, Long Hair

Long hair can be really challenging, so plan ahead. If you want to draw all of the hair, you will have to draw a much smaller head so that it all fits. If you are sketching with a thick marker, a small head may be hard to draw. On the other hand, if you are drawing with a thin pencil, drawing all that hair may take a long time. And remember, you will have to color it all in later. Consider these things before you set out to draw.

Losing the Long Hair

Draw from a three-quarters view or front view if you want to de-emphasize the hair.

1 Draw the Structure
Start with the profile line. You can incorporate the forehead with this line if you like.

Visit www.impact-books.com/cartoonfaces for free bonus demonstrations.

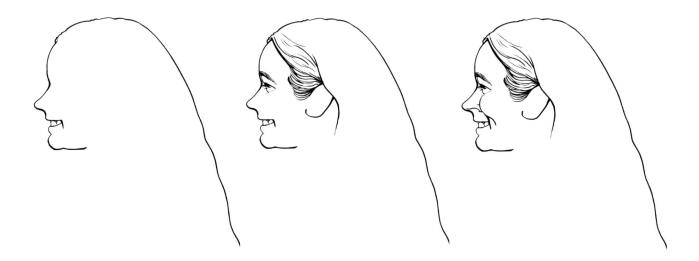

2 Add the Hair

For very long hair, draw line 2 of the hair first so you will know how much hair will actually fit on the page. You can also compare it to the head to get the look you are trying to achieve.

3 Start Adding Features

Add line 1 of the hair. Include the ear as part of line 1. Draw the hair in sections, adding some decorative lines as you go. Draw the eye next.

4 Add More Features

Add the details on the nose and the cheek line. Watch for overlaps such as the cheek and the nostril. Double up the smile lines, too.

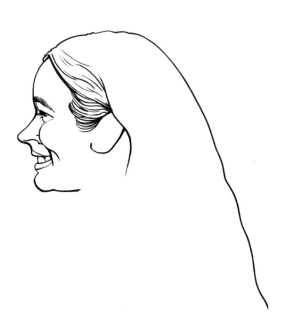

5 Finish and Refine the Features

Add lips to the mouth. This should be the only thing you have left to add to the mouth area at this point.

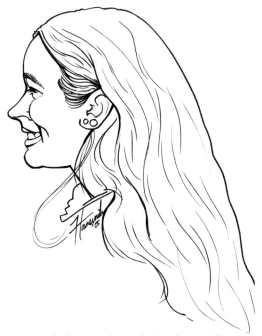

6 Add the Neck and Final Details

Finish the hair by adding decorative strokes. Remember, the hair will probably end up being the most important part of the sketch. Complete the sketch by drawing the neck and collar.

Full-Figured Subject

There are all types of people and figures. Don't be afraid to try something new! By practicing different figures, you'll be able to draw a full range of characters. When drawing full-figured subjects, the neck is an important part of the sketch. Compare where the neck lines up in relation to the other features.

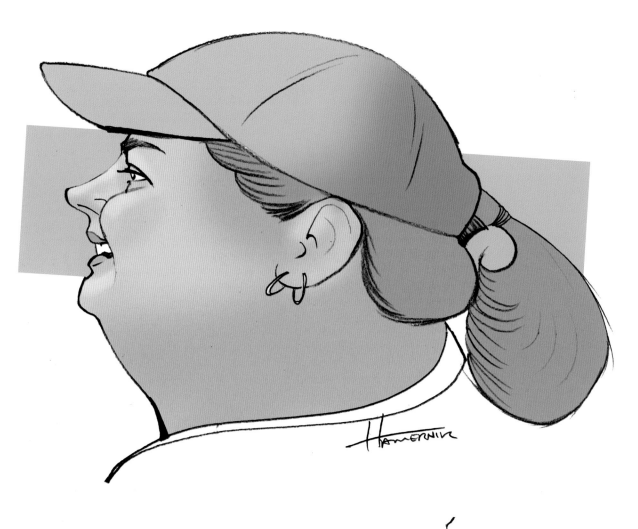

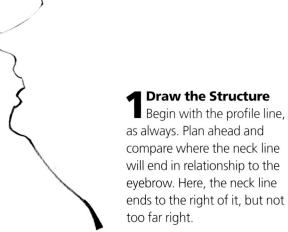

1 Draw the Structure
Begin with the profile line, as always. Plan ahead and compare where the neck line will end in relationship to the eyebrow. Here, the neck line ends to the right of it, but not too far right.

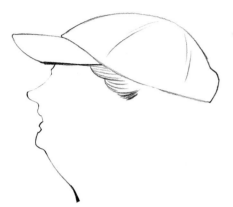

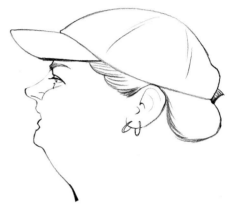

2 Add the Hat
Hairlines 1 and 2 are made up of the hat lines. Add the hair where it shows under the hat, toward the ear.

3 Start Adding Features
Develop the hair and add detail to the ear. Then add the eyebrow and eye, and work your way down the face.

4 Add More Features
The nostril and cheek line are easy to draw; however, note how the cheek covers the nostril a bit.

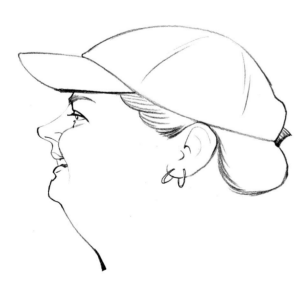

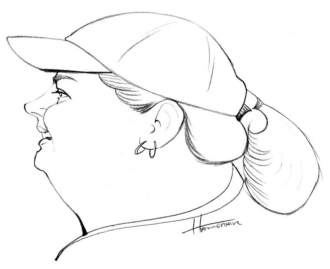

5 Finish and Refine the Features
Catch all the details of the mouth, including any quirks. These quirks give the sketch character.

6 Finish the Hair and Final Details
Finish the hair by including the ponytail that extends from the back of the cap. Then add a simple collar.

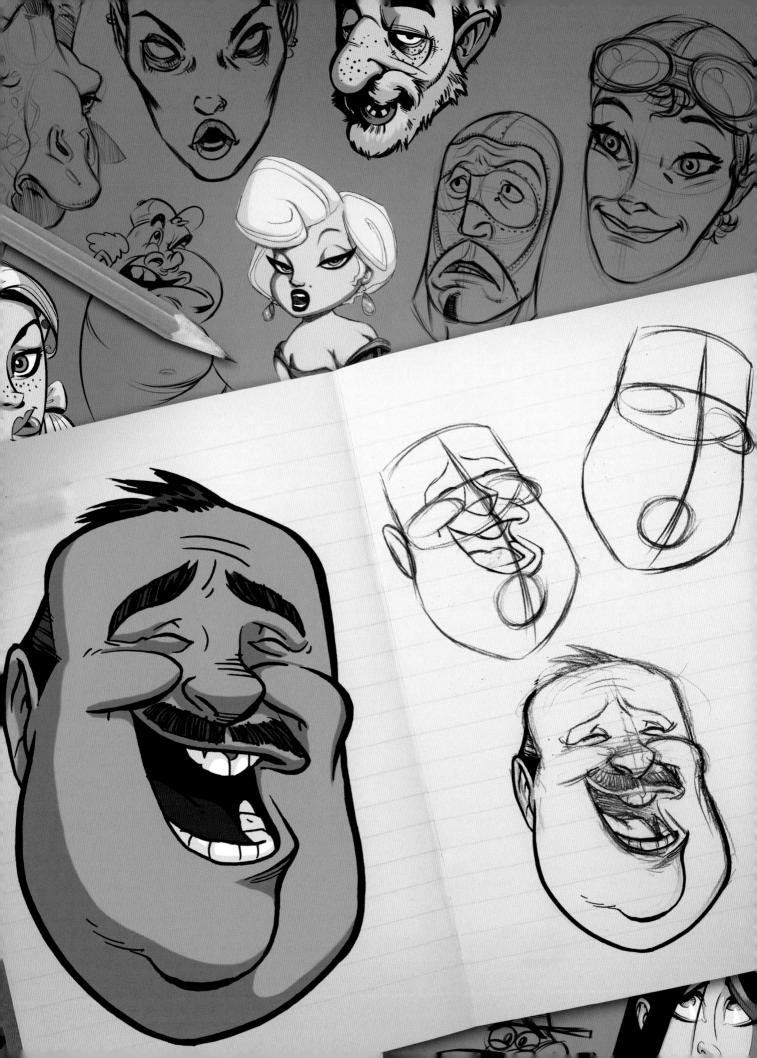

3

Scenarios & Characters

Let's look at creating specific expressions step-by-step. We've included demonstrations on how to draw multiple expressions. Because context is so important to expression, we've grouped the demonstrations into scenarios. Each scenario is a scene where we see different expressions from a single character as they react to the world around them.

This format gives you the opportunity to see how a face changes from expression to expression. You also learn how expressions can help move a story along, frame-by-frame, in comics books, animation and other forms of visual storytelling.

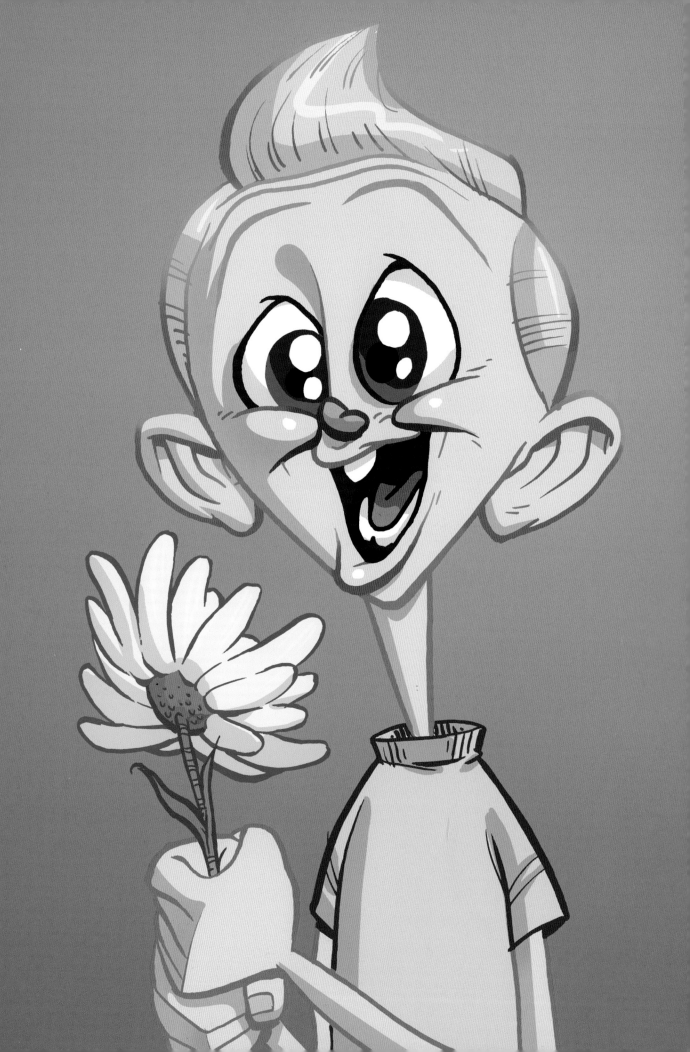

Billy Finds a Flower

We'll start our scenarios by telling the story of Billy finding a flower. Brandon will show you how to draw some simple expressions such as happy and sad, but will also introduce some subtle variations.

Joyful

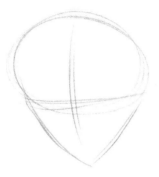

Artist's Note

I wanted to start with some expressions that are simple and generic. That way there's something to build on for variations. Because we're looking at simple expressions, I also wanted to use a simple character design that is easy to understand and duplicate in terms of structure and form.

The expressions for this scenario are also exaggerated to make them clear and readable, and to make the elements that typify them obvious.

That's why Billy's eyes and mouth are gigantic. Since most expressions are communicated through the eyes and mouth, it should be very easy to see what's going on.

1 Draw the Basic Structure
Start with a simplified head shape, but give the jaw some more length. The mouth is going to open, so you want to stretch the face out. Add your construction lines.

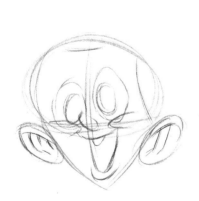

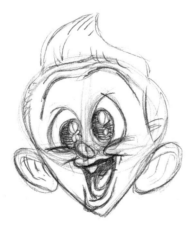

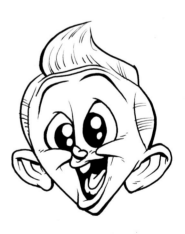

2 Rough In the Features
Make the expression big. Draw his eyes wide and his eyebrows high, and open his mouth to exaggerate the smile. Draw his cheeks squished up high in his face by the power of his smile. Indicate the details inside his mouth.

3 Add Details
Think of your drawing as if you were throwing a rock in a pond. The big shapes are the rock; they go in first and send ripples of details across the face. Indicate how the movements of the big shapes pull and twist the face around them. Finally, add Billy's shock of hair.

4 Clean Up
Clean up the artwork. Make sure your lines taper at the ends. This will make them feel like they're wrapping around the form instead of lying flat on the paper.

Happy

Billy is a pretty generic character. He's an innocent, well-meaning kid—nothing too specific or unique there. He provides a good place to start creating simple expressions.

Let's suppose Billy is strolling through a lovely meadow. The air is crisp and fresh. A smile breaks out across Billy's face.

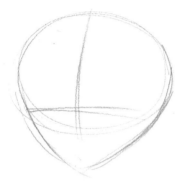

1 Draw the Basic Structure
Draw a simplified version of the head shape. The cranium in this case is a squashed oval, and the jaw is pointed. Draw your construction lines, indicating the middle of the head and the eye line.

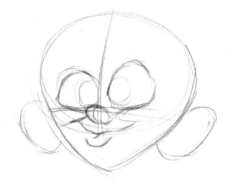

2 Rough In the Features
Make the features a little bit asymmetrical. Draw the corners of the mouth pulled up in a smile, and give the smile some twists and turns to show he's kind of sticking out his bottom lip, too. Draw his eyes big and wide, and place his irises close together to show his naive and goofy personality.

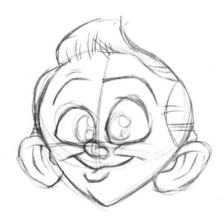

3 Add Details
Now that you have the main features roughed in, start adding details. Remember to wrap your details around the form. Use them to describe the bigger shapes. Draw in his hair. It's like a tidal wave cresting on top of his head. Add the raised eyebrows to accentuate his wide-eyed stare.

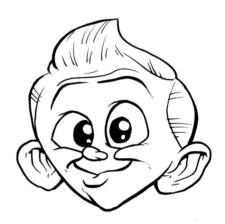

4 Clean Up the Sketch
You can use felt-tip markers, a brush and ink, or clean up the drawing digitally. I used felt-tip markers and a brush marker here.

Use thicker lines for the larger shapes and thinner lines for smaller shapes. Also, use thick lines for areas of focus, such as the eyes and mouth. Use your smallest lines for details that describe the form, such as the detail of Billy's hair and the lines on his forehead.

Visit www.impact-books.com/cartoonfaces for free bonus demonstrations.

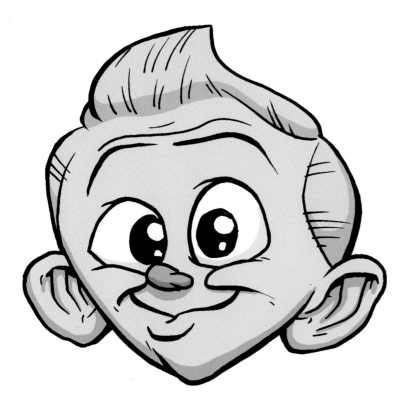

5 Add Color

I wanted to use color that would work for animation, and I wanted it to feel as though Billy were being bathed with sunlight. To give it the animation feel, all the shadows have an equally hard edge; there are no subtle changes in value. This also helps sell the daylight feeling. The colors in the shadows are warmer than the colors in the light areas, which also helps to make it feel like daylight.

Artist Variations - Happy

Bronze:
I tried to think of the happiest person I know...and here he is.

Gibbs:
When I was drawing this, I was thinking that happy can be pretty simple, if not subtle.

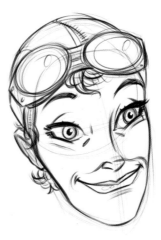

Ben:
Happiness comes in all different ways. Hers just happens to come from shooting down the enemy in a deadly 1920s aerial dogfight. Isn't she pretty?

About to Sneeze

What Billy doesn't know is that he's allergic to flowers. He picks up the flower and gets a hearty snoutful of pollen. He tries to hold back a sneeze, but he can feel it coming.

In this demo, you're going to draw an involuntary bodily reaction. Any emotion Billy is feeling is obscured by his body telling him he has to sneeze.

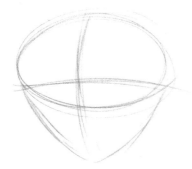

1 Draw the Basic Structure
Start with the modified head shape again. Squash it a little bit to show the tension Billy's face is holding before he sneezes. The head is also going to be tilted back here, so rotate your eye line up a bit.

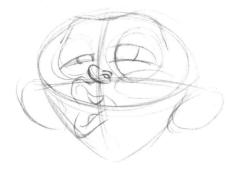

2 Rough In the Features
Make the features asymmetrical to show the high energy and imbalance of this expression. Draw his lips puckering out to one side. Draw his nostril flaring to show that he's inhaling before he sneezes.

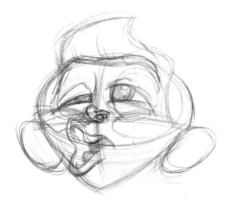

3 Add Details
Wrap the eyelids around the form of the eyes, and darken the mouth to show depth. Add the hair.

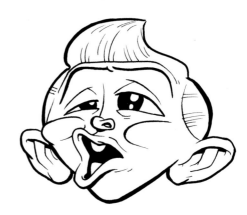

4 Clean Up the Sketch
Clean up the drawing. Add smaller detail lines around the points of tension in his face.

Visit www.impact-books.com/cartoonfaces for free bonus demonstrations.

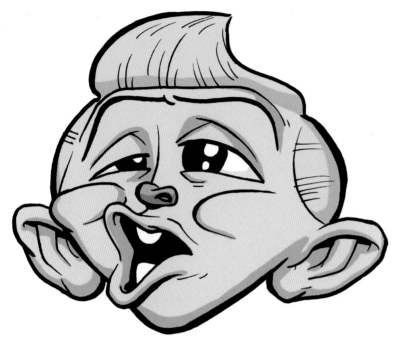

5 **Add Color**
A little color finishes things off. Now all you have to add is the prairie animals running for cover.

Artist Variations - The Sneeze

Gibbs:
Getting ready to sneeze can be pretty tricky. The face can contort and twist in so many ways that the more asymmetrical you can make the face, the better.

Ben:
The desert does strange things to a man—and one of them is sneezing.

Sad

Billy, with a single sneeze, has now destroyed the one thing he loved the most. The flower that had once filled his heart with joy is now a ruin of scattered petals. The grief is more than Billy can bear.

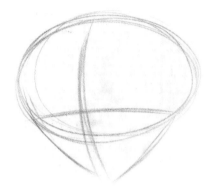

1 Draw the Basic Shape
Start with an oval head shape. Draw the construction lines so the eye line is at a normal level again.

2 Rough In the Features
Draw the shape of the eyes with the eyelids closing on the irises. Draw a standard frown mouth shape with the corners pulled down.

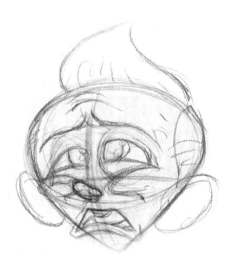

3 Add Details and Strengthen Forms
The eyebrows are important here. Draw them so they push up the middle of the head. Strengthen the most important forms, especially the eyes and the mouth. Add indication of the teeth inside the mouth. Finish with the soft-serve ice cream hair.

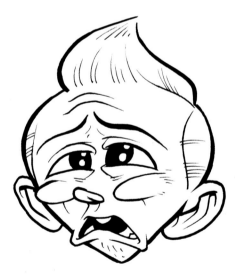

4 Clean Up the Sketch
Once again, clean up the expression. Keep your focus on the overall shape of the face and the important elements of the expression. Add details around the eyes, on the cheeks and on the chin to describe the tension in the form.

Visit www.impact-books.com/cartoonfaces for free bonus demonstrations.

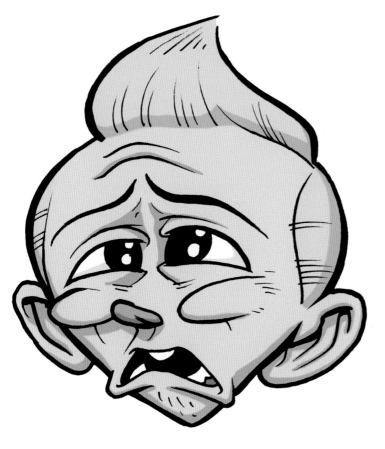

5 Add Color
You can use your coloring to make the forms more three-dimensional. Shadows should do the same thing as details on the face: wrap around the form.

Artist Variations - Sad

Gibbs:
Sad can also vary depending on the context of the character. Here, it's as if he just found out that his goldfish died.

Ben:
He finally broke down from the barrage of fat jokes, and then everyone felt severely ashamed.

Bronze:
His kitten ate his goldfish, and then his kitten died. Sad.

The Villain

In this scenario, Gibbs will explain how to properly draw the facial expressions of a villain. We'll develop faces that look conniving, angry and deep in thought. We will then see who is possessed with the spirit of a great artist.

Conniving

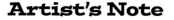

Artist's Note

When I approached work on the various expressions of a villain, I immediately decided to go with someone who was intellectual and clever. I thought he would be the perfect foe for a brutish hero.

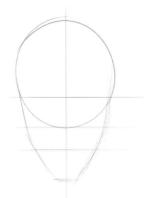

1 Draw the Basic Structure
Draw a circle for the cranium and a "U" shape for the jaw. Add construction lines for the eyes, nose and mouth.

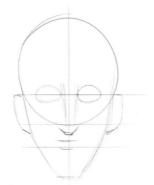

2 Rough In the Features
Lightly draw the eyes as ovals and the shape of the nose and ears.

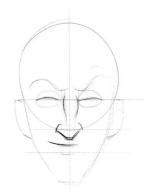

3 Add Details
Add heavy lids and a raised brow to indicate that he knows something we don't.

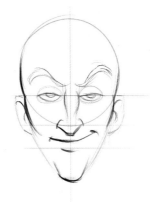

4 Refine the Features
Draw the smile and add some more form to his face. Add slight details to the ears and face.

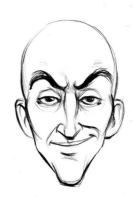

5 Darken and Clean
Darken and clean up the lines, using thicker lines where your shadows will be. Notice how the villain's left cheek wrinkle is darker than his right. Look out, hero!

Angry

The villain has been foiled by the hero once again, and he is angry. Once I was foiled; I was so furious it took three grown men and one orangutan to snap me out of it.

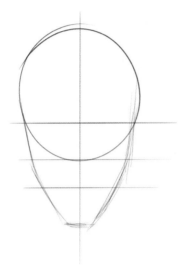

1 Draw the Structure
Draw a circle for the cranium and a "U" shape for the jaw. Add construction lines for the eyes, nose and mouth.

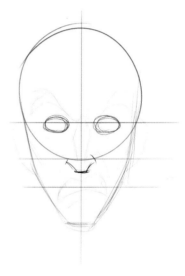

2 Rough In the Features
Lightly draw the shapes of the features. A squinched brow and lowered corners of the mouth express anger. An open mouth makes him look even angrier.

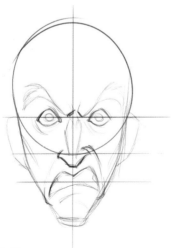

3 Add Details
Add detail to the nose and eyes. Leave some white showing between the irises and the eyelids to show the intensity of the expression.

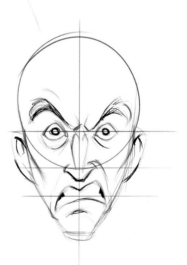

4 Refine the Form
Refine the form of his face by adding some contours to the sides using thin and thick strokes. Add more details to the ears and face.

Visit www.impact-books.com/cartoonfaces for free bonus demonstrations.

6 **Add Highlights and Shadows**
Make sure you know where your light source is so you know where to put the shadows. Wrap the shadows and light around the form so it doesn't look flat.

5 **Clean Up**
Darken the lines and add subtle shading to define the contours.

Artist Variations - Angry

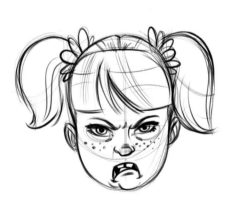

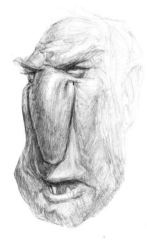

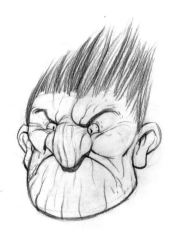

Ben:
They were warned not to touch Polly's princess scooter. Now they're gonna pay.

Bronze:
Apparently long noses and anger mix well.

Brandon:
To me, anger is all about tension. I wanted to use all the details to show how angry energy is compressing his face into a tight packet.

Deep in Thought

The villain tries to figure out what he can do for revenge. He slowly formulates a plan to cover the hero's toilet seat with plastic wrap—that'll get 'im.

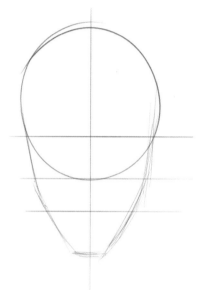

1 Draw the Basic Structure
Draw a circle for the cranium and a "U" shape for the jaw. Add construction lines for the eyes, nose and mouth. Starting to sound familiar?

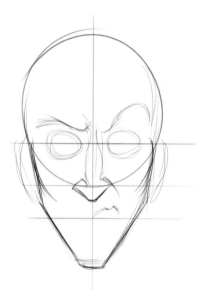

2 Rough In the Features
Lightly draw his pointy nose, eye sockets and tight lip. Give him one raised brow. Add a hint of form in the head.

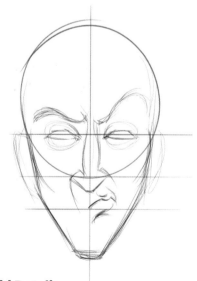

3 Add Details
Draw squinting eyelids. Then add lines around the nose and mouth to show how the mouth is pushed out toward the side. He is frozen in thought.

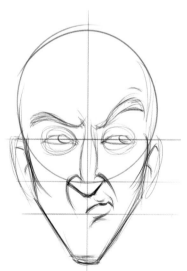

4 Refine the Features
Draw the eyeballs looking toward the side to indicate that he's thinking deeply and seriously. Add slight details to the ears and face.

Visit www.impact-books.com/cartoonfaces for free bonus demonstrations.

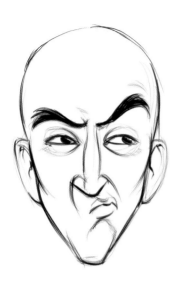

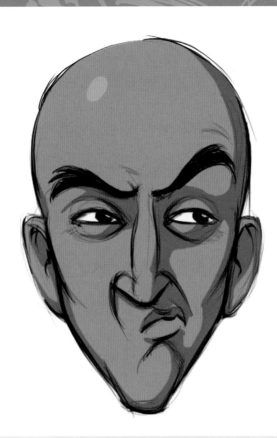

6 Add Color
Color and lighting can set a mood. To make things really dramatic, or to create a "horror" moment, color it so that the light source appears to be below or to the side.

5 Clean Up
Add details using a stroke that varies in width to bring in interest. Darken lines and add shading if desired.

Artist Variations - Deep in Thought

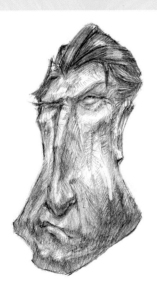

Bronze:
"Hmmm," he thinks to himself.

Ben:
"Pssh, 'Long neck!' I'll show those girls," she says.

Brandon:
There's some sort of link between a twisted-up mouth and thinking. I still haven't found the exact connection, but it's fun to play with anyway.

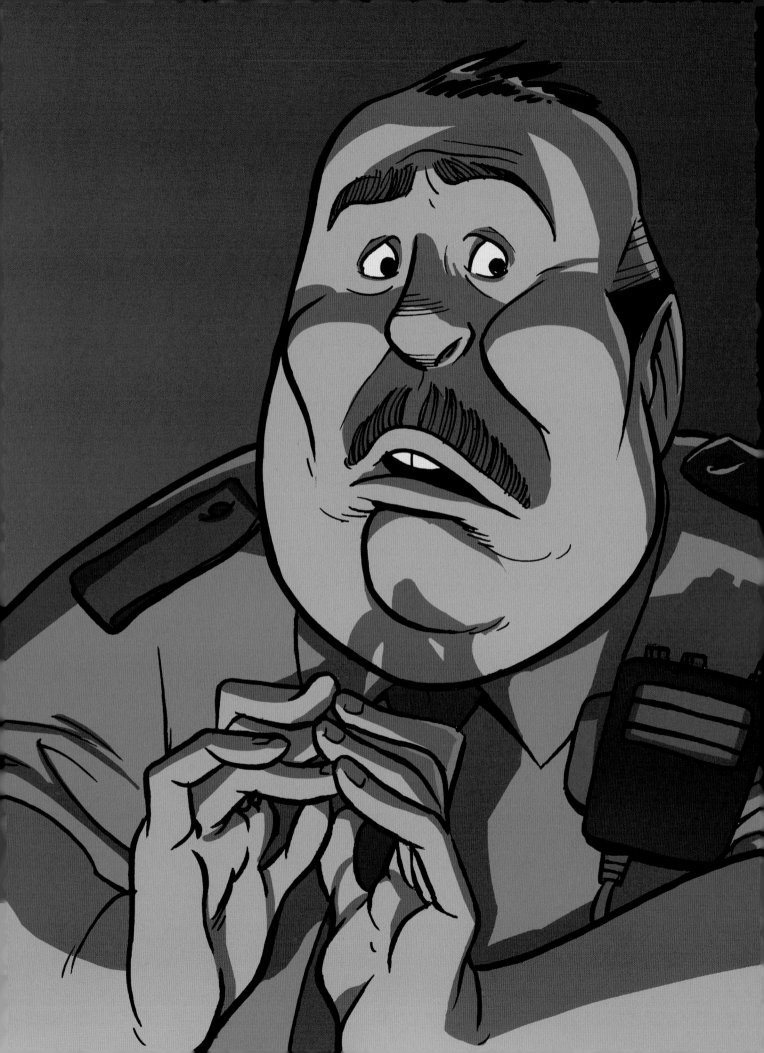

Stages of Fear

In this scenario, Brandon will use a typical security guard character to walk you through a range of emotions associated with fear. Our character's composure will slowly unravel. He can go from dread to laughter and then to terror.

Dread

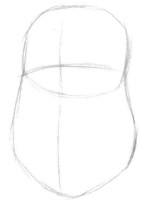

1 Draw the Basic Structure
Start with the block-shaped cranium and massive "U" shaped chin. Add construction lines.

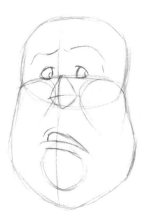

2 Rough In the Features
This expression needs to show potential: energy in reserve. He's scared, but trying not to let fear overcome him, so the expression won't be big. Rough in the nose. Draw the mouth with the corners dropped to show a hint of distress. Draw the eyes with the pupils looking in the direction of the creepy noise. With only the eyes changing direction, we see his concern with the noise and his hesitation to confront it. Draw his eyebrows raised in distress, and elongate the shape of the cheeks to show them being pulled down by the mouth.

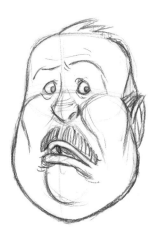

3 Add Details
Extend the shape of the cheeks to show how they interact with the frowning mouth. Add shape and a nostril to the nose and detail lines wrapping around, radiating out from the larger forms. Finish with the hair and mustache following the direction of the forms of the face.

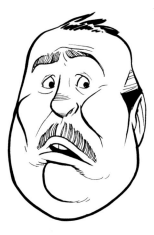

4 Clean Up
Ink the drawing. Indicate the hair with big, fast brushstrokes. If you're drawing on bristol board, it helps to wear a cotton glove with the fingers and thumb cut out. This will keep your hand from sticking to the surface and will help you make long, smooth strokes.

Artist's Note

I wanted to take a different approach for this scenario than I did for the one with Billy. The design for the security guard is more realistic and more along the lines of what you would see in a superhero comic.

Like Billy, the security guard is expressing some strong feelings, so the expressions shouldn't be too hard to read—but there are definitely more subtleties here. Looking at the details that distinguish them is a worthwhile exercise.

Laughter

Let's do an expression that contrasts sharply with fear: laughter. It's a relaxed, safe and confident expression, so when we switch to fear, the contrast will make the fear seem even stronger.

Our security guard is on the radio with one of his buddies, joking about how bad his wife's cooking is. He lets out a hearty laugh.

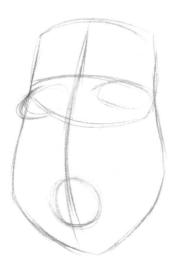

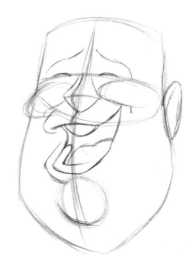

1 Draw the Basic Structure
Make the cranium more like a square block than a sphere. Next, make the jawline a big fat "U" shape to make room for his double chin. Add your construction lines. The eye line should fit inside the cranium. Offset the centerline for this modified three-quarters view. Using the centerline as a guide, indicate where the actual chin sticks out of the double chin. Rough in the large masses of the cheeks.

2 Rough In the Expression
This is where you need to spend the most time to get it right. Draw the eyes closed with simple curves. Draw the nose, indicating the form with construction lines. Add a smile: wide-mouthed and pushing up the cheeks. Indicate the placement of the ears.

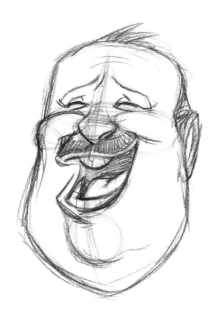

3 Add Form and Detail
Reinforce the important forms with thicker lines. Thicken the lines under the chin to emphasize its weight. Indicate the shape of the eyeballs under the eyelids by having the eye folds sink into the face. Add detail to the mouth with a horseshoe shape to show the form of the bottom teeth and a half-moon shape for the top teeth. Add the hair and mustache, wrapping them around the shapes you've already established.

Visit www.impact-books.com/cartoonfaces for free bonus demonstrations.

4 Clean Up

For this demo you can use a brush marker and other felt-tip markers, or you can clean up your drawing digitally. Darken the areas of emphasis, and draw thicker lines at the bottoms of shapes to give them weight. Use your smallest strokes to show the little details.

5 Add Color

No big surprises, just some warm colors. I used hard edges rather than subtle shading to give it an animation look. To give it some extra pop, you could color the lines.

Artist Variations - Laughter

Gibbs:
Here is my version of a big, hearty laugh—maybe more of a guffaw.

Bronze:
Ha ha ha! It's so funny to be a tin man!

Terror

Let's suppose our security guard hears a strange noise and has the guts to investigate. He warily probes a utility closet with his flashlight shaking in his hand. All of a sudden, a mangled corpse drops from the ceiling. The shock of the body makes his hair stand on end, and he jumps back.

Terror is an extreme but momentary feeling at the climax of an unpleasant surprise.

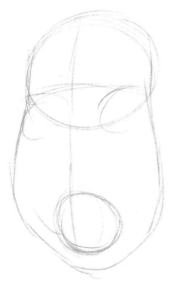

1 Draw the Basic Structure
Start with the cranium and jaw shape. Elongate the jaw this time, and push the real chin down farther into the double chin. Add the construction lines.

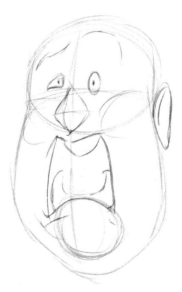

2 Rough In the Features
Draw the mouth as big as possible. Indicate the horseshoe shape of the bottom teeth and the half-moon of the top teeth. Pull the eyebrows up and the eyes open, but make them asymmetrical. This will help to make the expression look more out of control and energetic.

3 Add Details
Add a lot of details wrapping around the bigger forms to show the energy and exaggeration of this expression. Pay particular attention to how the eyebrows push up the forehead and how the chin and corners of the mouth push down on the bottom of the face and the double chin. Add the mustache and hair, making the hair stand on end to elongate the pose and add more energy to the moment.

Visit www.impact-books.com/cartoonfaces for free bonus demonstrations.

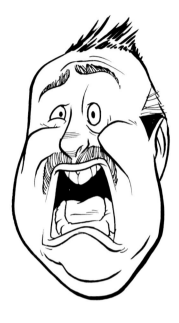

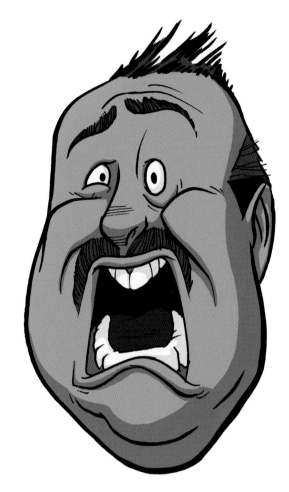

5 Add Color
Color is the icing on the cake. If you've created an effective drawing, coloring it is no sweat.

4 Clean Up
Use single, bold strokes originating from the wrist or elbow to ink over your sketch. Practice strokes on the side of the drawing before you commit to the cleanup.

Artist Variations - Terror

Ben:
A flesh-eating salty lake! What are we going to do?

Gibbs:
His eyes wide with terror, he gazes up at the giant beast.

Tuna for Lunch

"Not again," says Joey as he opens up his lunch box. "This is the third time this week!"

Let's learn along with Bronze as he stylistically shows us a glimpse into the dreadful daily life of a sixth-grader. We will explore the subtle expressions he shows when he feels annoyed, when something stinks and when he feels disgusted.

Annoyed

1 Draw the Basic Structure
Draw the head structure. I erased the jawline in my final drawing, leaving only the chin. I did this not because Joey is fat, but because he has one of those youthful, almost nonexistent jawlines.

2 Rough In the Features
In this expression his nose is pinched in, but his nostrils are flared and turned up. His brow is turned down and inward, but not too much or he'll look really angry. His lips come up toward his nose, past where the mouth construction line is. His lower lip is frowning, but the top lip is pulled up with his nostrils.

Artist's Note

I'm not going to lie. Drawing kids or youths is not my strength. I like drawing old people—wrinkly, ugly, old people because they have a lot of features to work with. Kids, on the other hand, have smooth, round faces, and if you throw in too many wrinkles or if they're too deep, then suddenly the kid you're drawing looks like he's forty.

For reference, I turned not to a mirror with my ugly face in it, but to the Internet for images of kids making the expressions I was after. Stock photography sites are a good resource, as are the sites of child photographers. Remember to use the images you find only as references; don't copy the pictures directly. References can help you stretch and develop your skills, but your drawings should be unique. All right—that's enough talk. Let's draw a kid!

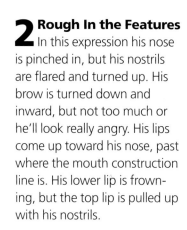

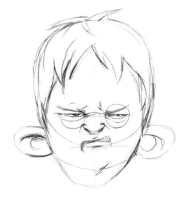

3 Refine and Add Details
Draw his upper eyelids as straight lines and have the lower lids dip slightly below those lines. Draw a few short, upward lines near the inside of the brow lines; these soften the angry look and makes his brow look more frustrated. Draw bags under his eyes that come from the nostril flare and his furrowed brow. Tilt his upper lip to one side and make sure the ends of his upper lip point down.

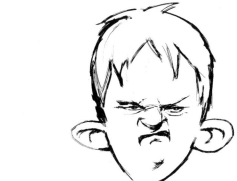

4 Clean Up
Finish by inking over your pencil lines. Try varying your line widths, making thicker lines where shadows would be. After the ink dries, erase your pencil lines.

Something Stinks

Joey is like any kid; he enjoys a good sandwich. But today his mom threw a tuna sandwich into his lunch box. "Why?" he asks, knowing there are perfectly good meats like bologna to choose from. As he peers inside his sandwich to assess the damage, the stink of tuna hits his nostrils, sending Joey's giant head rearing back.

Kids like Joey have some of the most expressive faces of all humans, but without the deep facial lines found on adults. Let's stretch and squash his face to get the expressions we need.

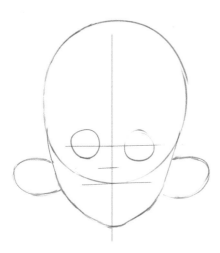

1 Draw the Basic Structure
Start with the basic head structure, using a circle for the cranium and a soft "V" shaped jaw with the sides angled toward a smaller chin. I drew huge ovals for Joey's ears, which makes him look goofier and younger. Draw construction lines for the eyes, nose and mouth. Kids generally have big craniums and smaller, rounder jawlines. Notice how small his features look in relation to his giant cranium.

2 Rough In the Features
Draw circles for his eyes fairly close to the centerline. Draw a long oval for his nose since he's pulling it up and pinching it to avoid more stench. I moved his lips down and puckered them by making the upper lip a subtle "U" shape and the lower lip a little oval underneath it. Draw two diagonal lines pointing inward and upward for his eyebrows, and just below those, add two smaller diagonal lines tilted just slightly more downward. Draw some shaggy hair just off his noggin.

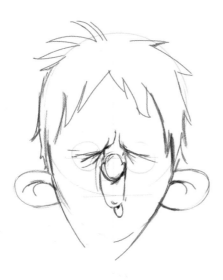

3 Add Details
Add wrinkles for his nostrils, making them look pinched. Draw more lines around his eyes to create a tight, squeezed look, and add some wrinkles above his nose to show it's being pushed into the bridge between his eyes. A little "U" shape above his upper lip makes his lip look more pushed out than tucked in. Add a few arching lines in the ear to roughly suggest ear anatomy. (Take some time to look carefully at an ear. Mentally break it up into simple shapes so you can later refer to those shapes in your head.)

Visit www.impact-books.com/cartoonfaces for free bonus demonstrations.

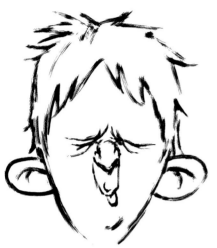

5 Add Simple Color

For color, just throw on something to give it texture—nothing fancy. This character is a little more stylized, and I want that to come through more than any color scheme.

4 Clean Up

Clean the drawing by inking over your pencil lines. I like to use a messy ink brush because it gives extra personality to my lines, and it works well with a drawing that's supposed to look stinky. You may want to make a few copies of your pencil drawing and practice inking over those until you get a good feel for your inking process. After the ink dries, erase your pencil lines.

Artist Variations - Something Stinks

Gibbs:
Perhaps he smells himself.

Ben:
Nothing is better than Mr. High & Mighty realizing that, after blaming everyone else, it's him who stinks.

Brandon:
I wanted to try something more subtle here. Maybe I should have added a stink line wafting into his nostril or made him cross-eyed.

Disgusted

Now that the stink has made it into Joey's brain, he stretches his mouth open and sticks out his tongue in disgust.

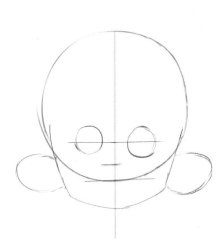

1 Draw the Basic Structure
Draw in the head structure. I usually draw the jaw where it would normally be in a closed position, and then draw a second jawline later to figure out a good range of motion.

2 Rough In the Features
His eyes and nose are similar in this expression, pinched in toward the centerline of his face. Notice how I've drawn a second jawline down farther to accommodate an open mouth. I moved his lips down and then opened his mouth with downward lines. His lower lip is hidden by his tongue, which is hanging out of his mouth. I didn't push the tongue out too far to avoid making him look as though he's about to vomit.

3 Refine and Add Details
Open up his nostrils now, but keep the oval, pinched look. Add lines around his eyes to create that tight, squeezed look and a few frown lines above his eyebrows to show tension in the eyes. Draw even stronger wrinkles above his nose to show it being pushed up.

4 Clean Up
Finish by inking over your pencil lines, trying to follow the most important and strongest pencil lines you've made.

Visit www.impact-books.com/cartoonfaces for free bonus demonstrations.

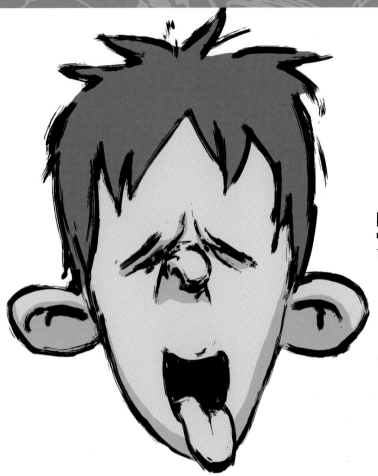

5 Add Color
Add a little color to give this bad boy some life.

Artist Variations - Disgusted

Gibbs:
For this I thought of the face I made when I ate bad sushi.

Ben:
Have you ever tried monkey food? It's disgusting!

Brandon:
I was thinking along the lines of self-righteous disgust here. For me, it adds some interest to have this guy reacting to another character.

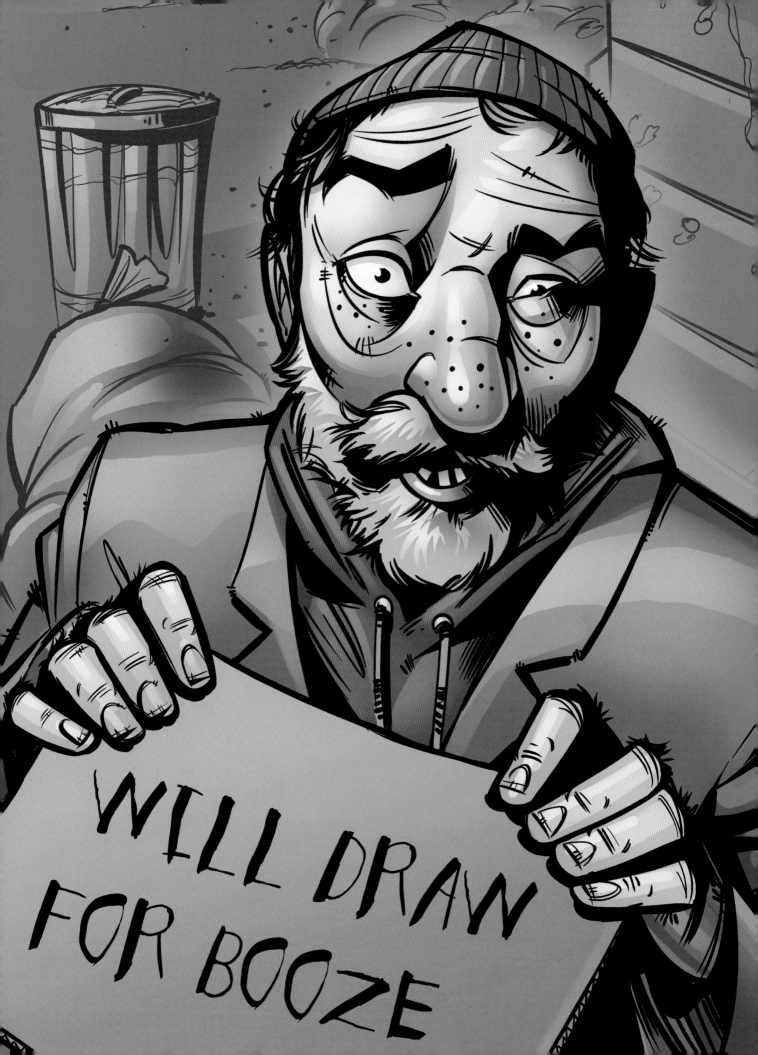

The Hobo

In this scenario, Ben will describe the dynamic facial expressions for crazy, yummy, drunk and hung over, as shown through the daily life of our hobo, Stinky Joe. Warning! Booze will severely handicap your drawing abilities, especially when it comes to detail. Now, let's have some sober fun!

Crazy

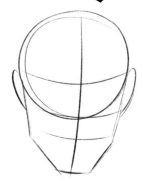

1 Draw the Basic Head Structure

Draw a circle for the cranium and a "U" shaped jaw with the sides angled to the chin. Block in the ears using thin ovals. Include the construction lines for the face. Notice that the centerline is slightly curved and off center, and that the construction lines are curved down. This will make the head more dynamic.

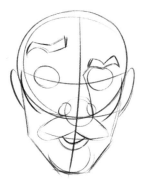

2 Rough In the Features

Draw the nose using one large circle and two smaller ones. Draw the bridge of the nose with a single line. Draw two circles for the eyes. Then draw two slightly tilted ovals for the mustache. Below that draw three half-circles; two smaller ones for the mouth and one large one for the chin. Indicate cheekbones by drawing two half-moons on either side of the head. Draw the eyebrows using long rectangles formed into "S" shapes with one higher than the other.

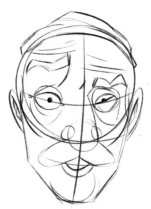

3 Refine the Features

Begin adding expression by drawing one eye closed more than the other. Draw lines for the wrinkles on the forehead and bags under the eyes. Complete the inside of the ears by drawing a few vertical lines. Draw the beanie cap, using sweeping lines for the folds.

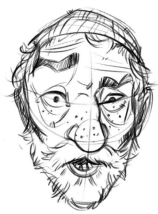

4 Add Details

Now erase your construction lines and add detail for the hair, more small wrinkles, dots for the nose and cheeks, and ribbed lines for the beanie cap. Draw three gapped teeth, then darken the eyebrows, mouth and eyelashes. Add shading under the cheekbones and define the bridge of the nose by adding a bump.

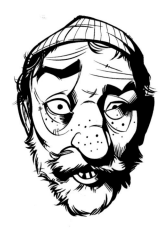

5 Clean Up

Clean up the drawing by inking your lines. Add shadows by filling in the right side of the face, around the eyes and under the nose. Let the ink dry, then erase the pencil lines.

Yummy!

What luck! After rummaging through some trash, Stinky Joe finds a bottle of liquor and spends several minutes savoring the thought of pouring it down his gullet. His tongue licks his lips while his wide eyes stare in amazement.

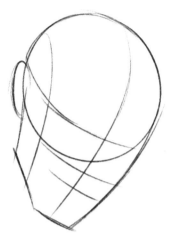

1 Draw the Basic Structure
Draw the same basic head structure, but this time rotate and tilt the head for a lower three-quarters view.

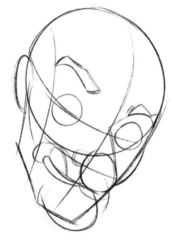

2 Block In the Features
Block in the basic shapes of the face. Draw the tongue using a half-circle coming up from the bottom lip. Draw the mouth closed and wide. Draw a circle for the chin sticking out from the structure. Make sure your shapes correspond to the angle of the construction lines.

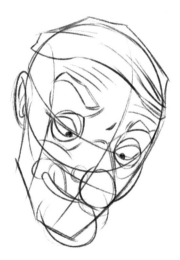

3 Add Rough, Expressive Features
Begin adding expression by drawing in the shape of the eyes with dots for the pupils. Draw lines for the wrinkles on the forehead and bags under the eyes. Draw a line on the cheek that cuts off the lower bag under his right eye. Complete the inside of the ear by drawing a few vertical lines. Draw in the beanie cap and use sweeping lines for the folds.

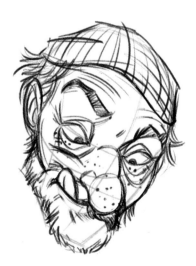

4 Add Details
Now add the detail of hair, more smaller wrinkles, dots for the nose and cheeks, and ribbed lines for the beanie cap. Darken in the eyebrows, mouth, eyelashes and lines around the tongue. Add shading under the cheekbone and nose, then define the bridge of the nose by adding a bump.

Visit www.impact-books.com/cartoonfaces for free bonus demonstrations.

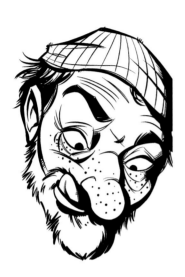

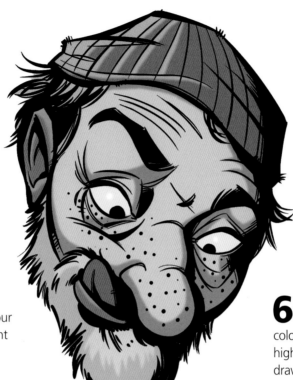

5 Clean Up
Clean up the drawing by inking your lines. Add shadows by filling in the right side of the face, around the eyes and under the nose. Let the ink dry, then erase the pencil lines.

6 Mmm! My Favorite!
For these demos, I have kept the coloring fairly simple, emphasizing highlights and shadows. For your own drawing, try playing around with some other lighting and color combinations.

Artist Variations - Yummy!

Gibbs:
When I was drawing this, I was imagining a pig looking at a plate of pork chops.

Bronze:
Fine dining by a fine gentleman.

Brandon:
I wanted to see if I could show yummy without using a tongue. I guess you could interpret this as just happy, but I like to think there's something about his gaze that suggests something more specific.

Drunk

Having downed a fifth of gin, Stinky Joe is now drunk off his rocker and pestering the pigeons as he stumbles along the alleyway he calls home. His eyelids are heavy, covering glossed-over eyes. His smile lifts the bags underneath them.

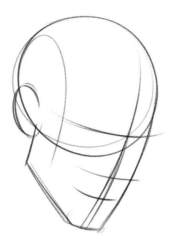

1 Draw the Basic Structure
Draw the basic head structure, tilting it down again, but this time rotating it even more.

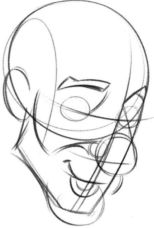

2 Block in the Basic Shapes
Block in the basic shapes of the face. Draw the mustache using curved lines for the top and side. Draw a full circle for the right eye, even though most of it will be hidden. Draw the mouth gaping open using two half-circles. Draw another circle sticking out for the chin. Make sure your shapes correspond to the angle of the construction lines.

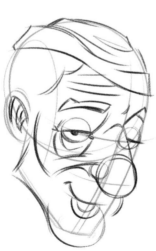

3 Refine the Features
Begin adding expression by drawing the shape of the eyes and dots for the pupils. Draw lines for the wrinkles on the forehead and bags under the eyes. Draw a line on the cheek that cuts off the lower bag under his right eye. Draw a curved line on the left corner of the mouth to show his smile. Complete the inside of the ear by drawing a few vertical lines. Draw the beanie cap using sweeping lines for the folds.

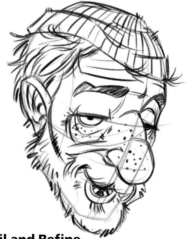

4 Add Detail and Refine
Add details for the hair, more small wrinkles, dots for the nose and cheeks, and ribbed lines for the beanie cap. Draw three gapped teeth, then darken the eyebrows, mouth and top eyelashes. Add shading under the cheek-bone and nose, then define the bridge of the nose by adding a bump.

Visit www.impact-books.com/cartoonfaces for free bonus demonstrations.

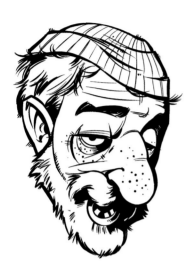

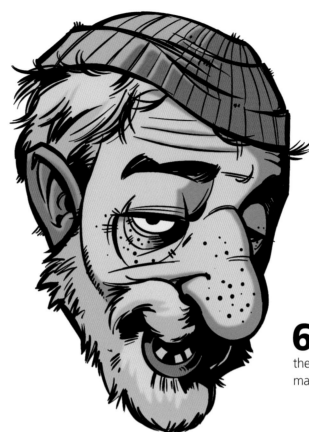

5 **Clean Up**
Clean up the drawing by inking your lines. Add shadows by filling in the right side of the face, around the eyes and under the nose. Add some extra lines on the top eyelids. Let the ink dry, then erase the pencil lines.

6 **One Too Many**
Now that you've nailed the expression, complete your masterpiece with some color.

Artist Variations - Drunk

Brandon:
I played around with this one a little bit before it felt totally right. The features that seemed to make it work were the underbite and the curled up smile. The crossed eyes also help to sell it.

Gibbs:
For this, I just wanted to draw a drunk lug.

Bronze:
Drunk fun! No, wait—it's not fun.

Hung Over

After a night of heavy drinking, Stinky Joe is now hung over. He leans against the brick wall, his ears ringing ever since he opened his eyes. His face is long, and his skin hangs loose on his skull. His eyelids are heavy, and he's lost the strength to close his mouth.

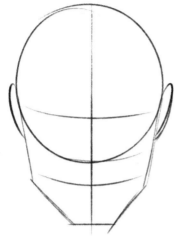

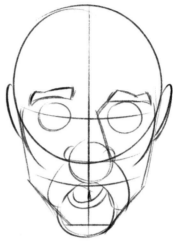

1 Draw the Basic Structure
Draw a circle for the cranium and a "U" shaped jaw with the sides angled toward the chin. Block in the ears using thin ovals. Include the construction lines for the face. Notice that the construction lines are slightly curved down.

2 Rough In the Features
Draw the nose using one large circle and two smaller ones. Draw the bridge of the nose with a single line. Draw two circles for the eyes. Add curved lines on either side of the nose for the mustache. Below that, draw three half-circles: two small ones for the mouth and one large one for the chin. Indicate cheekbones by drawing two half-moons on either side of the head. Draw the eyebrows using long rectangles with dents on the top.

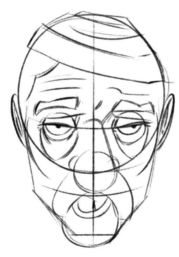

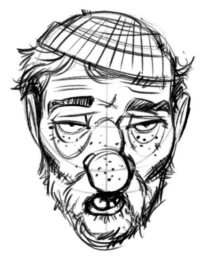

3 Refine the Features
Begin adding expression by drawing heavy eyelids and offset pupils. Draw lines for the wrinkles on the forehead and oval bags under the eyes. Complete the inside of the ears by drawing a few vertical lines. Draw the beanie cap using sweeping lines for the folds.

4 Add Details
Add details for the hair, more small wrinkles, dots for the nose and cheeks, and ribbed lines for the beanie cap. Draw three gapped teeth, then darken the eyebrows, mouth and eyelashes. Add shading under the cheekbones and define the bridge of the nose by adding a bump.

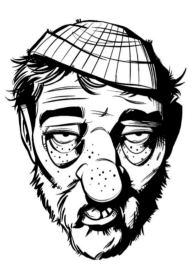

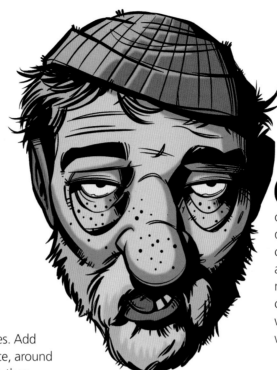

5 Clean Up
Clean up the drawing by inking your lines. Add shadows by filling in the right side of the face, around the eyes and under the nose. Let the ink dry, then erase the pencil lines.

6 Rough Morning
Add mood to the character by rendering your drawing in color. I used a computer and software that allows me to color underneath my ink work, but you could use colored pencils, watercolors, markers or whatever. Just color away!

Artist Variations - Hung Over

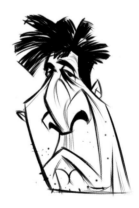

Brandon:
This is how I look most mornings—and I don't even drink!

Bronze:
But man, the stories he has to tell.

Gibbs:
Just woke up after some heavy drinking.

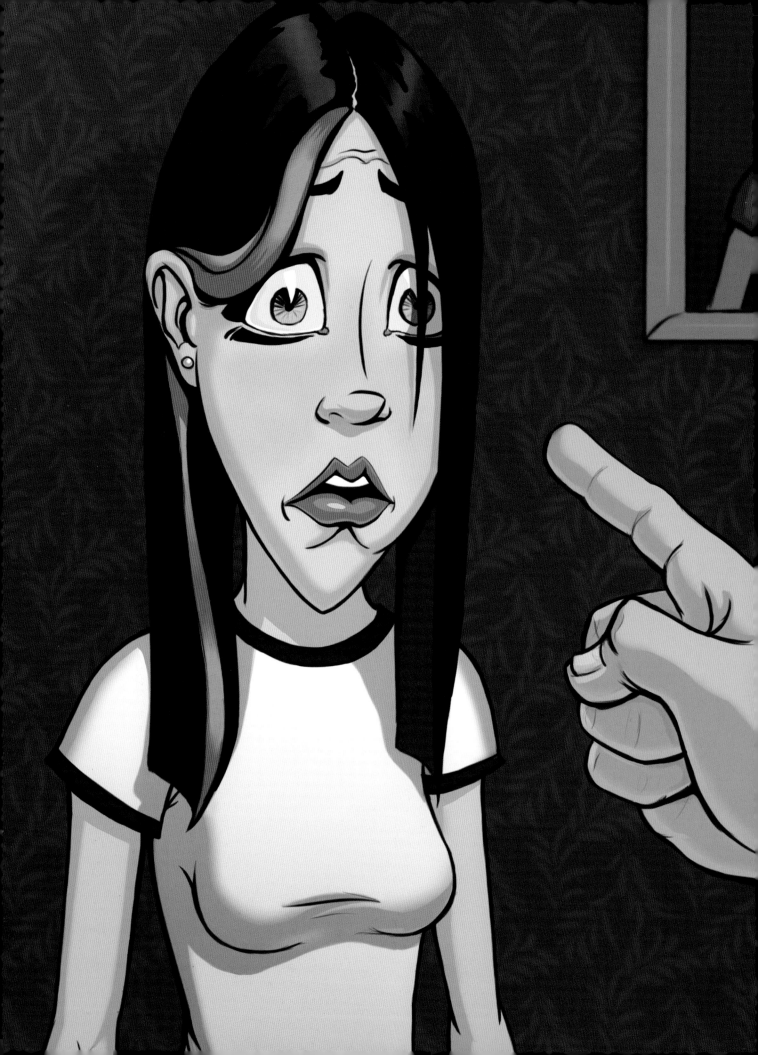

Gina Gets a Lecture

So, like, now Blake is going to draw expressions for, like, a teenage girl. Gina is an "emo" girl, so emotions are her trademark. She normally ignores her dad—until he lays down the law.

Dumbfounded

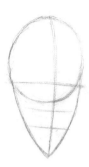

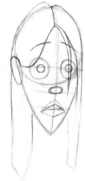

1 Draw the Basic Structure
Draw the circle for the cranium. In this drawing, her mouth will be open a bit, so the jawline needs to extend down farther. Remember to make it more of a "V" shape; that is a defining feature of this character. This is not a full three-quarters view, so be sure the centerline corresponds to the curve of the form.

2 Rough In the Features
Draw the mouth open and somewhat pouty. Draw circles for the eyes. Place the irises carefully because they have a dramatic impact on the expression. After you indicate where the eyebrows will be, you should really get a sense of how the emotion is coming across. If the expression doesn't work, revise the drawing.

Artist's Note

Teenage girls present a great opportunity to explore expressions. If you have ever watched a group of girls talking, you know that their faces convey a lot of emotional messages. It's a good thing, too, because they're usually not the most verbally coherent people.

When I was in high school, I had a friend I liked to watch when she was on her phone. Even though the other person could not see her, her face still displayed all her emotions. I may not have been able to hear the whole conversation, but I could always tell what was going on.

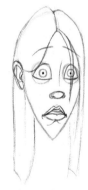

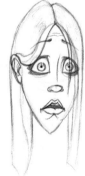

3 Refine the Features
Add the eyelids, making sure that they don't overlap the irises. Add nostrils and a thin line to indicate the bridge of the nose. Because she is young, you don't want to over-define the nose. Describe the contours of the lips and indicate the fleshy muscles below them; this is an important feature to this character. Define the shapes of the ear.

4 Add Details
This is where it all comes together. Darken the inside of the mouth and give her thick eyeliner. You may need to add some bulk to her cheeks to help show that her mouth is open and relaxed. Having the right cheek overlap the chin adds bulk and reinforces the expression.

5 Clean Up
Use ink lines to add drama. Render the pupils quite small, and draw thin radial lines in the irises to create the effect of light-colored eyes. Make thick lines under the lips and nose. Add a thick line under the light streak of hair to suggest a shadow. Add a thin line in the light streak of hair to break it up and make it look more like hair than a thick cord.

Rolling Eyes

Dad tells Gina that they need to have a talk. Gina rolls her eyes.

Oh great, another one of Dad's "little talks." Gina thinks this will be some minor discussion, maybe just a suggestion that she MIGHT want to be home on time. Since she doesn't really know the seriousness of the talk, her expression should be somewhat lighthearted. She's not angry—just inconvenienced. "This had better be quick; I've got some text messages to send."

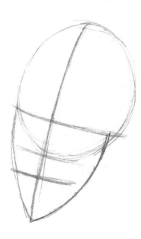

1 Draw the Structure
Draw a circle for the cranium and a pointed "U" shape for the jawline. The centerline will be slightly curved because this is a three-quarters view. Indicate your eye line halfway down the mass of the head. Also draw lines for the general placement of the nose and mouth.

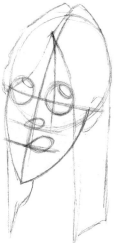

2 Rough In the Features
Draw the circles for the eyes. Notice that the irises should be oval-shaped because they are toward the edge of the sphere of the eyes. Her mouth is pushed to the side, which affects the angle of her nose, so you should tilt the oval of the nose. Draw the overall shape of the hair, keeping in mind the way long hair would fall across the face.

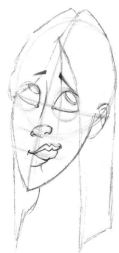

3 Refine the Features
Because she is looking up, her upper eyelids are fully open and her bottom lids are pulled up. Define the nose and mouth further. It is important to articulate these features correctly to support the expression. After you draw the lips, draw the tension in the muscles around her mouth. Once you add the eyebrows, her expression should be apparent.

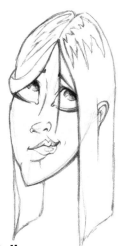

4 Add Details
This stage is important for clarity. Shade in the lighting for the irises and draw the eyelashes. Show how the eyebrows are affecting the shape of the eyes. Add detail to the ear. Add some lines on the right side of the mouth to reinforce the smirk. Indicate the details of the hair.

Visit www.impact-books.com/cartoonfaces for free bonus demonstrations.

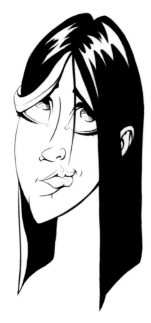

6 Whatever...
The color scheme not only highlights the hair and lips, but also integrates them.

5 Clean Up
Consider your line thickness as you ink. Lines can be thicker in areas of implied shadow and depth, such as the jawline, under the lips and where the eyes meet the brow. Draw faint indicators of highlights on the lips and eyes. Also, draw a thin line on the tip of the nose to show the contour.

Artist Variations - Rolling Eyes

Bronze:
Oh please! As if I would ever listen to Kenny Rogers, let alone his version of "Lady."

Gibbs:
This is the car mechanic who rips you off and laughs behind your back. He rolls his eyes as you pretend to know what you're talking about.

Brandon:
This is a kind of pudding-pop type of eye roll: whimsical and silly.

Hostile

She's forbidden to see Brad ever again.

Dang, Gina! Well, that's it. She's about to storm off to pout in her room. She'll be giving her dad the silent treatment for weeks—but before she goes, she gives him an intense glare.

As with most expressions, the eyes are crucial to the portrayal of hostility. All of the flesh surrounding the eyes is brought into play. The eyebrows come down, the cheeks come up and the eyelids nearly close. Her mouth will be a mixture of a sneer and a pout. Gina's trademark muscles below her mouth will be very prominent here.

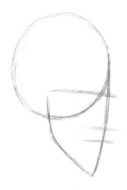

1 Draw the Structure
Draw a circle for the cranium. Because this is a profile view, the bottom part of the face will be a bit different. The line for the front of the face curves in slightly toward the chin. The jawline angles up, then curves, ending halfway into the cranium. Draw the eye line halfway from the top of the head to the chin. The nose is a little less than halfway down from the eye line. The mouth is a third of that remaining distance.

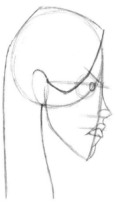

2 Rough In the Features
Indicate the end of the nose with an oval that extends beyond the face line. Indicate the lips, then draw the profile of the nose, lips and chin. Draw a circle for the eye and an oval for the iris. The eyes are not flush with the face, but are set in. Indicate the shape of the hair. By angling the eyebrow down, partially obscuring the eye, you suggest hostility.

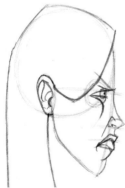

3 Refine the Features
Refine the angry sneer of the mouth and add a slightly flared nostril. In this expression, her eyes act almost like a black hole: All the surrounding features are pulled toward them. Not only does the eyebrow come down over the eye, but the cheek rises and pushes the lower lid up. This keeps the eye open just enough for the pupil to see out.

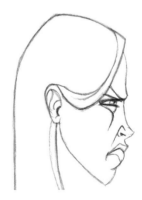

4 Add Details
Erase the construction lines that established the face. Add a protrusion where the eyebrows have pushed out a mass of skin above the eyes. These exaggerated eyebrows cast a shadow, so darken the area around the eyes. Draw the last details of the ears and hair. Look away from the drawing for a while, then quickly look back. If the expression doesn't read hostile the instant you look back, you need to revise.

Visit www.impact-books.com/cartoonfaces for free bonus demonstrations.

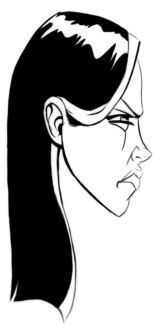

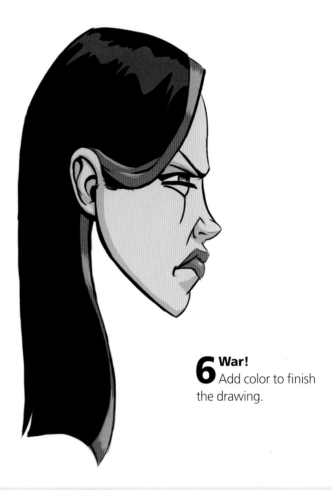

5 Clean Up
As you ink your drawing, emphasize the thickness under the jaw and the thinness of the lines on the front of the face. Ink the hair so it looks like she has shiny, jet-black hair with a light streak at the front.

6 War!
Add color to finish the drawing.

Artist Variations - Hostile

Gibbs:
You'd better get scarce.

Bronze:
Jim has just complimented the regional manager again and Barry has had it with his cheap attempts to climb the corporate ladder.

Brandon:
To me, hostility is a very focused emotion. I wanted to show that this guy's hostility is directed someplace specific and is very intense.

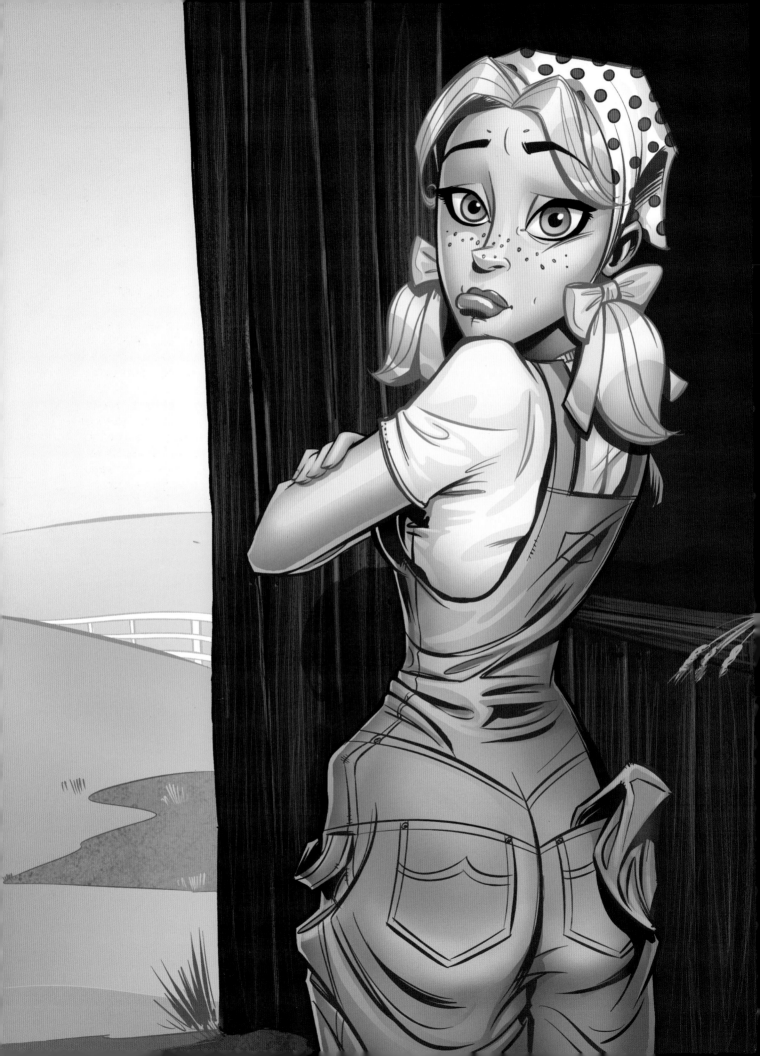

Betsy the Farm Girl

Betsy is not your typical airhead: She knows how to get exactly what she wants. This farm girl has an arsenal of deadly facial expressions that could break the willpower of any man. In this scenario, Ben will demonstrate how to make her look pouty, sassy and flirty. Knowing what goes into such expressions will increase your confidence—and maybe prepare you to withstand such tactics from your own significant other!

Pouty

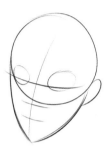

1 Draw the Basic Structure
Nothing new here. By now you must be really good at laying down those construction lines and doing it really quickly.

2 Block In the Features
Give yourself some placeholders for the hair, eyes, nose and so forth by using our favorite circle shape. Notice that for this expression, the pupils of the eyes are larger than normal.

Artist's Note

This scenario was supposed to be about an airhead girl and her not-so-smart boyfriend. I went to work sketching some character ideas, starting with a stereotypical hot farm girl. I tried other ideas but kept coming back to this one. As I began sketching expressions, Betsy began to evolve from an airhead worthy of all blonde jokes to a foxy lady who knows how to use her beauty to get her way—even if it means playing the airhead.

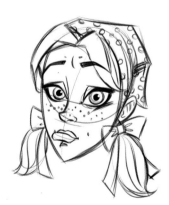

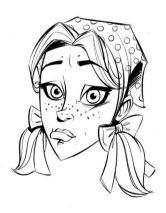

3 Refine the Features
Draw the eyebrows high and pinched toward the center of the forehead. Draw the outer shape of the eyes much wider than normal. Complete the nose. Draw the bottom lip more pronounced, almost covering the upper lip. Add a pucker line under the bottom lip.

4 Add Details
Darken the eyelashes, eyebrows and pupils. Complete the pigtails by flipping the hair at the tips, using sweeping lines. Do the same for the bangs. Draw the pattern of the kerchief and add freckles to the nose and cheeks. Complete the ear.

5 Clean Up
Ink over your pencil lines. Add shadows that correspond to your light source. Let the ink dry, then erase the pencil lines.

Sassy

Betsy's boyfriend comes over after a long night on the town with his buddies. One look at Betsy's face tells him he's in big trouble!

In this demo, I will show you how to throw some sass into your character to help her get whatever she wants. The sassy look has one eyebrow raised while the other is lowered. The nose is slightly crinkled and pulled to one side with the mouth; the face and jaw are twisted the same way. Usually this expression is followed by some head wagging and the index finger in the air. She's getting impatient, so let's get to it!

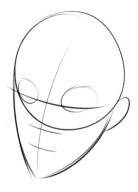

1 Draw the Basic Structure
Draw a circle for the cranium and a pointed, "U" shaped jaw. Block in one ear using a half-moon shape and the eyes using angled ovals. Add construction lines for the face. Notice that the head is tilted down and to the left.

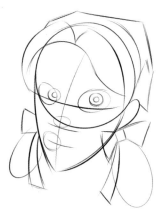

2 Block In the Basic Features
Use basic shapes for the pigtails, kerchief, bangs and bows. Use circles to plot the placement of the mouth, nose and eyes.

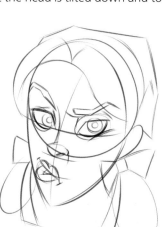

3 Refine the Features
Draw the eyebrows, making one lower than the other. Refine the shape of the eyes, making the outer point much higher than the inner. Complete the nose by drawing a tapered line vertically from the tip to the left eyebrow, a flat circle for the nostril and curved lines for the bottom of the nose. Draw the mouth pursed, slightly open and off to the left side.

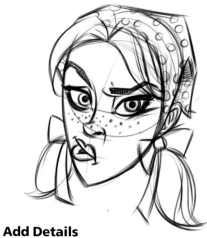

4 Add Details
Darken the eyelashes, eyebrows and pupils. Complete the pigtails by flipping the hair at the tips with sweeping lines. Do the same for the bangs. Draw in the pattern of the kerchief and add freckles to the nose and cheeks. Finish the ear. Then add a slight wrinkle to the forehead using a small pencil mark.

Visit www.impact-books.com/cartoonfaces for free bonus demonstrations.

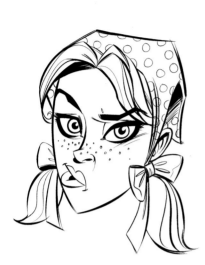

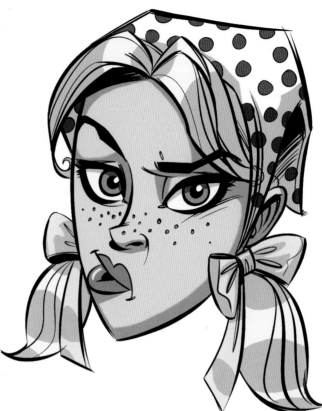

6 **Sassy... and Freckly**
When coloring the hair, remember that blonde doesn't mean yellow; blonde is more like a warm tan color. Sometimes it might be almost the same color as the skin.

5 **Clean Up**
Ink over the pencil lines using sweeping lines that vary in thickness. Add shadows to the fold of the kerchief and under the nose and bangs. Let the ink dry, then erase the pencil lines.

Artist Variations - Sassy

Brandon:
In an attempt to make the expression more specific, I had her in the middle of saying something. I think it worked out OK.

Bronze:
Only women are sassy.

Gibbs:
Devil with an attitude.

Flirty

Betsy notices that her boyfriend has something hidden behind his back. She tries to get him to show her what it is by turning on the charm.

The flirty expression can be really subtle, so if a hot girl looks at you like this, pay attention (and don't forget your name or reasoning power!). Just in case you don't know what you're looking for, flirty usually has one eyebrow slightly raised, dreamy eyes and a soft, sly smile in one corner of the mouth. If you're on the other end of this expression and still not getting the point, she might try nibbling on an earlobe and whispering sweet nothings into your ear. Take a minute to regroup, then start drawing!

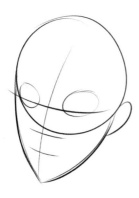

1 Draw the Basic Structure
Draw the basic head structure, remembering to point the chin. Don't forget the ear, and place those eyes along the construction lines as shown here.

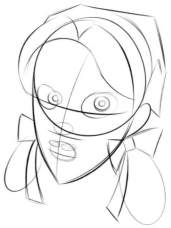

2 Block in the Basic Shapes
Draw basic shapes for the pigtails, kerchief, bangs and bows. Use circles to plot the placement of the mouth, lips, nose and eyes.

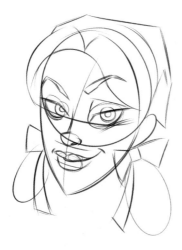

3 Refine the Features
Draw the eyebrows, arching one higher than the other. Refine the shape of the eyes, making the outer point much higher than the inner. Complete the nose. Draw the mouth closed and slightly curved upward, with one corner pulled more to the upper right for the sly smile.

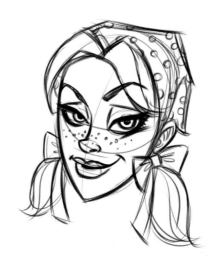

4 Add Details
Darken the eyelashes, eyebrows and pupils. This helps to see what the finished image will look like. Use those sweeping arm movements to complete the pigtails and bangs. Fill in the kerchief with a dotted pattern. Add freckles to the nose and cheeks, and then finish the ear.

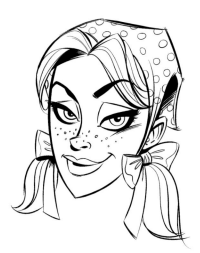

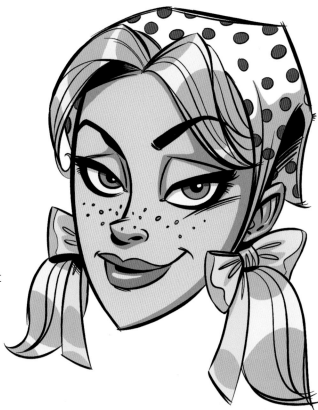

5 Clean Up

Ink the drawing using lines that vary in thickness. Decide which direction you want the light to come from and fill in the shadow areas. Let the ink dry, then erase those pesky pencil marks.

6 Hubba Hubba

Complete your drawing with some color. I used a computer, but you can achieve the same effect with a set of markers or your favorite medium. Whatever you use, it takes a lot of practice to get a professional look.

Artist Variations - Flirty

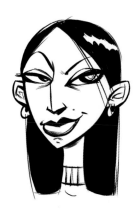

Gibbs:
She's flirty but dangerous.

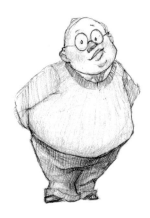

Bronze:
Across the aisle, Franky's eyes meet the newest edition of Java Script Weekly. He starts to put the moves on.

Brandon:
She's flirting with a false shyness. More on this later.

The Fight

Finally, a chance to draw what comics are really all about: violence! In this scenario, we're going to follow a no-holds-barred slugfest between Captain Thunder and Serpentra. Brandon will show you how to make Captain Thunder look when he's ready for action, yelling, slugged in the gut and exhausted. Gibbs will draw Serpentra when she's growling, attacking, electrocuted and gloating.

Prepare for battle!

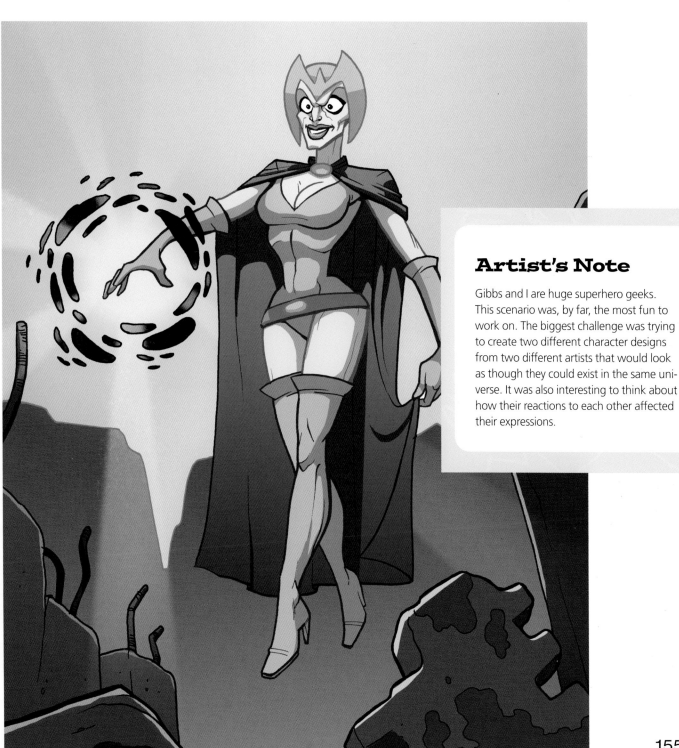

Artist's Note

Gibbs and I are huge superhero geeks. This scenario was, by far, the most fun to work on. The biggest challenge was trying to create two different character designs from two different artists that would look as though they could exist in the same universe. It was also interesting to think about how their reactions to each other affected their expressions.

Ready for Action

Captain Thunder is a hardened veteran. He knows not to run hot-headed into a brawl. He takes a moment to size up his opponent before jumping into the fray.

The expression here is subtle and contained—but not too subtle, because Captain Thunder is a superhero.

Think about the inner state of the character as he prepares for a fight. He cannot be sure of the outcome, but he doesn't want to show any weakness. There's potential for some pretty complex stuff.

1 Draw the Basic Structure
Start with a pretty standard head shape. Superheroes are not much different in design from regular people; they're just stylized in a few places to make them look more noble and masculine. For this head design, make the chin a bit more prominent than usual and give the cranium a squared, blocky shape to really emphasize his masculinity.

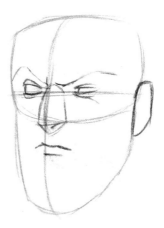

2 Block In the Features
Give him tight lips to show the tension in his face, and open one of his eyes to suggest a bit of uncertainty in his glare. Remember to make the eyelids wrap around the eyes.

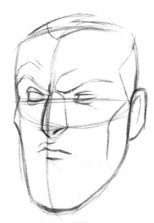

3 Add Secondary Shapes
Sketch in the area of the hair. The hair should just crop into his face from the top of the head and the temples, suggesting a receding hairline. Show how the muscles around his face are affected by the movement of his mouth and eyes. Indicate strong cheekbones on both sides.

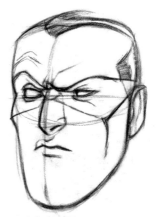

4 Add Details
Add additional lines to show energy and tension. Thicken the lines under the chin, between the lips, around the eyes and along the profile of the nose. Indicate the highlights in the hair. He's got shiny, slicked-back hair, so a single broad bar will do the trick. Finally, indicate where his mask will sit. The top edge of the mask will follow his eyebrows.

Visit www.impact-books.com/cartoonfaces for free bonus demonstrations.

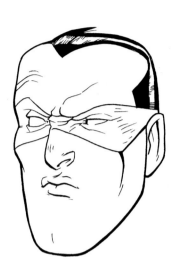

5 Clean Up

Ink over the pencil lines. Fill in the hair with black, leaving the white highlight. You can add a few light strokes in the highlight to suggest the direction of the hair. If you're feeling confident, add a few additional lines to indicate tension and describe form.

6 I Don't Like Your Green Face, Serpentra

I'm imagining that Captain Thunder's face is illuminated by an eerie bluish-green light that makes his skin cooler and grayer than normal.

Artist Variations - Ready for Action

Bronze:
He doesn't even blink. He just keeps eyeing the table waiting for someone to make the wrong move.

Gibbs:
Even an extraterrestrial can be ready for action.

Ben:
Sliver eyes and a small mouth say "ready for action" to me.

Growling

Serpentra is extremely angry. The mere appearance of her nemesis fills her with disgust. These feelings appear on her face as a hideous growl. Think of a cornered badger trying to escape.

1 Draw the Basic Structure
For this demo, our villainess will appear in a three-quarters view. Draw an oval shape for the cranium and add construction lines for the eyes, nose and mouth. The face should be somewhat squashed and not too narrow for this expression. Notice how the head juts out from the neck.

2 Block In the Features
Draw her lower lip pulled down in one corner for an extreme frown. Draw her mouth open with gritted teeth. Make her brow lowered and squinched together and her nostrils flared.

3 Add Details
Refine the features and add details such as wrinkles. Be sure to indicate the cross-eyed stare. Darken the lines you intend to ink.

4 Clean Up
Keep the lines showing the contours of the helmet shiny. Use heavier lines for areas in shadow, such as inside the mouth and around the nose and chin.

5 **I Don't Like Your Silly Face Mask**
Sickly green is the color of a sick mind.

Artist Variations - Growling

Bronze:
Arrgh!........ Arrrrrrrggh!

Brandon:
Animals are really great at growling.

Ben:
Caution: Do not steal food from squirrels!

Yelling

Captain Thunder heads into the fray full throttle. He's holding nothing back, so we're going to show all his energy unleashed in his facial expression.

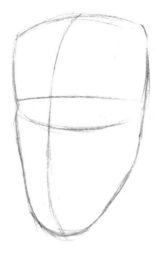

1 Draw the Basic Structure
Start with the same basic head shape but elongate the jaw because he's going to be yelling.

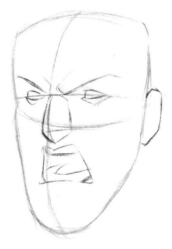

2 Block In the Features
Draw the mouth wide open with a frown and a sneer. Draw the half-moon for the bottom row of teeth. The eyebrows should be pulled down.

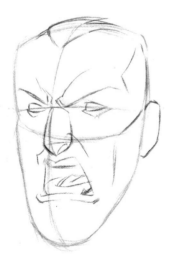

3 Add Hair and Refine the Features
Sketch in the hair. Add the furrows in the brow and other lines that indicate the effects of the expression.

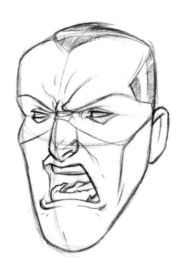

4 Add Details
Indicate the highlights in the hair. Draw additional lines on the tip of the nose and the forehead to show how the rest of the face ripples as his muscles tense. Add details to the teeth.

Visit www.impact-books.com/cartoonfaces for free bonus demonstrations.

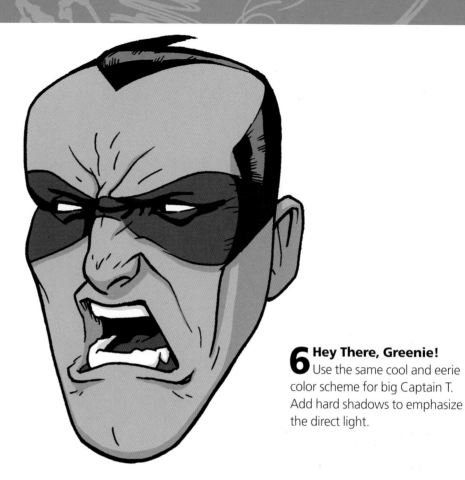

5 **Clean Up**
Ink your drawing. Keep the hair glossy and darken the mouth. Add additional detail lines to show the stress and form of the face.

6 **Hey There, Greenie!**
Use the same cool and eerie color scheme for big Captain T. Add hard shadows to emphasize the direct light.

Artist Variations - Yelling

Bronze:
Get back here so I can tear your puny face off!

Gibbs:
This is a pretty extreme and goofy yell, but it's also a yell of anguish and despair.

Ben:
Hey! Try hitting it out to left field, sissy pants!

Attacking

Infuriated, Serpentra attacks, lunging like a vicious serpent. How angry she must be to attack with such ferocity!

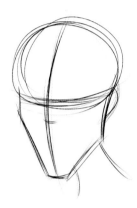

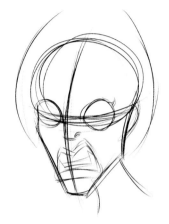

1 Draw the Basic Structure
Start with the same basic shapes and construction lines, but this time elongate the face to accommodate her open mouth.

2 Block In the Features
Draw her lower lip pulled down in both corners for an extreme frown. Her mouth is opened extremely wide, and her teeth are apart. Draw her brow lowered and squinched together and her nostrils flared.

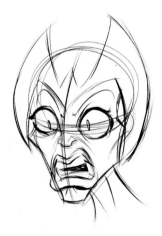

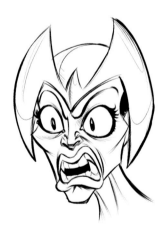

3 Refine the Features and Add Details
Refine the features and add details such as wrinkles. Be sure to indicate the cross-eyed stare. Draw the irises vertical as if they too are strained and stretched. Darken the lines you intend to ink, especially around the eyes so they appear to pop out of her skull.

4 Clean Up
Keep the lines near the edge of the helmet so it appears shiny. Use heavier lines for areas in shadow, such as inside the mouth, around the nose and chin, and around the eyes. Erase any pencil marks.

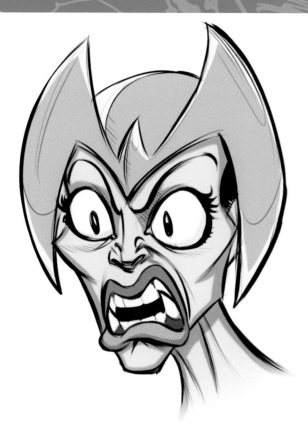

5 **Add Color**
Nyeeeeehhhh!!!!

Artist Variations - Attacking

Bronze:
This is the most terrifying killing machine in the galaxy: Kevin.

Brandon:
This is one of those expressions that needs body language to really sell it. This guy's expression could read a lot of different ways, depending on what his body is doing. In this case, imagine that he's running at you with big, jagged zombie claws.

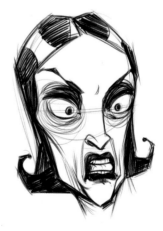

Ben:
Biting the curled-back tongue right before an attack is a trademark among the siblings in my family.

Slugged in the Gut

Captain Thunder is smart, but he's lost some of his edge over the years. Between his blows, Serpentra sneaks a sucker punch to the kidney.

In this demo, you'll draw the moment of Captain Thunder's most intense pain. This is the frame you must show to tell the story properly. In animation, it's called the "extreme."

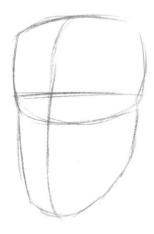

1 Draw the Basic Structure
Draw the head shape: a typical superhero head shape with a big chin.

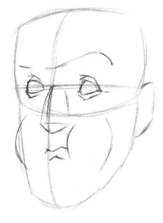

2 Block In the Features
Draw his cheeks puffing to show the air in his lungs being forcefully expelled. Draw his eyes wide open in shock and his lips pursed together as he tries to hold it all in.

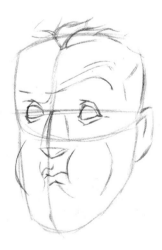

3 Refine the Features
Block in the hair, making it a little messy. Describe more of the form of the lips, cheeks and wrinkles on the forehead.

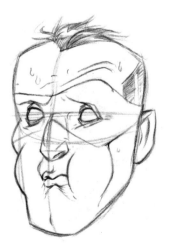

4 Add Details
Add the mask and solidify the most important shapes. Use a zigzag for the highlight of the hair to follow its messed-up pattern. Add sweat beads to show the slightest panic slipping into his psyche.

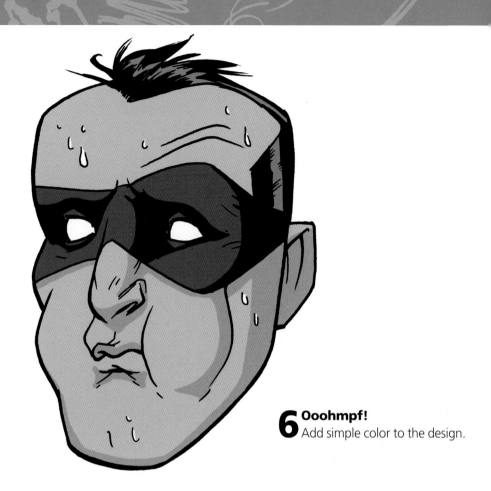

5 Clean Up
Ink your drawing. Make sure that any details you add follow the contours of the form.

6 Ooohmpf!
Add simple color to the design.

Artist Variations - Slugged in the Gut

Bronze:
Right in the bread basket.

Gibbs:
He keeps his mouth closed, trying to hold in the wind that's just been knocked out of him.

Ben:
"Get your own lunch money," I said, full of confidence—until he slugged me in the gut.

Electrocuted

When I approached this expression, I thought about the time that I was electrocuted. A friend of mine hooked a battery to the sink as a practical joke. I laugh about it now.

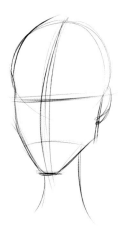

1 Draw the Basic Structure
Draw the structure for a three-quarters view. Again the face will be elongated, but for a different reason: It will be absorbing the electric bolts that are sent upward through her body. Make her head sit straight up on her neck.

2 Block In the Features
Block in the main shapes. Draw her lower lip pulled down for an extreme frown. Her teeth should be clenched. Draw her eyebrows raised dramatically over her bulging eyes.

3 Refine the Features
Add pupils to her crossed eyes and wrinkles to show tension in her face and neck. Sketch the form of the helmet.

4 Add Details and Clean Up
Add electric current lines to the top of the helmet. Also, add burn marks to her face to give her a singed appearance. Ink your drawing, remembering to vary the thickness of the lines.

Visit www.impact-books.com/cartoonfaces for free bonus demonstrations.

5 **Zapped**
I usually color my stuff using Adobe Photoshop®. I use one layer for flat color, and then add a second layer for details like highlights and shadows.

Artist Variations - Electrocuted

Bronze:
Electrocuted to the max.

Brandon:
I'm just copying Gibbs here.

Ben:
I don't know what to think of this sketch. Apparently, being electrocuted is no laughing matter.

Exhausted

Captain Thunder has given his all to bring down Serpentra, but it hasn't been enough. His strength is completely sapped, and he's gasping for breath.

In this demo, we're pushing Captain Thunder to the extreme again. His body is totally taxed, and his exhaustion shows in his eyes and in the way he breathes. Think of what must be racing through his mind: He knows he has nothing left to give and is scrambling to find some way to get out of this alive.

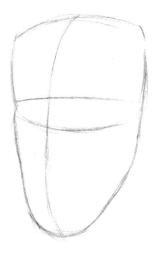

1 Draw the Basic Structure
Draw the head shape with an elongated jaw. Captain Thunder is going to be gasping for air, so you'll need room for his open mouth.

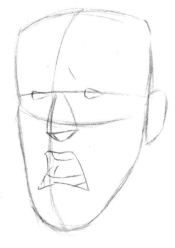

2 Block In the Features
Draw the mouth shape similar to the yelling mouth, but notice that the lower lip is droopier. Make the eyes a bit more open, round and relaxed.

3 Refine the Features
Add lines around the eyes and under the eyelids to make them look heavy and puffy. Sketch the hair and the upward push of the eyebrows. Start to sketch in the mask.

4 Add Details
Indicate the highlight and shadow areas of the hair. Add details to the nose and mouth, and draw some beads of sweat.

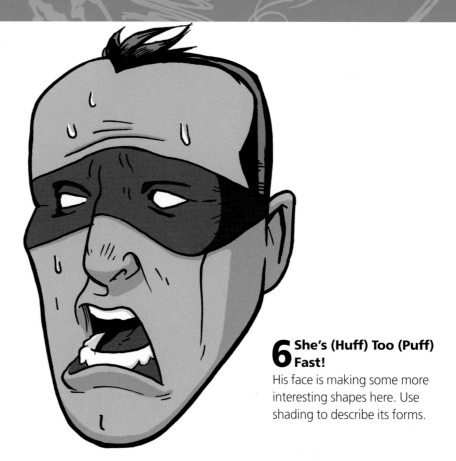

5 Clean Up
Ink your drawing, remembering to vary the thickness of your lines.

6 She's (Huff) Too (Puff) Fast!
His face is making some more interesting shapes here. Use shading to describe its forms.

Artist Variations - Exhausted

Bronze:
After getting up from his recliner, Hal is pooped.

Gibbs:
Have you ever felt so exhausted that you felt like you could just melt in a puddle?

Ben:
A long day of snake charming really is hard labor.

Gloating

The villainess laughs, her ego boosted as she watches her worst foe crumple to the ground. To help me develop this expression, I thought of a time when I wasn't as good at this one video game as my friend. He would always rub defeat in my face.

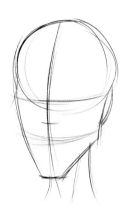

1 Draw the Elongated Oval Shape
Draw the basic head shape as you did for the previous demos, elongating the face to accommodate the open mouth. The neck will not be quite as stretched in this view.

2 Block In the Features
Draw her upper lip pulled upward in the corners for an extreme smile. Her mouth should be open very wide, and her teeth should be apart. Make the eyes more relaxed and almond shaped.

3 Add Details
Add the rest of the features and the details. Draw the mouth more open and relaxed. Push the corners of her lips into a sinister smile. Relax her neck by playing down the wrinkles.

4 Clean Up
Keep the helmet shiny by leaving the bulk of it white with dark, contrasting edges. Darken the eyebrows and the areas in the mouth. Add detail to the mouth and eyes, but don't separate the teeth as much as before. She no longer needs to be vicious.

Visit www.impact-books.com/cartoonfaces for free bonus demonstrations.

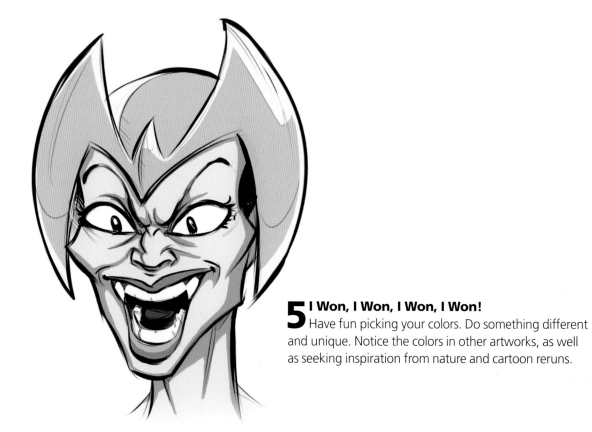

5 **I Won, I Won, I Won, I Won!**
Have fun picking your colors. Do something different and unique. Notice the colors in other artworks, as well as seeking inspiration from nature and cartoon reruns.

Artist Variations - Gloating

Bronze:
Da Boss just had someone whacked.

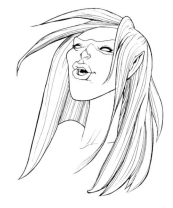

Brandon:
OK, confession time. I originally intended this to be seductive, but it ended up looking much more like gloating. Sometimes things just turn out that way.

Ben:
Look at that ant squirm. This glue works good!

Love Is in the Air

Ahhh, love: the greatest of emotions—and ahhh, the facial expressions that come with it. Love and attraction, the lure, the chase, the relationship—they are all so complicated.

The expression on one's face may be hidden or obvious. Bronze is going to draw the obvious (obviously!), and he'll show them on a little lady named Louise. She's come to the park and laid out a lovely spread for this summer day. But with whom can she share the experience? She lounges strategically next to a strapping young man wearing a fine pair of swim trunks. Now she must restrain herself so she doesn't come off as desperate.

Coy

1 Draw the Basic Structure
Draw the basic shapes tilted. I threw in a shoulder to, well, show that she's looking over it.

Artist's Note
Of course they wanted me, almighty Bronze, to illustrate this love scenario because they thought, "Oh, surely a handsome man like him is very familiar with the eager looks of love from many fine ladies." It's true. I am familiar with those looks— but not from real life. I've just seen them in movies. (Sigh.)

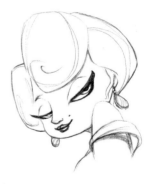

2 Define the Features
Draw her upper eyelids low to give that alluring look. Draw her eyes looking over her shoulder and a more relaxed smile than the shy one. Add an oval for the lips. I drew her dress strap slipping below her shoulder to add a little more spice. Don't forget to add the mole above her lip.

3 Add Details
Pay close attention to where you place the eyelids and the eyelashes; this is where the mystery and coyness will shine through. Draw extra lines through her hair to show direction and shape. Don't space them evenly through the hair, but vary the spacing and draw most of them closer to one side of the hair.

4 Clean Up
Darken the eyelashes and pupils. Shade the lips, leaving soft highlights to add dimension and make them look full. I'm leaving the rest pretty light because I want the focus to be on her eyes.

Shy

Louise notices being noticed and is caught off guard by the glance from the hunky man. She's also caught off guard by his amazing buttocks.

For shy, I'm going to show her looking down and avoiding eye contact, an action commonly associated with shyness. We'll also tuck her chin into her chest so she has to peer out through her eyelashes.

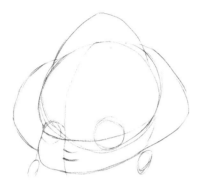

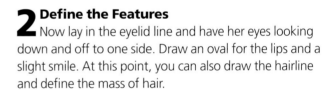

1 Draw the Basic Structure
Lay out the head shape. Remember that Louise has soft, childlike features such as a pronounced forehead and round cheeks.

2 Define the Features
Now lay in the eyelid line and have her eyes looking down and off to one side. Draw an oval for the lips and a slight smile. At this point, you can also draw the hairline and define the mass of hair.

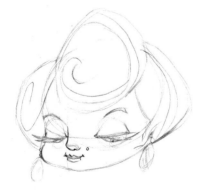

3 Add Details
Add the nostril contour of the nose and sharpen its perky look. Add a divot to the lips and define the eyelashes and eyebrows. Notice the small 45-degree lines at the ends of her smile. These make her smile look tighter. Add a beauty mole above her lip.

4 Clean Up
I had trouble finishing the eyes because her eyelashes cover so much of them, making it hard to tell where she's looking, but I settled for this and it seems to be enough information. For the cleanup on this demo, I was concerned that I would lose the softness of her features by using ink, so I decided to finish with pencil instead.

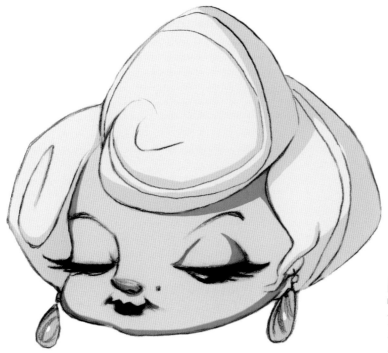

5 Awww!
Of course, she's a blonde! Color your drawing with tones that suggest a bright, sunny day. Just add a simple shadow and midtone.

Artist Variations - Shy

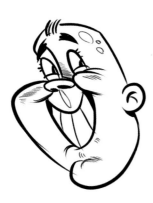

Gibbs:
Giggle, giggle.

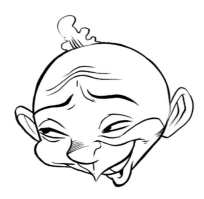

Brandon:
This time shy is shy. I imagine this guy is so shy, it's painful.

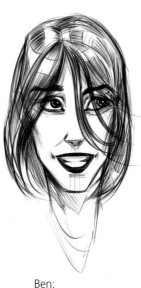

Ben:
Hee hee hee...sorry.

Seductive

Louise now feels that her subtle glances at the almost-naked man have been noticed, but with no clear advances from him apart from a smile, she must let him know that she is indeed interested. Not only interested, but very interested. She must let him know that he can do with her what he may.

1 Draw the Basic Structure

Draw the basics for a three-quarters view. Her bangs are a bit more pronounced when we see them from more of a side view. I'm cheating by drawing her shoulders and bust, which, of course, add to the mood we are trying to create.

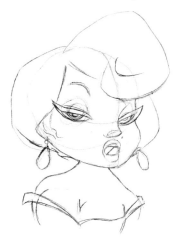

2 Add the Features

Draw her upper eyelids low again. We want those alluring "bedroom eyes," but there is nothing shy about her eyes now that they are fixated on her prize. Draw her mouth open but her lips relaxed. Because her mouth is open, her lips will appear more like soft tube shapes, and we'll see her teeth a bit. Draw her tongue touching her top teeth. Her eyebrows should be slightly raised, and one could be cocked a bit to create a look that asks, "Do you want me?"

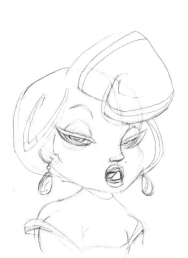

3 Add Details

Further define the curve and shape of her tongue and nose, and add hair details. Adding curved lines in her earrings suggests that they might be made of polished stone or wood. I modified her eyebrow slightly to make the peak of the arch more toward the inner side. This sells that inviting look.

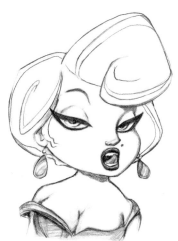

4 Clean Up

Darken the eyelashes and pupils. Shade her lips with a long, narrow highlight to give them a soft, tubular look. Define her teeth, and shade her tongue so it's darker on the bottom but catches more light on the top as it comes up and back to touch the teeth. I added subtle cast shadows under her bangs and chin to give her a little dimension.

Visit www.impact-books.com/cartoonfaces for free bonus demonstrations.

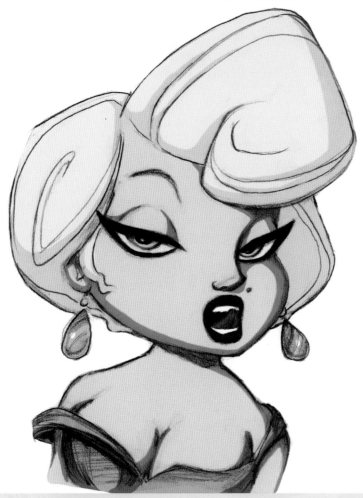

5 Interested?
Some of the form should already have been described in the initial sketch. Follow the shadows and form you've already created to determine where to put the color.

Artist Variations - Seductive

Gibbs:
Seductive—but in a sleezy, snobbish, billionaire playboy sort of way.

Brandon:
She's seductive in a very aggressive way here. Take no prisoners.

Ben:
OK, I copied Gibbs here—but not on purpose, I swear.

Storytelling

Now that we've explored expressions pretty thoroughly, we're going to look at how to use them in actual storytelling situations. As we've discussed before, expressions are always reactions to something. In this section, the demos are all about characters reacting to other characters. This means that we'll be crawling inside the head of each of our characters and feeling what they are feeling, even if only for a moment. To do this, we need to understand points of view. Specifically, we must understand how characters see each other and how the point of view affects their reactions and expressions.

While color does play a big part in telling the story, we really want to focus on the importance of storytelling, point of view, body language and composition. When you compose a frame, imagine that you are seeing that shot through the eyes of one of your characters. How does that character feel about what he or she is looking at? The answer should help you decide how to frame your shot.

Framing

The type of information you want to convey to your audience will determine how you should frame each part of your story. Framing options include close-ups, medium shots and long shots, but those general categories encompass an infinite range of possible views.

Medium Shot
A straightforward view of a clown crying.

Close-up
This view of the clown's eyes allow us to focus on his tear.

Close-ups

Close-ups are about focusing on details. A close-up says, "This thing we're looking at right now is important—more important than all the other stuff around it."

Close-ups put your audience in physical proximity to your subject. This can be a way of communicating intimacy and warmth, as when we cut tightly into lovers' faces, or a way of communicating awkwardness or revulsion, as when we focus on all the warts, zits and rotten teeth of a thug.

Close-ups always require more detail, but it's up to you to decide which details are most important. If you want to focus on the reaction of a specific part of the face, then draw an extreme close-up of that feature.

Extreme Close-up of an Eye
This view is intimate and revealing.

Extreme Close-up of a Mouth
This view shows someone who is happy and healthy.

Visit www.impact-books.com/cartoonfaces for free bonus demonstrations.

Close-ups Provoke Responses

Showing intimate details—especially of a character's face—can provoke strong emotional responses from your audience. Use close-ups to focus those reactions and create the right feeling for your story.

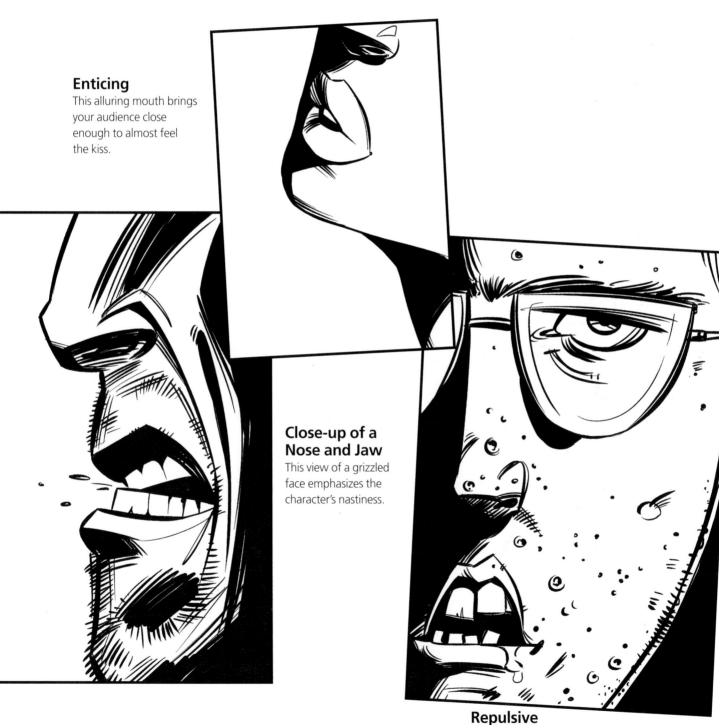

Enticing
This alluring mouth brings your audience close enough to almost feel the kiss.

Close-up of a Nose and Jaw
This view of a grizzled face emphasizes the character's nastiness.

Repulsive
The details of this ugly face are sure to repel your audience.

Long Shots

On the other end of the spectrum is the long shot. Long shots are used to emphasize and describe environment. Typically, the first panel in a comic book will be a long shot (called an establishing shot) that tells us where the action is taking place. Long shots can also be used to show distance between two characters and describe how that distance causes them to react to one another.

Describing the Environment
We thought a knife-throwing act was the best and most common way to show long shots in action.

Long Shot
Details of the eyes and mouth are very simplified.

Extreme Long Shot
Facial details are totally gone. She's waving her arm to get attention.

Visit www.impact-books.com/cartoonfaces for free bonus demonstrations.

Medium Shots

Medium shots are best for important facial expressions because they allow you to show a full face with a lot of details. As you pull back from the head to include more of the body, you will lose much of the detail, so you must decide how much detail you need to convey the necessary information.

Medium Shot
Dull expression, dull mind.

Long Shot
Not very active in body, either.

Maintaining Expression

The most critical details of any expression are the eyes and the mouth. As you pull away from the figure, the nose is often the first detail to go. As you can see from the examples at right, even with the nose gone, the woman's expression still reads loud and clear.

The farther away you go, the harder it is to read the expression clearly. You start to lose the pupils and the eyebrows, and you can do less and less with the eyes and the mouth. As your distance from the figure grows, it becomes increasingly important to use body language.

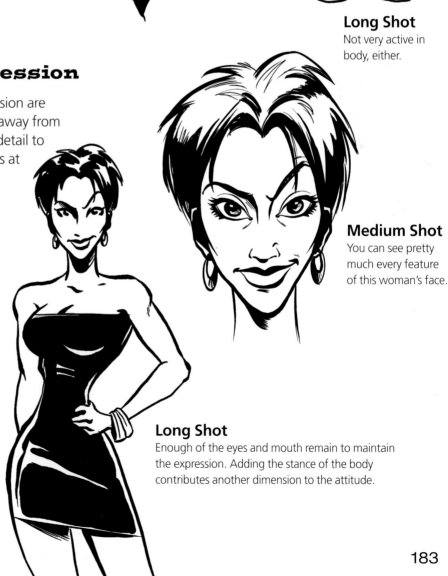

Medium Shot
You can see pretty much every feature of this woman's face.

Long Shot
Enough of the eyes and mouth remain to maintain the expression. Adding the stance of the body contributes another dimension to the attitude.

Body Language

Think of the body as an extension of the face. If the face is compressed with anger, have the body do the same. If the face is bursting with energy, the body should explode as well.

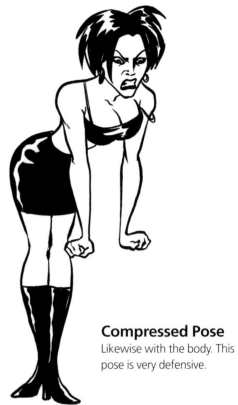

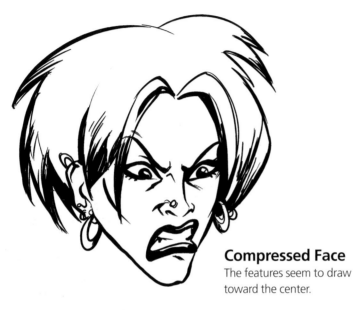

Compressed Face
The features seem to draw toward the center.

Compressed Pose
Likewise with the body. This pose is very defensive.

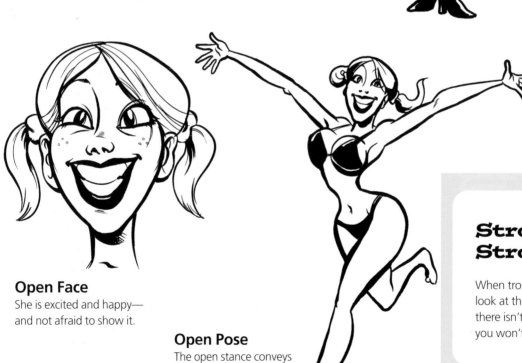

Open Face
She is excited and happy—and not afraid to show it.

Open Pose
The open stance conveys the explosive energy of her happiness.

Strong Line = Strong Pose

When troubleshooting your poses, look at the line of action first. If there isn't a strong line of action, you won't have a strong pose.

Visit www.impact-books.com/cartoonfaces for free bonus demonstrations.

Line of Action

The energy of a body can be most simply expressed through a line of action. A good line of action shows a specific, direct motion through the entire body, with all of the details reinforcing that line. A bad line of action moves all over the place, with a lot of little energetic details fighting against each other.

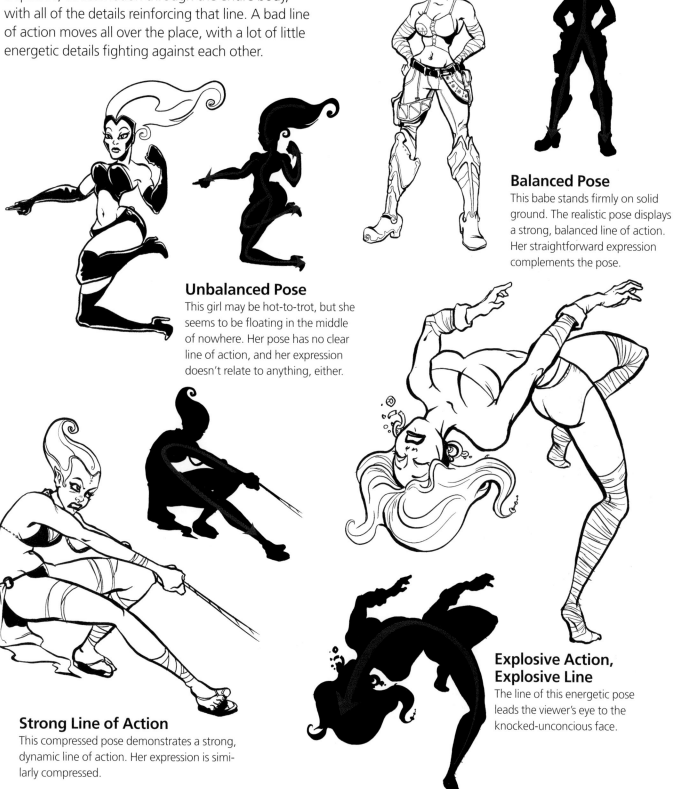

Balanced Pose

This babe stands firmly on solid ground. The realistic pose displays a strong, balanced line of action. Her straightforward expression complements the pose.

Unbalanced Pose

This girl may be hot-to-trot, but she seems to be floating in the middle of nowhere. Her pose has no clear line of action, and her expression doesn't relate to anything, either.

Explosive Action, Explosive Line

The line of this energetic pose leads the viewer's eye to the knocked-unconcious face.

Strong Line of Action

This compressed pose demonstrates a strong, dynamic line of action. Her expression is similarly compressed.

Single Panel: Zombie & Cave Girl

When you are working with a classic genre such as "Cave Girl–Zombie" comics, make sure you know your sources. For this demo, Gibbs researched actual encounters between cave women and zombies. A little research can go a long way. Make the action pop by creating lines that are as dynamic as possible.

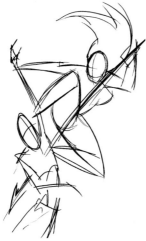

1 Create a Thumbnail
These crude drawings are called thumbnails. They are usually very small, somewhere around 2" × 2" (5cm × 5cm). Thumbnails offer a very quick way to get your ideas down on paper, and the size prevents you from getting bogged down with details. I draw a thumbnail in less than a minute to get an idea of how I want to compose the scene. This composition really makes the cave woman the aggressor.

2 Try a Different View
I created another thumbnail with the roles reversed and the zombie on top. It turned out OK, but if I were to redo it, I would probably make the angle more extreme. I don't think I will go with this one.

3 Explore Your Options
Try another for exploration's sake. You might find something you like but didn't visualize until you pushed yourself to think differently. I like the equal struggle between the two characters a little better. Perhaps I would rotate the point of view a little to the right. The energy is in here somewhere, but I think I will go with the first view.

4 Choose a View and Create a Rough Sketch
Now that you have chosen your favorite thumbnail, create a rough sketch from it, using another sheet of paper. Block in more of the actual shapes and anatomy. I added lines to show how the bodies will be positioned and a hint of the final expressions.

Keep a Sketchbook

Keep a sketchbook and fill it with thumbnails of all those crazy ideas in your head. This will be a valuable resource later on when you're trying to think of something cool to draw. It won't take a whole lot of time, either.

5 Add Details

Now lay a new sheet of paper over your rough drawing. Can you see through it? Kind of? If you can, use this as your guide to create the final, tight version. If you can't, try a light table. At this point, you can add all the details, figuring out how such things as those fingers should look.

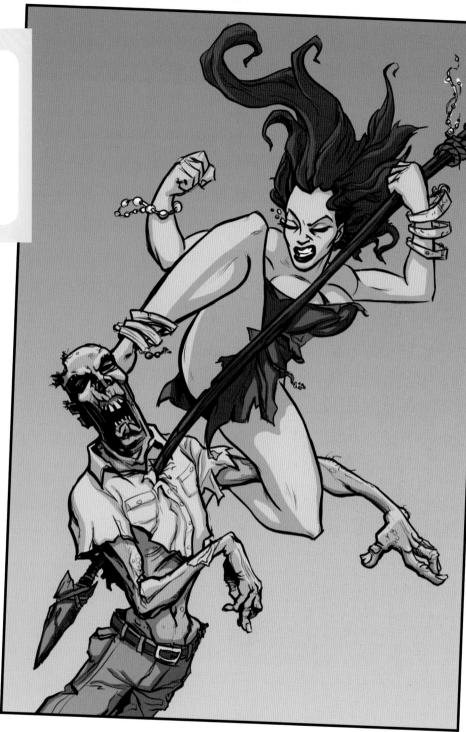

6 Dead Guy, Meet Cave Girl

Finally, ink and color your beautiful drawing. Remember to vary the width of your strokes to accent your curves and lines.

Single Panel: Space Man vs. Alien Monster

Space, the final horizon... no, wait, I mean the other thing! Something about space and the unknown has fascinated artists for a long time. For Ben, this subject still packs a lot of excitement. In this single-panel demo, Ben will show how he composes a scene for maximum impact, while allowing body language and facial expressions to take center stage.

1 Create Some Thumbnails

I use thumbnails as visual thoughts to explore composition ideas. To some they may just look like scribbles, but to me they make perfect sense. Don't worry about anatomy; establish a design that will tell the story. Create several thumbnails, even if you feel like you already got it down with your first one. This exercise will help stretch your thinking and may lead to ideas that you've never thought about before.

2 Refine the Drawing

Choose your favorite thumbnail and use it as a guide for your drawing. You can do this by drawing a larger version on a new piece of paper, or you can enlarge it on a photocopy machine, then trace that onto a new sheet. Rough in the figures, correcting anatomy and fixing those compositional details that didn't make it into the thumbnail.

3 Add Details, Tighten and Ink

If your rough sketch is tight enough and you feel you have all of the necessary details, you can begin inking it using your favorite tools. I took my sketch into the computer and inked it there, but the same effect can easily be achieved with pen and ink.

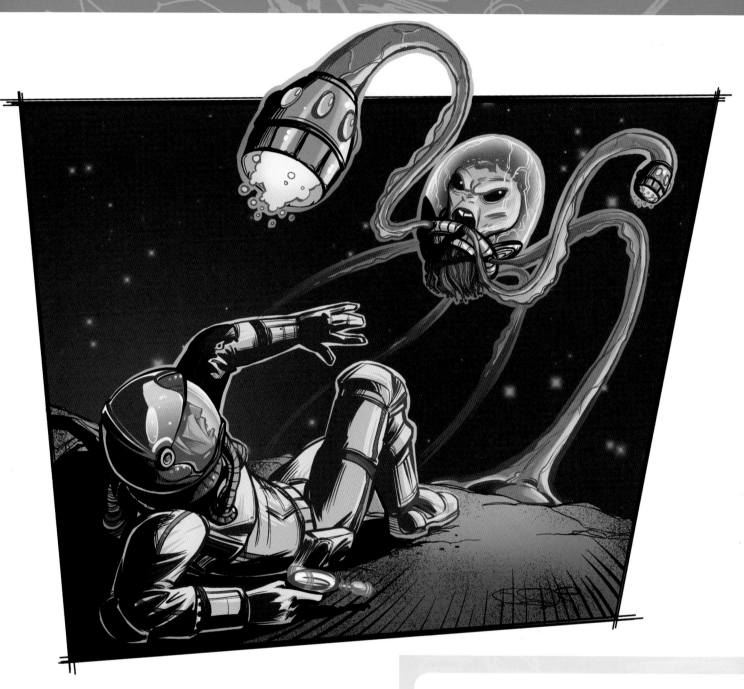

4 Add Color

Ah, the final piece, beautifully colored. It's great to see the payoff after all of those steps. At this point, it's a little late to evaluate the image, but I think this successfully shows the fear of being overcome by an angry alien creature.

Inking Inspiration

There aren't really any rules for inking. It's all a matter of personal style. When you're learning the craft, open up a copy of your favorite comic book and see if you can reproduce the look and feel of the work. After much practice, your own style will eventually emerge.

Two Panel: Shot/Reverse Shot
Noir Interrogation

The noir style was developed by film directors of the mid-twentieth century and has become popular with comic artists as well. This genre is characterized by low-key lighting and dramatic camera angles. This piece will be set in the 1940s, so the clothing and hair should fit the time period. Blake is going to show us how to tell a story using the shot/reverse shot.

1 Create Some Thumbnails
Start creating thumbnails. This one explores the concept of shot/reverse shot. We have one view from behind the interrogator and one from behind the guy under investigation. I decided this doesn't work well because there isn't an establishing shot to show the setting and convey the relationship of the figures to one another.

2 Keep 'Em Coming
In this sketch, I was playing with the body language of the interrogator. This is slightly better than the first thumbnail because we get more of a sense of where the characters are in relation to one another. I won't go with this one, however, because the two panels are too similar and don't heighten the drama.

3 Make Your Choice
At this point, you must decide whether to use the best aspects of your previous thumbnails or come up with something completely different. I chose to take what I learned from the first two drawings and tighten the idea. The body language makes the first panel more dramatic. I also like the angle of the table. The light between the figures heightens the drama. The first panel will show the expression of the man being interrogated; the second panel will be a reverse shot of the interrogator's face.

Visit www.impact-books.com/cartoonfaces for free bonus demonstrations.

180-Degree Rule

Put simply, this rule involves an imaginary line that runs between two points in a scene. In a scene with two characters, those characters are the points. Once you establish this line, you should compose all of your shots from the same side.

Shots from different sides of the 180-degree line are confusing. Here, the most effective designs show the characters from the same side of the line. As you compose your own sequences, experiment with jumping across the line to get a good idea of how this rule works.

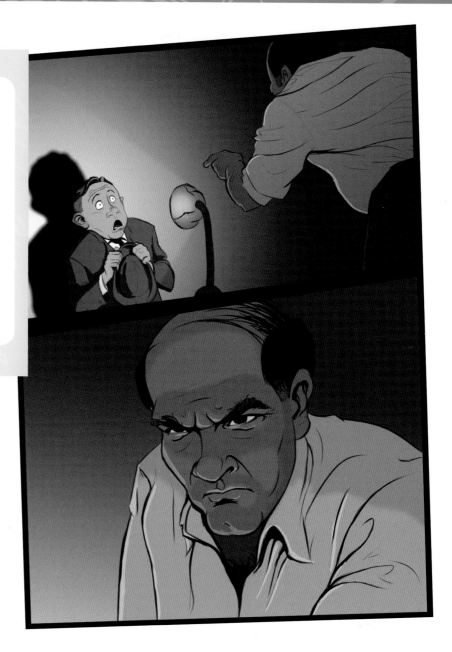

4 Refine and Add Detail
I took the composition of the third thumbnail and expanded upon it. Here we can see the man cowering because he is being overwhelmed by the light and the interrogator's accusing finger. The reverse shot allows us to add more detail to the interrogator's face. The expressions should work together to tell the story.

5 Tighten, Ink and Color
Tighten your rough sketch, ink in your lines and finish it off with a bit of color. It sounds like a lot for one step, and in a way it is; but when you take time to figure out the composition in the thumbnail and the expressions in the rough stage, the rest is just icing on the cake. Here is where I really added the noir-style elements. By coloring it in dark, muted tones, I conveyed the idea that this was the 1940s film noir era. The hat and slicked hair of the man under interrogation reinforce the time period. Gradations of tone behind the characters not only help to set the mood but also work as a compositional device to lead your eye.

Three Panel:
Establishing Shot and Close-ups Western Standoff

Ah, the Western standoff. Is there any scene more iconic? More than likely, if you are drawing a scene from such an old, common genre, you're going to be drawing scenes that people have already seen. This isn't necessarily a bad thing; it allows you to tell the story more easily because the images are so familiar. Listen to Blake, he knows what he's doing... sort of.

1 Create Some Thumbnails
In this first thumbnail, I was playing around with how to set up the establishing shot and the other panels. This establishing shot seems too boring. I like the arrangement of the three panels, so I will explore that further.

2 Experiment With Angles
Experiment with different "camera" angles. The first panel here is a classic for the genre, but since we don't yet have a sense of who is who, it won't work. We need a better establishing shot.

3 Try Again
Time to push yourself. In this sketch, I tried the full-body establishing shot again, but with a more dramatic point of view. By placing a close-up of each guy on the same side where he appears in the establishing shot, we let the viewer know who's who.

4 Add Details
Now that you have an arrangement you like, tighten it up by adding details. This is where I really focused on the characters' expressions. In the establishing shot, the one in the distance has a tense, scared posture. The guy closer to us has a more confident, statuesque pose. I have arranged the bottom two panels to portray the two men staring into each other's eyes. Even though the arrangement has condensed the space between them, we know they are far apart because of the establishing shot.

Visit www.impact-books.com/cartoonfaces for free bonus demonstrations.

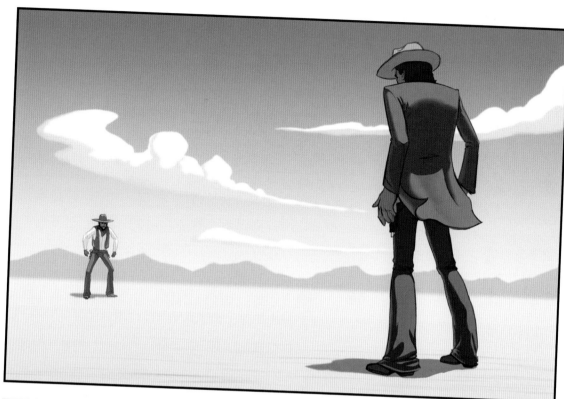

5 Clean Up and Color
Clean up the drawing and add color to establish the lighting and mood. Standoffs always seem to be more interesting when set at midday. To indicate this, I painted the shadows directly underneath the figures. The form shadows also reinforce the idea that the the sun is directly overhead. The faces are in shadow because of their hats, but notice that because the sunlight is so strong, there is an intense reflected light from the desert ground below.

Single Panel:
Sectioned With Three Characters
Mexican Standoff

Now that we've looked at some ways to show two characters interacting in a scene, we'll throw in a third character to make things more complicated. What better scenario for three characters than a Mexican standoff, which is basically the same thing as a classic Western standoff, but with three or more antagonists instead of just two.

In this demo, Brandon will compose three panels, each representing the point of view of one of the parties involved in the standoff.

180-Degree Rule With Three Characters

You can still use the 180-degree rule for scenes with three characters. Pick two figures to draw your 180-degree boundary through. The third character can be on either side of the line.

In this case, I drew my line through the guy holding his gut and the guy on the ground.

1 Create Some Thumbnails
Plan your rough layout. This is going to take the most thought and effort. Be prepared to redraw your composition until you get it right. If you're using pencil, use one that's easy to erase so you can make changes easily.

2 Tighten and Add Details
Tighten up your rough layout. Fix any anatomical and proportional errors and add dramatic details.

3 Clean Up and Ink
Clean up and ink your drawing. Use bolder strokes for figures that are closer to you and lighter strokes for objects that are farther away.

Visit www.impact-books.com/cartoonfaces for free bonus demonstrations.

4 **A Bad Situation**
Use colors to help distinguish the three figures from one another.

Single Panel:
Three Characters With Inset Damsel in Distress

Insets provide a great way to tell the story from two different points of view. The inset allows you to zoom in to a specific area or pull back for a wide establishing shot. It's kind of like having a second camera. Ernie explains this one.

1 Create Some Thumbnails

Begin sketching thumbnails and remember to keep them small. I started working fairly loosely, just scribbling in the bulk of the characters and their positions. I wanted to see the face of the damsel in distress and wanted to use the bad guy to frame the rescuer. The only thing I wasn't quite sure of at this point was what kind of head my villain had.

Using tracing paper, I explored another version of the villain's head. I liked how the big, bulky shoulder and arms contrasted with the skinny turtle neck.

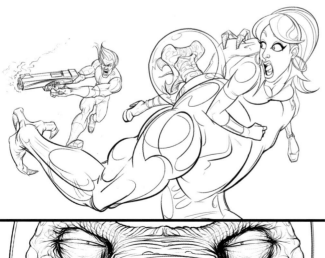

2 Refine Your Rough

Because I have done a lot of drawing over these many, many years, I can go straight from rough to final line work. After drawing the three figures, I thought it would be really cool to get a look at the villain's eyes, so I drew them in an inset at the bottom. I'm not the kind of artist who uses a lot of black ink for the shadows. I try to describe the texture and use colors to add the shadows. I loosely ink in the outline of the character, then start adding the details. I accidentally crossed the wrinkles, but decided to keep them that way because they looked like elephant skin. Don't be afraid to explore different ways of doing things.

Visit www.impact-books.com/cartoonfaces for free bonus demonstrations.

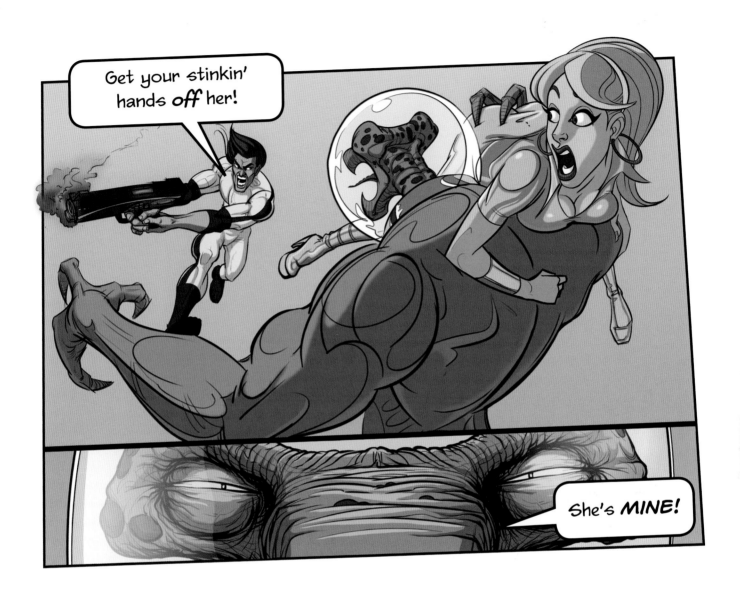

3 How Did You Guys Meet, Anyway?
Now color it! I usually paint from background to foreground. Starting with a large background shape, I throw in a gradated color. Using a separate layer in Photoshop®, I block in flat areas of color for the characters and props such as the gun. Then I add detail to the flat areas of color. If the background color isn't working, I can change it without affecting the character color layer.

Cover: Splash Page Superhero Team

You know you've made it big when you get the opportunity to do a cover. And in case you forgot in all of the excitement, they are actually going to pay you for doing it! As cool as that may be, covers are tricky business. They can make or break the sale for someone who is browsing the shelves looking for something cool, so pay attention as Ben takes you step-by-step through the process of creating our Superhero Team cover.

1 Create Some Thumbnails
Think about the individuals on your team. How do they interact with one another? If each of them has different personality traits, how can you show that in the body language? Remember to keep your drawings small, and don't worry about the details or correct anatomy.

2 Refine the Drawing
Choose your favorite thumbnail and use it as a guide to create a rough sketch. Establish each figure's proportions. Decide where and what you want to overlap. Rough in the particulars, correcting anatomy and fixing details that didn't make it into the thumbnail.

3 Ink
When inking, think about how lighting can influence the story. For example, side lighting with strong contrast can add interest, or backlighting a superhero with a ray of sunshine can make him stand out. You need to ink more black areas rather than just lines in this step.

Visit www.impact-books.com/cartoonfaces for free bonus demonstrations.

4 The Good Guys

Now add color to your image. This can be done in any manner of ways including markers, watercolor, colored pencils, etc. But if you want a professional look, it's best to take it to the computer and use a program like Adobe Photoshop® or Corel Painter®.

Cover: Splash Page Supervillains

Here's an odd collection of supervillainy: the brute, the fatty, the lackey and the genius, with the female as the leader. This demo will explore Gibbs's take on the team cover with the big, the bad and the ugly.

1 Create Some Thumbnails

This is just your run-of-the-mill group shot. By posing the villains in various sizes, you can create an effective composition that also conveys their collective personality—which is nothing short of evil. I blocked in the shapes very loosely, not worrying about any facial expressions yet.

2 Another Variation

This thumbnail is also a group shot with the characters positioned a bit differently. I like the first one better because the composition here looks a little weak.

3 Action Shot

This sketch shows the villains in action. The reason I didn't go with this one is that it looks too heroic.

4 Choose and Refine

Tighten your favorite thumbnail with a layer that is a bit darker. Add more detailed lines to show how the bodies will be positioned, and add hints for the final expressions.

Visit www.impact-books.com/cartoonfaces for free bonus demonstrations.

5 The Not-So-Good Guys

Add ink and color, using strokes that vary in thickness to accent curves and lines. I chose to change the expressions a little from the previous sketch to add more variety. I liked it this way much better.

Battle Scene

Now, Brandon is going to mix it up a bit and show five characters in a life-or-death battle with each other. This will give us a great opportunity to explore all of the principles we've talked about: close-ups, long shots, composition, body language and line of action.

1 Create a Thumbnail

Here I've established three different planes of action: foreground (close-up), mid-ground (medium long shot) and background (long shot). Make sure there is a clearly defined line of action for each character.

2 Sketch and Adjust

Create a sketch of the scene based on your thumbnail. Make adjustments for placement, and add the details you want to focus on, such as the facial expressions of the foreground characters. This is a good time to rework and make subtle changes to your layout. If you're not drawing digitally, use a pencil with a soft lead and a good, soft eraser so you can keep making adjustments.

3 Refine Your Drawing

Tighten up the pencil work. Make any final adjustments to pose and detail in this step. Pay attention to the level of detail in the background characters; it should be lower than that of the foreground characters.

4 Clean Up and Ink

Clean up the drawing. Try to maintain the energy of the sketch in the final linework.

5 **Battle Royale**
Add color. Since this isn't a book on color theory, I'll
just recommend that you have fun with it. If your eyes are
bleeding, your color is probably too intense.

Index

The following artwork appeared in previously published IMPACT books (the initial page numbers given refer to the original artwork; numbers in parenthesis refer to pages in this book):

Harry Hamernik. *Face Off* © 2006. Pages 12–25 (8–21), 32–33 (22–23), 34–49 (26–41), 50–53 (42–45), 54–55 (50–51), 56–57 (54–55), 58–61 (58–61), 62–73 (64–75), 74–95 (80–101), 96–101 (106–111), 102–103 (114–115), 104–105 (118–119).

8fish. *Making Faces* © 2008. Pages 4–5 (8–9), 6–11 (14–19), 26–27 (10–11), 28–31 (20–23), 37 (36), 39 (34), 41 (30), 43 (37), 45 (24–25), 106–111 (38–43), 112–121 (46–55), 122–125 (60–63), 126–127 (66–67), 128–133 (70–75), 134–145 (80–95), 146–153 (98–105), 154–171 (110–127), 172–175 (130–133), 176–177 (136–137), 178–191 (140–153), 192–203 (156–167).

 Other fine IMPACT Books are available from your favorite bookstore, art supply store or online supplier. Visit our website at fwmedia. com.

18 17 16 15 14 5 4 3 2 1

DISTRIBUTED IN CANADA BY FRASER DIRECT
100 Armstrong Avenue
Georgetown, ON, Canada L7G 5S4
Tel: (905) 877-4411

DISTRIBUTED IN THE U.K. AND EUROPE
BY F&W MEDIA INTERNATIONAL LTD
Brunel House, Forde Close, Newton Abbot, TQ12 4PU, UK
Tel: (+44) 1626 323200, Fax: (+44) 1626 323319
Email: enquiries@fwmedia.com

DISTRIBUTED IN AUSTRALIA BY CAPRICORN LINK
P.O. Box 704, S. Windsor NSW, 2756 Australia
Tel: (02) 4560-1600; Fax: (02) 4577 5288
Email: books@capricornlink.com.au

ISBN 13: 978-1-4403-3616-4

Edited by Beth Erikson
Designed by Geoffrey Raker
Production art by Amy Wilkin
Production coordinated by Mark Griffin

Harry Hamernik has spent years teaching caricature drawing to artists for theme parks such as SeaWorld, LEGOLAND, Knott's Berry Farm and Paramount's Kings Island. He has taught at the Art Institute of California in San Diego, the Art Academy of Los Angeles and Orange County Art Studios. Harry holds a Bachelor of Arts degree in graphic design with an emphasis in commercial illustration. He and his wife, Kate, also own a freelance art business. Harry is available for hire as a caricature or freelance artist for any event or project. For more information, go to www.hamernikartstudios.com.

Metric Conversion Chart

To convert	to	multiply by
Inches	Centimeters	2.54
Centimeters	Inches	0.4
Feet	Centimeters	30.5
Centimeters	Feet	0.03
Yards	Meters	0.9
Meters	Yards	1.1

8fish is a jack-of-all-trades creative workshop that has been producing mind-blowing animation, design and illustration for years. The secret to 8fish's success is a feisty team of incredibly talented and versatile artists who constantly challenge themselves and each other. Their combined artistic knowledge is enough to fill volumes, but they are working on unloading it one book at a time.

Blake Loosli

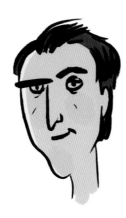

Brandon Dayton

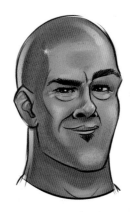

Ernest Harker

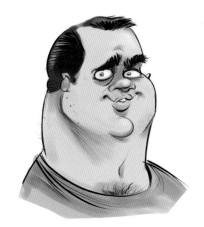

Gibbs Rainock

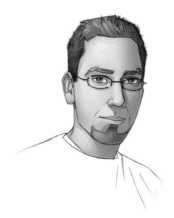

Ben Simonsen

Bronze Swallow

Ideas. Instruction. Inspiration.

Download a FREE bonus *Drawing Cartoon Faces* demo at impact-books.com/cartoonfaces.

Check out these **IMPACT** titles at impact-books.com!

These and other fine **IMPACT** products are available at your local art & craft retailer, bookstore or online supplier. Visit our website at impact-books.com.

Follow **IMPACT Books** for the latest news, free wallpapers, free demos and chances to win FREE BOOKS!

Follow us!
@IMPACTbooks

IMPACT-BOOKS.COM

- ▸ Connect with your favorite artists
- ▸ Get the latest in comic, fantasy and sci-fi art instruction, tips and techniques
- ▸ Be the first to get special deals on the products you need to improve your art